Günther Friesinger, Jana Herwig (eds.)
The Art of Reverse Engineering

Cultural and Media Studies

GÜNTHER FRIESINGER, JANA HERWIG (EDS.)
The Art of Reverse Engineering
Open – Dissect – Rebuild

[transcript]

This publication was supported by
the Department of Art Funding/ City of Vienna, Austria.

This publication is based on the symposium »Open. Dissect. Rebuild.«,
which took place 2012 in the context of the paraflows Festival in Vienna.

Bibliographic Information published by the Deutsche Nationalbibliothek
The Deutsche Nationalbibliothek lists this publication in the Deutsche Nationalbibliografie; detailed bibliographic data are available in the Internet at http://dnb.d-nb.de

© 2014 transcript Verlag, Bielefeld

All rights reserved. No part of this book may be reprinted or reproduced or utilized in any form or by any electronic, mechanical, or other means, now known or hereafter invented, including photocopying and recording, or in any information storage or retrieval system, without permission in writing from the publisher.

Cover layout: Kordula Röckenhaus, Bielefeld
Cover illustration: Sylvia Eckermann, Crystal Math, 2012,
 One video channel, 5.1 Sound, 5000 m Nylon wire
Proofread: Nicole M. Boitos, Jana Herwig
Typeset: Anika Kronberger
Printed by Majuskel Medienproduktion GmbH, Wetzlar
ISBN 978-3-8376-2503-5

Table of Contents

INTRODUCTION

Technology vs. Technocracy
"Reverse Engineering" as a User Rebellion
Frank Apunkt Schneider, Günther Friesinger | 9

Reverse Engineering the Senses: Sight/Hearing and Touch
Jana Herwig | 23

1. OPEN

Biohacking: Keeping Synthetic Biology Research Safe and Responsible Among Amateur Biologists
Markus Schmidt, Lei Pei, Alexander Kelle, Wei Wei | 31

The Technosensual Body
The Emergence of Fashion & Technology
Anouk Wipprecht | 43

Eliminated in a Hardly Noticeable Way
Johannes Grenzfurthner | 63

2. DISSECT

Hacking Feminism
Stefanie Wuschitz | 71

The Return of the Physical: Tangible Trends in Human-Computer Interaction
Tanja Döring | 83

**Can Someone Pause the Counting Please?
Encountering the new Gamified Reality of Our Times**
Daphne Dragona | 97

It's a Cyborg's World? Synthetic Bodies as "Social Engineering"
Judith Schoßböck | 115

3. REBUILD

Appropriation of Vacancies – by Capital or by People?
Mara Verlič | 135

Cyberpeace, Not Cyberwar
Sylvia Johnigk | 149

Asking the Girls Out? Reverse Engineering and the (Re-)Writing of Austrian Film History
Thomas Ballhausen, Katharina Stöger | 159

Playing with Glass Beads
Nicole Prutsch | 177

List of Contributors | 185

Introduction

Technology vs. Technocracy
"Reverse Engineering" as a User Rebellion – Preliminary Thoughts on *paraflows .7*

FRANK APUNKT SCHNEIDER, GÜNTHER FRIESINGER

1. OPENING THE DEVICES

The term "Reverse Engineering" was originally used in the context of mechanical engineering, but, in recent years, it has been increasingly used, discussed and thereby popularized in the context of digital technology. It signifies those modes of operation in which an existing artefact should be imitated. In order for this to be possible the blueprints have to be exposed first, enabling the reproduction of the functional relationships underlying the artefact. The interior of the artefact can only be understood and grasped as: the parts and their interdependent functions and reactions, or as: the source code.

In case the copy works as well and in the same way as the original, one can say that the new device was "read out" from the original, that its "trade secrets" were recovered as well as appropriated creatively.

Underlying the user interface of an artefact or a program is the knowledge of those that have created it. The outer form, the casing, which impedes our direct access to the mechanical and electronic innards, is therefore not only a protective layer. It also constitutes a deflective barrier for prying eyes: The interior workings of the artefact should not be any of our business.

When technology is hidden from us, by manifesting itself as mere "design" or a set of controls, we are kept at a distance. We are barred from the arcane knowledge of the engineers and programmers that pulsates within the artefact. And when repairs or modifications are needed, we are relegated to customer service and specialists. Only they have the legitimate right to open, check and repair our tools, gadgets and apparatus. To the extent that we are unable to

understand the inner workings of our tools, we are also dependent: upon the tools themselves and upon the heteronomous structure that was erected for their maintenance.

The opposite is expressed by "Reverse Engineering": it is the demand, the claim of the users to be able to open, to explore, to modify according to one's own requirements, to expand and develop new characteristics and adapt everything to the ever-changing technological framework. Only in this way are we no longer confronted with our means of production and reproduction as complete and closed (segregated) systems. We thereby acquire and appropriate the technology with which we (have to) live and work, to which we are referred, which shapes our every-day life and which constitutes us as those beings which we can be within the scope of our technological possibilities.

In those instances where we let the designers, engineers and salespeople define our technology (because we don't want to know or are not allowed to know more than the basics needed for its use), we let others define our lives. When we, however, explore its secrets, we invert our relationship to it: by surpassing superficial usage (merely knowing which levers and buttons to push and pull in the correct sequence), we can truly gain control over technology. We are no longer forced to adapt to the machine (as we were in the Fordistic relationship to machinery), rather, we become autonomous subjects – to the extent in which we are able to understand, replicate and modify technology.

We can thereby free technology from all the alienation which we experience again and again in its heteronomous use, turning it against the technocracy to which we are subjected when we utilize technology in accordance with the political and economic interests of those who provide it.

In this manner we do not only learn how to replicate technology in detail (letting the new tool function like the original one – or also, the own like the other) but we also learn how to modify, create and design it. We are therefore no longer constrained by user manuals, interfaces, manufacturer information and our habits. When we turn and use technology contrary to the intentions of its creators, we must defend ourselves against that conditioning which was imposed in their name.

Opening artifacts does not only mean unscrewing them or breaking open their shell in order to gain access to their innards, it is rather a form of technological self-empowerment with which we conquer our tools, assigning new functions and uses different to those that were originally assigned by the manufacturer. By doing so we free ourselves from the disenfranchising snippets

of knowledge to which we are condemned by keywords such as "user friendliness". Thus, we open that capitalist technology whose specific form is the closed, trade-secret-protecting product.

Capitalism is based on the principle of constant exploitation. All that is exploited is converted into products or aids their production. This is not only valid for aspects of nature (such as resources, water, genetic information in the scope of pharmaceutical patents or lifeforms), but also for the acquisition and dissemination of the knowledge on which human culture is based, the acquisition and dissemination of which is a central impulse of our psyche.

Because this knowledge is converted into a product (as a device or as software) and is therefore subject to the principle of exploitation, it needs to be made scarce and limited. Only when it may not be exchanged freely can it be traded profitably. When knowledge is limited, regulated and made inaccessible in such a way, those who possess it – either because they control its distribution or because they possess the necessary means to acquire it as a technological product or as access to education – acquire a privilege.

Knowledge, so an old proverb says, is power. And to the extent that the power that is knowledge increasingly comprises excluding others and keeping them dependent, that power will be increasingly allocated in a non-democratic, monopolistic and technocratic fashion.

In the last decades, which were characterized by a fundamental opening of the knowledge society, the question of whether to limit access to knowledge or make it globally accessible (digitisation and worldwide networks having provided the necessary basis long before) was discussed again and again. The formation of so-called Pirate Parties gives voice to the demand of humanity to no longer be excluded from knowledge and technological participation as enforced by the principles of a profit-based economy.

The unconditional protection of intellectual property (as current copyright laws instate) is no longer seen to be as self-evident as fifty years ago. This is because of the fact that our daily interactions with the web often bring us in conflict with copyright, and our digital day-to-day lives have long since evolved into a legal limbo in which we ourselves often no longer know exactly what we may or may not do – and what legal consequences we might face when doing what everybody does and getting caught by coincidence. The practice of admonishing internet users, mainly widespread in Germany, causes a state of permanent uncertainty in the web.

Medical patents have led to health becoming a commodity which is not affordable for all. This brings us to the following contradiction: Those who subscribe to the common arguments of the pharmaceutical companies which value their economic interests higher than the lives of many millions of people whose illnesses could be healed easily if they could afford the medication (e.g. generic drugs). Patents and intellectual property rights protect and isolate knowledge upon which we are all dependent in order to live well or even just survive.

The main reason given for the existence of licenses and patents is the cost incurred in developing a drug or a technological artefact. Of course, what is seldom mentioned is that the societal long-term cost of capitalist production (e.g. the depletion of global resources or the production of CO_2) are paid by all of us. The production of knowledge or goods always means exploiting others or expropriating them, as demonstrated by those cases of bio-piracy in which pharmaceutical companies patent traditional knowledge which, in case of a successful patent, is no longer freely available to those who originally developed it. This example shows how intellectual property rights are exclusively used to protect the interests of those who want to exploit knowledge profitably. They uphold a system of exploitation and oppression which we can break open by not subjecting ourselves to the logic of intellectual property, but rather raising our voices claiming democratic structures that enable transparency and participation.

2. THE APPROPRIATION OF OUR ALIENATION

The popular fearful projections of technology, as found in science fiction narratives, public debates or paranoid delusions (such as the carcinogenic properties of mobile phone rays), are not exclusively caused by that "anthropological constant" which fears "the other" of technology because it threatens "the self" in a very stone-age sense. They are rather fed by the way in which technology is implemented socially: in the specific power relationships of Fordism and Post-Fordism it always manifests itself as coercion, as an invocation and the relationship of human capital, as the pressure to adapt and as a call for increased performance. We are subjected to this coercion during working hours and leisure time, publicly as well as privately. The new possibilities and spaces invoked by technology, under the imperative of capitalist valuation, are always imbued with a coercive necessity to use them: Those who do not and can not utilize the ever following next generation of tools become technological losers. The social Darwinist imagery of threats of the bourgeois society (as constructed by

contemporary debates on life-long learning and the losers, those left behind in our education system) convert delight in technology into Fordist duty and post-Fordist commitment to be competent technologically.

What scares and coerces us about technology is not, as technophobes and critics of civilization would have it, some ingrained part of technology's nature. It is rather the paradigm of valuation that we are bleakly confronted with in this form – and which is founded in that relationship which forms *all* cultural and technological artefacts while the economic order that creates it remains in power.

Because technology cannot be anything else than an instrument for the unhindered exploitation of humanity and nature under the given circumstances, we sometimes experience its presence and might as so suffocating that we fantasize about pre-technological spaces which, since the conversion of ape to man through the use of tools, have never existed. The relief we imagine gaining through the absence of technology can of course not know (nor want to know) of the fact that it is not technology that overstrains us, but rather its ingrained interests of exploitation – in whose name we are being driven.

Destruction, the motor of capitalist economy, is therefore not specific to technology, but merely the scope in which it is delivered under the given circumstances. What we fear is not technology, but the capitalist relationship that it purveys – just like any other cultural utterance of capitalist added value production.

This can be seen mainly in the application of the concept of alienation, with which Marx characterizes the relationship between the worker and his or her product, to technology. Not only the "alternative" movement has used concepts critical of capitalism in a diffuse and emotional way, speaking of a general experience of alienation in our technological age – and thereby contaminated conservative fears of losing the traditional (e.g. the substitution of small, personal shops through anonymous supermarket chains) with the criticism of ideology.

While *capitalist* technology (especially since the advent of the personal computer and the internet, available everywhere at all times) completely transposes the heteronomous relationships of the capitalist factory into the daily lives of its subjects, alienation from "grown", "natural" structures can be seen as having emancipatory potential. Therefore, it is necessary to separate the two aspects. Technology as an agent of alienation from the supposed own and "actual" (identity, tradition, social roles, hierarchies and the positions of the subjects of bourgeois society) can be used against technology as a representative of exploitation. The following dialectic could be expanded upon: alienation as emancipation (which creates autonomy from tradition) *and* alienation as an effect of

capitalism (the heteronomous relations of production). In order to achieve such differentiation we first need to learn how to use technology in such a way that enables us to choose which form of alienation we want to realize with it.

3. Deconstruction, not Destruction

By (re)appropriating technology and thereby taking control of the positive aspects of alienation we escape from that power relationship which was imposed on us by its heteronomous nature. Insofar as we convert it into participation, its seriousness into a game exposing its inaccessible depths, we can escape our dependency of it. Only in this way are we able to re-write those aims and causes alien to us, to which technology subjects us, with our own.

We also learn how to extract abstract principles from concrete artefacts and apply them to other problems and intentions than those originally intended – and thereby transpose existing technical or program-like solutions to a higher level of abstraction, another thing that the enclosures of our artefacts would want to make impossible.

In a life-world mostly characterized by technological routines and automatization, "Reverse Engineering" is the current form of the historical project of the "enlightenment": through it, we learn not to blindly trust technology simply because of the fact that we are controlled by it. We question and permeate it and expose the source codes of our experienced reality. In a certain way, this mimics Kant's definition of the enlightenment: "man's emergence from his self-incurred immaturity".

"Reverse Engineering" is not fueled by weariness from technology, but it rather takes its classic promise literally: improving all of our lives. This is, however, only possible if we redistribute it as a means of production of reality and prosperity.

When we practice "Reverse Engineering", we do not want to destroy technology as the luddites did, the proletariat of the industrialization fighting against its enslavement through technology. We want to make it democratic and therefore deconstruct its capitalist ideology of exclusion and exploitation that has found entrance into its blueprints and a concise articulation in the encasings.

We take it as a given that it's not only important what technology we have in which way and what we are able to do with it. We see the technical forms themselves, in which technology presents itself, as equally powerful. They can never be innocent or without ingrained values. Their form is partly shaped by the

ideologies of the people and institutions that create them. And that ideology has an effect on who has what access to them, who is attracted or repulsed, and how one is able to understand them. It is because of the necessary adaptations to the needs of groups and subcultures that the artefacts (and their encasings) need to be modified again and again. In the free-market economy, these subcultures would have to constitute a sufficiently large and wealthy target group to be noticed and included.

The term "deconstruction" makes it clear that "Reverse Engineering" is not exclusively concerned with technology-specific relations to the artefact. In a metaphoric sense, its strategies can be adapted for the so-called "cultural technologies", and therefore also for the current political battles for representation and definition of symbols.

Our social or cultural programming may be re-coded in a similar fashion to digital culture re-coding its means of production. For instance, the binary structure of gender, which still gives order and structure to large parts of our lives, and therefore limits our possibilities of action, according to ideas from the 18th century, can be overcome by intervening in the cultural and genetic source code of gender and sex, e.g. through hormonal treatments, sex change operations and plastic surgery, gender bending, cross-dressing and polyamorous relationships.

"Reverse Engineering" is therefore not only a technical game for nerds and hackers, but it is itself a program which can change the seemingly naturally given (which, as a matter of fact, is merely programmed) and thereby articulate desires that are made invisible by existing artefacts or programs. We need only understand the cultural codes that constitute the existing order of things and know how they were ingrained culturally and socially – as specific forms of relationships between people and artefacts – in order to write our own "programs", e.g. "coding" our very own gender (apart from the obsolete male-female dichotomy).

Gene technology and stem cell research work on decoding the blueprints of life itself. The current knowledge in biology and medicine would not be possible without the principle of dissection, opening the bodies.

In the field of art the last decades have brought forth methods for disassembling existing aesthetic artefacts and using the thereby produced material as a cheap, low-prerequisite and easily accessible means of production (e.g. collage, digital image processing, sampling, remixing).

Seen in a metaphorically expanded way, "Reverse Engineering" is a key social technology that forms the basis of art, science, politics, even societal production and development.

Even if the methods of "Reverse Engineering" gain plausibility and relevance because of the continuing permeation of our lives by digital and other technology, they are in no way a genuine invention of digital culture or even modernity. Disassembling pre-existing things and modifying them is a constant throughout the history of humanity that leads directly from the stone that is turned into a weapon to software that is cracked.

4. License Regulations as Rools of Rule and Power

Through the transposition of technical solutions into the specific form of ownership that is intellectual property, humanity's history has acquired a new form of hindrance to its development which nullifies the progress made available through our digital networking (with which solutions could be propagated worldwide instantly for the benefit of everyone).

Because bourgeois society cannot imagine technological development as a collective effort, but rather personalizes it in individuals (from Galileo to Thomas Alva Edison and Steve Jobs) who acquired specific solutions supposedly on their own and had the luck of being the first to do so, it is converted into ownership (of the means of production). Others may only make use of that development by acquiring licenses (by paying for them).

While the dissection and reassembly of natural objects or technical hardware has become an undisputed means for acquiring knowledge and technology, the licenses of software – *the* central impulse of technological development – still have very restrictive access policies. Often, software may not be cracked, opened or edited. The reason given for this fact is that the program itself is not purchased by the user (and thereby owned). Rather, only licenses are sold, accordingly restricted and optionally imbued with measures to prevent access. The "non-material" nature of software, it is reasoned, lets it remain the intellectual property of the developers, even when it runs on our computers and e.g. causes windows-specific problems.

Therefore, many software license regulations forbid "Reverse Engineering" and impede access to their source code. Our daily experience tells us that this is not always beneficial for their functionality – similar to the copy protections of CDs and DVDs.

This is not only about the protection of ownership titles, however. The users of software are to be held in dependency, which then can again be exploited, not only through the coercion to purchase ever-changing upgrades and updates, but also through controlled obsolescence that forces us to purchase new software or hardware which remains compatible with its permanently progressing peripherals for a short time only.

Often, the developers no longer provide up-to-date drivers when the software ceases to run on the newest operating system. Without these, the expensive apparatus becomes useless. Those who possess the necessary skills and knowledge are able to write them themselves, but they are not allowed to provide these online for those less fortunate.

Software license regulations therefore protect the developing companies and their copyrights, but are in conflict with the interests of the users and the public. Scrapping incompatible scanners is a financial problem for those who need that tool for work or leisure, and for the rest of the world it is a problem of resource politics. Devices with short lifetimes consume global resources without any necessity for it, and their production and distribution increases the CO_2 output. The repeatedly propagated goals of climate protection (without any perspectives for their accomplishment) have to constantly avoid talking about this basic problem of the capitalist economy. This shows us how incontrovertibly ingrained the concept of not being able to produce sustainably now or in the future is, avoiding the contradiction with the basic principle of capitalist economy.

The common license regulations therefore not only make the users unable to fully control their means of production, they also coerce all others to bear the cost of their selfishness. Blockading the continued development and adaptation of existing software technology by the users and thereby forcing them into dependency hinders technological development and is in immediate contradiction to social development goals such as participation, inclusion and individual freedom. Not only are we denied our right to participate in the control over the devices that define our daily lives; the subject of the digital revolution is in this way also denied access to the constitutional level of its subjectivity.

When we unlock trade secrets and reconstruct them we are not merely producing "counterfeits" – illegal copies that leave the costs and effort of development to others – rather we re-imagine technology: it is no longer a relationship imposed by technological development (and the ingrained interests of those who possess the means of production), rather a cooperative effort for changing our lives, stemming from the need for (technological) participation. Instead of merely confirming and prolonging the relationships of capital, under whose

precepts technology continues to be developed, we convert it into public property. The critique of existing access regulations is therefore one of the most important confrontations of our time. We are presented with the fundamental decision whether and how the users should be able to participate in their devices or whether they should rather be subjected to them by acquiring licenses.

5. THE DIGITAL AVANT-GARDE AS A POLITICAL FORMATION

paraflows sees itself as a space for current debates in digital art and culture, and as a medium for net culture, whose ideas, goals and requests we try to bring into a theoretically founded form. It is from this position that we voice the claim for unregulated access to devices, and also show that this is not a software-specific problem, but rather a general problem of societal participation. In capitalism, the claims for participation and inclusion are confronted with interests in exploitation that exclude in order to secure and enforce their position on the market, i.e. their power. As we understand digital art and culture, it needs to support these claims instead of merely voicing their own.

It is in this scope that *paraflows.7* wants to examine the discussion about the access and distribution of digital culture (be it software or digitalized culture) not as a series of individual and basically unconnected conflicts, but rather as a concatenated series of conflicts that poses the question of ownership and access anew in the 21st century.

We believe that a societal paradigm shift is underway, of hitherto incomprehensible dimensions, in free access to software and free distribution of digital culture. Currently, this is most obviously visible in the medially effective conflicts about net freedom (e.g. the trial against the sharehoster Megaupload) – though not only there.

In order to make this conflict explicit and, at the same time, advance it, digital art and culture has to transgress the limits imposed by software and devices. It does, however, not only want to show what is possible in the scope of the currently legal. Instead, it shows us what could be possible – through spectacular interventions in net politics, playfully in digital art – and how we can achieve these possibilities in practice.
 "Reverse Engineering" is one of the central strategies in this endeavour, even though – as mentioned before – it is not an invention of digital culture, where this method is currently most advanced.

When we, as digital culture, fight for our freedom by gaining access to technology that wants to keep us as mere consumers, we have to be aware of the fact that this conflict has a symbolic aspect. When we remove access limitations (and their ingrained ideologies of intellectual property and social exclusion) in mere individual hacks – a simple task for a well-learned programmer – we miss the opportunity to voice the claim for autonomy of the human, which finds its most up-to-date expression in this act.

Net culture, as the contemporary cultural and technological avant-garde, needs to connect with other participatory projects and needs to be aware of the centuries-old history of its struggle. Only in this way can it achieve to productively include the knowledge and experiences of those that have fought for completely different things with the same methods, for example participatory models in companies, the legal codification of so-called "commons", the freedom from gender-specific preconceptions or the opening of closed structures, whether digital or analogue.

Therefore, our struggle should not end at claiming barrier-free technology, as the contemporary software-liberalism of the open-source and public domain culture does.

The activists of the free software community and similar groups are often led by the false idealist belief in the political power of media or technology. And this belief deteriorates into banal techno-optimism when the economic basis is ignored: the belief that societal economy could be changed by merely re-designing it technologically or medially. The struggle for a different economy, for the equal distribution of society's wealth and its means of production, disappears in the skirmishes of establishing always newer media and technology. These skirmishes have characterized bourgeois society since its inception and have only revolutionized it to such an extent that it could remain the same without becoming obsolete.

Digital art and culture needs to distance itself from this if it doesn't want to be merely the cultural avant-garde of the digital age, introducing, testing and enforcing new devices against the resistance of macro-economically obsolete structures – and presenting creative solutions for the resulting conflicts of interest. "Reverse Engineering" is also product development and in this way helps to adapt and rejuvenate the system. For instance through users adapting their programs and devices more quickly to new requirements, imposed by the logic of exploitation, than slow behemoths like Apple or Microsoft would be able to.

paraflows.7, as a representative of digital art and culture, does not want to advance the liberation of devices from repressive user manuals for all of us to be able to do more than intended and thereby enhancing our efficiency and market value as digital day laborers. We are also not about cleaning up the worst copyright anachronisms in order to bring capitalism up to speed in the 21st century. Instead, we want to articulate a general claim of humanity for participatory ownership, which is probably at the moment best seen in the embattled freedom of the web.

In order to do this we need to take a stand for all those who are excluded and left behind by the capitalist production of added value, which bars them from having means of production and from access to socially produced wealth.

Software liberalism, however, will only continue to be more of the same if it continues to claim, in a one-sided and transparently selfish way, just the one without also mentioning the other, if it fights for the freedom of digitalized culture without also creating a model for the distribution of goods that goes further than p2p exchange sites. If its claims are not brought into a general form, it remains that struggle for the best space at the trough and for class positions, for individual participation and for human capital, which stabilizes the system and in which the bourgeois society is reconstituted and reconfirmed daily.

6. Aesthetic Imitation as "Reverse Engineering"

In this context, we also want to examine the history of art – which has since forever been confronted with a specific form of "Reverse Engineering": the depiction of that which is considered nature. Through the imitation of that nature, art has always transcended the ideology of the "natural" – long without realizing it itself – by imitating it artificially as an aesthetic artefact. Aristotelian poetics had already defined art as essentially being imitation in the so-called "mimesis imperative".

Mimesis, understood as the imitation of the seemingly natural or nature-like as seen by human consciousness in a certain point in its evolution, does not, however, only signify the depiction of "nature", such as the pictorial depiction of a CD-R containing driver software (which would probably not pose a problem for the licensees). It moreover signifies the pervasive depiction of its subject – especially so through the decline of simplistic concepts of nature – to a certain extent exactly what "Reverse Engineering" means. Seen in this scope, mimesis casts off the old characterizations of illusion and imagination. Aristotle already saw imitation – in the specific case of the tragedy (about which his thoughts on poetics mostly were) – "the imitating depiction of an action" – not as end

in itself or mere depiction, but as a means to achieve emotional participation with the depicted: The viewers should empathize in order to achieve a cathartic experience of own or generally human emotions.

Since the start of modernity, art has become reflexive – with profound consequences even in the "post-modern" present. This means that its own media, symbols and structures have become its topics, that it talks about how it talks to us, and that the materials for its creation have become partially autonomous from their function of depiction: They are converted from tools into points of contact for reflection. This reflection is, however, no longer aimed at an extra-linguistic, incorruptible reality that may be represented correctly or incorrectly, but rather at the ways in which art reaches its depictions of reality. It has in consequence ceased to be a depiction of that first reality, but it rather articulates its own claim for reality, with grave consequences for the world in general. The world has started to dissolve itself because of competing routines of depiction, such as seen in the "linguistic turn" in the humanities.

Digital art is hereby dependant on the use of digital tools – sound and image editing software, the net or social media. If it wants to keep the state of reflection of modern art and not – as a soft update of illusionist art – merely produce digital spectacles (which is the case far too often), it needs to have free (as in free speech) programs which do not hamper access through license regulations and prescribe a certain stereotypical use while incriminating other uses. Therefore, the freedom of programs needs to be of the same value for art as the litigable freedom of art itself, which was historically established in long struggles.

7. Basis for Discussion

paraflows.7 will therefore examine problems and possibilities of "Reverse Engineering" in many mutually interconnected ways. Questions which transcend the tight limits of the discourse of legitimacy, as it has been practiced by the net community, open source activists and the owners of software patents, will be central. In opposition to that discourse we need to state that "Reverse Engineering" is not a problem of digital culture, but rather a cultural technique that incepted that development at whose current end we now discuss questions of intellectual property.

We therefore strive to show structural similarities – and equally significant differences – between the historical forms of "Reverse Engineering": How do its claims change with the changes in its subject matter? Which new possibilities

are created by current software problems – and which historical insights (especially about the structure of ownership in a bourgeois-capitalist society) could be gained by the currently implemented access impediments and restrictions?

How can access restrictions be seen as an indication of fundamental errors in the fabric of our society and which propagandistic effect for the claims of a de-regulated culture of have-nots is achieved by the often outrageous countermeasures of those protecting software?

We should furthermore ask whether or in which way the classic dissection of bodies practiced by medicine and biology is comparable with the dissection of software. Which methodological insights can be translated from one to the other, and which insights remain bleak analogies?

Who actually owns software, and which alternative models of ownership are conceivable – in contrast to the restrictive practice of tight license regulations?

Which exclusions are produced by open source culture? Where are the weak points of software liberalism? How is it positioned socially? Which subjects and types of subjects are generated by it, who is drawn to it and who is alienated?

Who is excluded by its concept of freedom? How can the ideological system in which it resides be hacked? How can it be re-written? How should social movements refer to it and which points of contact and similarities are ingrained in it implicitly or explicitly? To what extent is technological and digital basic knowledge available for all; who even has access to software?

And: How can the existing social systems be opened for us to reach their blueprints and change them? How do the economic relations constitute themselves as relations of class, race and gender, and which aspects of the social matrix can be "reverse engineered"?

And finally: digital art and culture also constitutes a system that needs to be opened. We will also have to think about: through which interventions and preconceptions can *paraflows.7* break with the state of net culture, in order to not only articulate claims, but also realize them?

Reverse Engineering the Senses: Sight/Hearing and Touch

JANA HERWIG

The theme of the paraflows symposium *Reverse Engineering: Open. Dissect. Rebuild* is expanded by a discussion of its possible application to the arena of the senses. Departing from Marshall McLuhan and his writings on the engagement of the senses in and through media, this short paper posits that access is the ultimate pre-requisite for any form of cultural reverse engineering to take place. In the case of the attempt to reverse engineer the senses through media, access takes the form of a theoretical model of sensual signals – which is well available for remote, but not for the proximal senses. As a result, the book of media history so far has been written as a success story of telemedia for eyes and ears only.

1. MEDIA AND THE SENSES

Ever since Marshall McLuhan's "The medium is the message" has become a catchphrase within high popular culture – i.e. among the academic, formerly keyboard-hammering, now touchscreen-swiping urban media crowd – the understanding of media as an extension of man has become such a commonplace itself, it is barely further scrutinized. Some of the blame has to be taken by Marshall McLuhan himself, for building those smooth analogies that caught on so well, there seemed no need for further interrogation: the wheel as an extension of the feet in rotation, the city as an extension of the skin, electromagnetic technology as an extension of our nervous system (cf. McLuhan 1964: 51, 67).

What went missing on the way to pop-cultural prominence is McLuhan's broader conceptual framework of the senses, from which these analogies emanated, including the peculiar role the sense of touch (as a common sense/ *sensus communis*) plays in this setup (66):

Our very word "grasp" or "apprehension" points to the process of getting at one thing through another, of handling and sensing many facets at a time through more than one sense at a time. It begins to be evident that "touch" is not skin but the interplay of the senses, and the "keep in touch" and "getting in touch" is a matter of fruitful meeting of senses, of sight translated into sound and sound into movement, and taste and smell.

In a world after McLuhan, the very act of using media cannot been seen separate from the engagement of the senses in and through media: "To behold, use or perceive any extension of ourselves in technological form [i.e. as media; J.H.] is necessarily to embrace it. To listen to radio or to read the printed page is to accept these extensions of ourselves into our personal system and to undergo the "closure" or displacement of perception that follows automatically." (50)

On the following few pages, I am going to elaborate on the suggestion that this beholding, using or perceiving can productively be understood as an attempt to reverse engineer the senses. Of course, the meaning of reverse engineering here is not limited to the realm of information technology or engineering. Instead – following the concept of the paraflows Symposium which Günther Friesinger and I curated – I will think of reverse engineering as a crucial cultural technique of *making sense of the world through artefacts*, be these artefacts of stable or ephemeral, visual, aural or tangible, data-based or material character. But why this insistence on artefacts when it comes to making sense of the world?

2. Beyond Active Audiences: Changing the World Through Artefacts

One of the aims of making artefacts a pre-requisite is to set off the notion of cultural reverse engineering from positions of pure spectatorship, including versions of active spectatorship that have been discussed over the recent years. Active audience theory has redeemed consumers from the status of dupes of the media industry into which previous high culture theorists had made them. John Fiske (1989:25), building on Michel de Certeau, described this form of active consuming as the art of "making do" with what people have: "The creativity of popular culture lies not in the production of commodities so much as in the productive use of industrial commodities." Re-reading Fiske in 2013, it is interesting to stumble upon the term "engineering" when he compares this to the bricolage of Lévi-Strauss' tribes (142), which is the everyday practice of

tribal peoples who creatively combine materials and resources at hand to make objects, signs, or rituals that meet their immediate needs. It is a sort of non-scientific engineering, and is one of the most typical practices of "making do".

Cultural reverse engineering can indeed be seen as a reorientation towards tribal organisation, finding new affiliations centred around skills and knowledge that provide a social mesh where nuclear families have failed us. It is also a reorientation towards the object and artefact: Where active audience theory saw consumers weave their (negotiating, complying, resisting, etc) readings as texts (e.g. Fiske's "producerly texts", 1987:76-77), the artefact is potentially more than a text. The artefact prevails, sometimes only momentarily, *for others* to consume, marvel at, resist to or reject. Artefacts are more than readings – they can be passed on and shared, allowing for further readings (and possibly further artefacts down the line). It is therefore the criterion of giving back to and into the world through perceptible artefacts with which I draw the line between cultural reverse engineering and spectatorship.

3. Down with Hierarchies: The Lab Is Everywhere

The term "artefact" was also chosen for its relative lack of implied hierarchical relations, unlike terms such as "art work", "opus", "handwork", "novel", "commodity", etc which are tied to certain more/less privileged positions within the cultural sphere. "Artefact" merely states that something was made, leaving open whether it was made by man (such as the archaeologists' artefacts) or machine (such as the visual artefacts which might occur as anomalies in the visual representation of digital images). Cultural reverse engineering does not look for a place within these handed-down hierarchies, it is no attempt to flatten or conceal them by introducing yet another term that conflates the productive with the consumptive end, such as the terms "prosumer" (Toffler in the 1970s) or more recently, "produser" (Bruns 2007). Instead, cultural reverse engineering seeks to convert the entire cultural sphere into a lab, populated by individuals who are capable of giving new meaning to artefacts *and* of making this meaning available to others. Meaning in this context has both a semantic and a pragmatic dimension: "What does this mean?" must inevitably be followed by "What can this do in the world?".

4. Three Steps: Open. Dissect. Rebuild.

On an analytical level, Günther and I broke cultural reverse engineering down into three steps, which served as a program structure for the three-day symposium: open, dissect and rebuild. In vivo, of course, these steps and their corresponding processes can barely be clearly separated from one another. For cultural reverse engineering to take place at all, access is the critical condition, requiring the rights, skills and knowledge to *open up* the given object or situation one seeks to change, improve, alleviate or work around. One cannot intentionally change what one does not understand; anything else would be tampering with culture. The cultural reverse engineer thus needs to acquire a solid understanding of the targeted object or situation; he or she needs to analyze and *dissect* it before things can be put back together, better than before. Finally, a vision or utopia of the reverse engineered state is necessary to *rebuild* the object or situation and in order to transcend this play with the elements beyond a mere accidental level.

The talks gathered in this book in print reflect the shifting emphasis on any of those three moments which, eventually, must all come together. But the question for this present piece of research remains: How can this process of cultural reverse engineering be of use in understanding what happens to the senses when they meet with media?

5. Accessing the Senses through Theory

McLuhan's description of media as "extension of ourselves in technical form" has to be taken literally. As it happens, the attempt to emulate the capacity of the senses through technology appears to be one of the driving forces in media history (besides war, of course). The camera obscura emulated the capacities of the eye, drawing on the theoretical models of optics that would make the workings of this organ transparent. Sound recording techniques register changes in atmospheric pressure, i.e. sound waves, emulating with its microphone diaphragms and devices the eardrum and ossicles in an application of the theoretical rules of acoustics.

Sight and hearing – which I will call the remote senses as they are able to gather signals from a distance – differ from the senses of touch, smell and taste through their accessibility through theory: We know how sight and hearing work through theory. "Let's move to a different table", a physicist friend instructed me when the group sitting next to us at the restaurant spoke too loud for his liking, "volume decreases in the square of the distance."

Such transparent models are not available for touch, taste and smell which I will call the proximal senses, as they require close proximity to gather signals. To date, no general and uncontested biological and physiological explanation is available for these three senses, as Mădălina Diaconu (2005:16) notes and continues (my translation, 17):

> They [the proximal senses, J.H.] are synaesthetically bound to other senses and are aesthetically "impure", as they are either affective-erotically charged or bordering on the ethical. Above all, they cannot be technically controlled and manipulated: No recording device can ban and archive them - and that (still?) to the day.

Engineering media to reverse engineer the proximal senses is thus an undertaking which, to this day, could only fail. Sometimes enjoyably – e.g. when John Waters enhanced a screening of his movie *Polyester* (1982) with scratch and sniff cards -, sometimes disturbingly – e.g. when Stahl Stenslie and Kirk Wolford administered strokes to their *CyberSM* partners, which on the way from Cologne to Paris were transformed into electric shocks to their private parts (1993-1994). The book of media history so far has been written as the success story of telemedia for eyes and ears only – hands, nose and tongue have mostly evaded engineering.

6. Learn, Dissect, Make It New

Any invention or technology is an extension or self-amputation of our physical bodies, and such extension also demands new ratios or new equilibriums among the other organs and extensions of the body (McLuhan 1964:49).

It is inevitable that, in order to intentionally reverse engineer the senses through a medium, one acquires mastership over that medium's language – but it is also clear that the kind of mastership that was held by reverse engineers such as Alfred Hitchcock or Jean-Luc Godard, who single-handedly established a new equilibrium among the organs and their bodily extensions (the purification of classical Hollywood narrative cinema, the shock of the nouvelle vague) is hard to strive for. And it is probably no longer necessary to become a master of such proportions. Learning, analyzing and dissecting is no longer a lone activity (if it ever was). Wikipedia itself is the reverse engineered form of privileged knowledge that was trapped for too long in huge tomes on the shelves of the saturated class. A mobile internet connection, software and lightweight computer technology turn the individual into a mobile reverse engineering lab, collaborating with others in seconds, exchanging short messages, hopping from interaction to interaction and making things new within seconds. This

does take a toll on the senses, but it would be too simple to take McLuhan's notes on self-amputation as the final verdict: This has been going on forever. The new equilibrium is nigh.

(The underlying research for this paper was conducted within the research project "Texture Matters. The Optical and Haptical in Media", funded by the Austrian Science Fund, FWF. See also http://texturematters.univie.ac.at).

REFERENCES

Bruns, Axel (2007). "Produsage: Towards a Broader Frameworkfor User-Led Content Creation". *Creativity and Cognition: Proceedings of the 6th ACM SIGCHI conference on Creativity & Cognition*, Washington, DC: ACM, 99-106.

Diaconu, Mădălina (2005). *Tasten - Riechen - Schmecken. Eine Ästhetik der anästhesierten Sinne*. Würzburg: Königshausen & Neumann.

Fiske, John (1987). *Television Culture*. London: Methuen.

Fiske, John (1989). *Understanding Popular Culture*. London: Routledge.

McLuhan, Marshall (2001 [1964]). *Understanding Media*. London, New York: Routledge.

Toffler, Alvin. *Future Shock*. New York: Bantam Books, 1990.

Open

Biohacking
Keeping Synthetic Biology Research Safe and Responsible Among Amateur Biologists

MARKUS SCHMIDT, LEI PEI, ALEXANDER KELLE, WEI WEI

SYNTHETIC BIOLOGY AND AMATEUR BIOLOGY

Synthetic biology (SB) is an extension of the continuum of biological engineering, a combination of biology and engineering. The tools developed by SB are said to enable further innovation in renewable chemicals, biofuels, medicines and environmental remediation. As the technology advances, SB approaches are expected to become simpler and easier to use than the protocols developed by traditional genetic engineering. Thus, the advent of SB will quite likely foster citizen science, i.e. bring new players, amateur biologists or do-it-yourself biologists (DIYBio) into the field traditionally reserved for highly trained professionals.

Amateur research societies have been founded in many scientific and engineering disciplines. These amateur movements are important to encourage the public engagement with science. For example, the standardization of basic electronic elements in information and communication technology has opened the door to amateurs in computer science, who have played an important role in the evolution of the field, either in the area of open access and open source software or hardware. Other science areas with an increasing community of do-it-yourselfers include e.g. astronomy that was enabled by the availability of rather cheap precision telescopes (see e.g. www.budgetastronomer.ca); aspirational space flight DIYrockets (www.openspaceuniversity.org/#!rocketchallenge/c22xk); or agriculture with urban gardening and window farming.

Amateur biologists are "individuals who conduct biological experiments as an avocation rather than a vocation". They are most likely composed of individuals without proper training in life science but highly curious on the science and/or methods used. Some estimate that thousands of self-appointed amateur

biologists worldwide are interested in DNA sequences, microbial screening, environmental monitoring, applications for health care and energy. The leading group is DIYBio, now a community with more than 2000 registered members in more than 20 regional groups from 10 countries. Currently, most of the groups of DIYBio are active in education – teaching members basic knowledge via seminars, workshops and hands-on activities. In practical projects, most of their activities focus on the basic biotechnology that matches with their simple local settings. One of the largest and most active groups of DIYBio is BioCurious based in the Bay Area, California, US, with nearly 400 members. The members of this group are organizing a dozen events on topics such as software for SB and alternative medical devices for rural settings. They provide their members not only basic knowledge but also access to wet labs equipped with basic tools for PCR (polymerase chain reaction, a standard method in biotechnology), microbial cultivation and deposit. Some DIYBio groups have built "community labs", i.e. dedicated lab space to share equipment and resources for practical projects. A typical example is Genspace, a community lab built in Brooklyn, New York. It is a 500-square-foot lab filled with donated equipments, where low safety-risk experiments – so called biosafety level 1 (it goes up to 4) – can be carried out. Some basic experiments can be conducted there – DNA isolation, restriction enzyme digestion, plasmid transformation, PCR and other basic molecular biology protocols. The practical projects conducted within DIYBio community are: "BioWeather Map" (a project to sequence the microbes on dollar bills collected from across the US to do environmental surveillance and to classify bacterial species in different regions); "sushi gate project" by students in New York city (collecting sushi samples from different restaurants to check if the fish species were correctly labeled), and a project in Nicaragua (to develop low-cost medical devices and lab equipment).

The overwhelming majority of the amateur scientists are highly creative, purpose driven and curious. They are likely the ones who "think outside the box" and the ones who would come up with "surprising" applications. The DIYBio Amsterdam group for example came up with a tangible project, the invention of the Amplino, a DIY quantitative PCR device, that can be used to detect malaria in remote places far away from medical labs and hospitals (www.amplino.org).

In December 2012, a number of European DIYBio groups met for the first time to define common goals and to increase international collaboration of their local activities. The European groups agreed on the following four common goals:

- A DYIBio starter kit, including all basic means for producing the consumables needed for genetics.
- Environmental biology quests, challenging people from all over Europe to

find specific bacteria with characteristics of interest in their backyard and reporting their data on a common platform for educational and statistical uses.
- Link DIYBio and the fablabs community together by producing bio-plastics that can be used in 3D printers.
- A new DNA-based communication network, setting up a DNA distribution network between European nodes.

Amateur biologists share an enthusiasm and curiosity for the living world and they want to understand how biology works by tinkering with it. Driving forces for their ambition includes the wish to democratize biotechnology and to educate the public, but also to embark on research and development projects that do not follow a capitalistic logic, in other words that is not primarily driven by the urge to increase the ROI (Return on Investment).

Yet amateur biologists are often the ones lacking sufficient life science knowledge and proper research facilities. Since complex engineering approaches are used in SB, many concerns are now raised, such as the safety of the research and its products, risk to public health and environment, dual use research issues, and the ethical and social implications. Among them, biosafety and biosecurity are the two immediate issues that need to be addressed not only by the professional synthetic biology community but also by the amateur biology community. These issues even seem to be among the most important ones for the amateur biology community to be solved in order to allow for a peaceful co-existence between professional and amateur biology.

New Developments of Synthetic Biology and Their Challenges to Biosafety and Biosecurity

The attraction of SB goes beyond the quest to understand genomes, the scientific curiosity on how a genome is built and what makes it function. The development of SB makes it possible to engineer a genome from scratch based on a computer-designed template. DNA synthesis techniques were first developed in the 1970s and are now improved in quality, capacity, affordability and accessibility. Several genomes were synthesized, from a relatively small one (the genome of a virus), to those in megabase size, such as the genome of *Mycoplasma mycoides* in full. More recently, it is also possible to synthesize genomes of eukaryotic cells, for instances the mouse mitochondrial DNA and the chromosome arm of *Saccharomyces cerevisiae*. Beyond the progress in DNA synthesis, the techniques for DNA assembly for a whole genome construction are also under investigation. Gibson et al. reported an approach for one-step

DNA assembling. Although this approach was conducted in a sophisticated lab, further development will enable the assembly of any genome of interest. Although the DNA synthesizers can be obtained on the market, it is still difficult to synthesize DNA fragments in large scale in "home brew" facilities. The orders for DNA synthesis will be subject to screening, including both the sequence and the purchasing organization. This is believed to help to limit the access of unauthorized individuals who do not obtain their clearance to handle sensitive materials. Amateur biologists, for example, as long as they work independently and without a legally accepted organization form (such as a biotech company), must not receive synthetic DNA from DNA synthesis companies.

The research on bioparts aims to create a toolbox of well-characterized, pre-fabricated, standardized and modularized genetic compounds for engineering biological systems. These standard bioparts could be assembled to construct larger "devices" to carry out defined functions, which would work as designed when they are integrated into "systems" or larger genetic circuits. In the future, "design by demand" may be no longer only in the realm of science fiction. DNA synthesis allows the circuits of assigned functions to be integrated into the genome instead of in the vector that also helps to make the construction more stable. This also means that multiple modules would be introduced into one host easily.

Turning an intestine-colonizing bacterium (e.g. salmonella) into a cancer therapy serves as a good example: not only must the microbe be equipped with tumor-killing regiments, but it must also be "invisible" to the immune system. Any such approach developed for a beneficial purpose would also enable creating a novel lethal bacterium that could escape recognition by the immune defense. Thus, different modules need to be introduced into the microbe systemically to function as a tumor-killing cell. Such a project clearly does provoke biosafety and biosecurity concerns. Experiments, for example, that invoke biosecurity concerns are those that:

- Would demonstrate how to render a vaccine ineffective;
- Would confer resistance to therapeutically useful antibiotics or antiviral agents;
- Would enhance the virulence of a pathogen or render a non-pathogen virulent;
- Would increase transmissibility of a pathogen;
- Would alter the host range of a pathogen;
- Would enable the evasion of diagnostic/detection tools;
- Would enable the weaponization of a biological agent or toxin.

Amateur biologists would thus not try to carry out the Salmonella project for several reasons. First Salomonella itself is a Biosafety Level BSL 2 organism, a pathogen, while amateurs only work with BSL 1. Second, to escape recognition by the immune defense means to enhance the virulence of a pathogen, and so it represents one of the 7 criteria mentioned above, which is a no-go for amateurs.

In the institutional setting, research proposals aiming to create virulent microbes are most likely rejected by institutional review boards at the very beginning (or conducted in special safety facilities). In contrast, research projects from amateur scientists would not be subject to a professional review system. Only when the harms become obvious, the authority will raise concerns on these amateur activities, such as if an individual turns ill of unknown or uncommon source. DIYBio groups, or at least the people who take the lead in such groups, however, are aware of such risks and have started to offer biosafety courses to its members. For example, the DIYBio community together with professional biosafety experts and members of the American Biological Safety Association (www.absa.org) created the online platform "Ask a biosafety Expert" (http://ask.diybio.org) where anybody can anonymously ask about any kind of chemical of biological issue.

Similar "community building" initiatives have been done for biosecurity in the US by the FBI. Following the bad press the FBI received with the Steve Kurtz case, they have changed their approach and have started to establish a series of community workshops with amateur biologists with the aim to educate the community and to offer themselves as a point of reference should anybody in the amateur community want to report on a security problem.

Technologies that Facilitate Amateur Movement

Other cutting edge developments may enhance the capacity of amateur activities. One of them is the development of DNA sequencing techniques, where improved technology clearly changes the field and opens up new opportunities for hobbyists. It took scientists from 20 international consortiums more than a decade to complete the first human genome (3 billion base pairs) with a price tag in the billions of dollars. The rapid development of sequencing techniques, along with the new generation of sequencers, has dramatically reduced the technical complexity and cost of DNA sequencing. This is reflected in the emergence of personalized medicine, whereby sequencing an individual genome (or part of it) has become much more affordable. The principles used for DNA sequencing can, in theory, also be applied to DNA synthesis. Thus, some of the advanced techniques developed by novel sequencing may also facilitate the DNA synthesis. Already, the progress in DNA synthesis techniques has

played an important role in promoting the use of synthetic genes in research. If the synthesis technology develops in a comparable manner to sequencing techniques, amateurs may afford to have their own synthesizers. In that case new regulation is needed to oversee DNA synthesized by amateurs.

The commercialization of do-it-yourself kits for biology will cultivate further the public interest in bioscience (see e.g. the BioBrick assembly kit https://www.neb.com/products/E0546-BioBrick-Assembly-Kit). Furthermore, cheaper or alternative versions of lab equipment, such as microscopes, PCR thermal cyclers, centrifuges, and other basic instruments in the life sciences, are being developed to provide a low budget infrastructure for amateur scientists. For example, the price for a prototype of personal PCR machine can be as low as 149 US dollars, only 5% the price tag of the standard ones. It is estimated that for a very basic BSL1 setting at home, the minimal budget will be less than 6000 US dollar while equipped with second hand or self-made versions. Besides decreasing equipment cost, the development of *in silico* research in SB will further reduce the dependence on wet labs. If more reliable, yet simple to use software for dry labs become available in the future, the capacity of hobbyists in SB projects will increase since the operation on wet lab will reduce markedly.

Existing Regulations Applicable to Synthetic Biology

The regulations of SB, ideally, should address a number of concerns including not only biosafety and biosecurity, but also intellectual property questions and ethical issues. Existing regulations with relevance for biosafety and biosecurity will be briefly discussed here. SB is a relatively new field but one that is based largely on previous genetic engineering efforts. So a number of regulations have already been set up to deal with either biological research as such or the use of recombinant DNA (genetic engineering). The Cartagena Protocol on Biosafety and the WHO guidance for biosafety provide the necessary guidance to conduct SB research in a safe manner. The US federal regulations bearing on SB are related to health, environmental protection, food and drug safety, and commerce. The amateur biology societies claims to adhere to the biosafety standards and several approaches have been developed to provide biosafety knowledge to its members. These include presentations on biosafety related issues (http://diybio.org/safety), the development of norms and codes of conduct (http://diybio.org/codes) (see table 1) and plan to provide hobbyists opinions from biosafety professionals via "Ask a Biosafety Officer" service (http://diybio.org/safety/disclaimer).

Table 1: Comparison of US (7) and European (10) DIYBio Code of Ethics

USA (July 2011)	Europe (09/07/2011)
Transparency: Emphasize transparency and the sharing of ideas, knowledge, data and results	Transparency: Emphasize transparency and the sharing of ideas, knowledge, data and results
Safety: Adopt safe practices	Safety: Adopt safe practices
Open Access: Promote citizen science and decentralized access to biotechnology	Open Access: Promote citizen science and decentralized access to biotechnology
Education: Engage the public about biology, biotechnology and their possibilities	Education: Help educate the public about biotechnology, its benefits and implications
-	Modesty: Know you don't know everything
-	Community: Carefully listen to any concerns and questions and respond honestly
Peaceful Purposes: Biotechnology should only be used for peaceful purposes	Peaceful Purposes: Biotechnology must only be used for peaceful purposes
Environment: Respect the environment	Respect: Respect humans and all living systems
	Responsibility: Recognize the complexity and dynamics of living systems and our responsibility towards them
	Accountability: Remain accountable for your actions and for upholding this code.
Tinkering: Tinkering with biology leads to insight, insight leads to innovation	-

The community lab Genspace has set up an advisory board to review activities in their facility (http://genspace.org/about_us.html). Due to the fact that all of the practical projects conducted by the hobbyists are those currently defined as "low bio-risk", the existing guidance will cover their activities. Yet, taking into consideration that most of the guidance on SB is voluntary, its implementation will not be supervised by traditional authorities nor guaranteed (however, not even traditional authorities can provide a 100% guarantee that activities are not unsafe).

The Select Agent Rules (SAR) and Department of Health and Human Services Screening Guidance for Providers of Synthetic Double Stranded DNA (SG-DNA) are of more direct relevance to the biosecurity aspects of SB. Yet the enforcement of the SAR is limited to registered facilities, which, in case of violation of the rules could be penalized by "revocation or suspension of a certificate of registration". Clearly this is much less applicable and thus much less of a deterrent in case of an amateur scientist with malign intent who is operating outside the institutional context of a registered facility. In contrast to the SAR, the SG-DNA is voluntary for the few companies that are currently dominating

the advanced DNA synthesis market. By adhering to the guidance, DNA providers commit themselves to screening incoming orders for both legitimacy of the customer and "sequences of concern". The latter are any sequences that are related to agents listed on the SAR. The viability of this governance measure depends on the current structure of the DNA synthesis market.

SAFE, SECURE AND RESPONSIBLE DIYBIO

The DIYBio community takes the debate about safety and security very serious. The community has voluntarily – as a precautionary approach – cooperated with law enforcement agencies to avoid misunderstandings like in the infamous Steve Kurtz case. Also in Europe, where working with genetically engineered organisms is regulated, amateur biologists adhere to the rules and work without genetic engineering so far. So far, only one biohacker in Europe completed the bureaucratic and technical tour de force and obtained a legal permission to genetically modify bacteria in his kitchen. Most others stick to naturally occurring bacteria, all of them falling into the lowest bio-risk category BSL1. For example, when the coordinator of Paris' Lapaillasse, Thomas Landrain, was looking for a new project to design a pen with bio-ink, he constrained his search to low risk organisms and products proven not to be toxic or otherwise harmful in any way. In the end he found a naturally occurring soil bacteria from South America that produces a non-toxic blue pigment that can be used to make blue ink. First tests have been successful and Landrain is now working towards integrating the bacteria into a pen than only needs to get fed with nutrients so the bacteria would secret ink to write on paper.

Another European DIYBio group around the Dutch Pieter van Boheemen developed a cheap and reliable test kit for malaria, the diagnostic tool called Amplino. Again they did not use any dual use technology but rather provided a useful open source/open access kit to fight one of the deadliest diseases in the world. To check for current activities of European DIYBio in different countries, here is a non-exhaustive list of self identified amateur biology groups:

- BiologiGaragen – Copenhagen, DK (http://biologigaragen.org)
- BrmLab – Prague, CZ (http://brmlab.cz)
- Dutch DIYBio – Amsterdam, NL (http://waag.org/en)
- IndieBiotech – Cork, IE (http://www.indiebiotech.com)
- La Paillasse – Paris, FR (http://www.lapaillasse.org)
- London Biohackspace – London, UK (http://biohackspace.org)
- MadLab – Manchester, UK (http://diybio.madlab.org.uk)
- Pavillon 35 – Vienna, AT (http://pavillon35.polycinease.com)
- Makerspace – Newcastle upon Tyne, UK (http://www.makerspace.org.uk)

OPTIONS TO REGULATE SYNTHETIC BIOLOGY RESEARCH AMONG AMATEUR SCIENTISTS

Governance measures to address the safety and security issues of SB have been proposed from the early stages of the field's development. The concept "safety first" was brought up by active scientists in the field. A proposal was put forward to address some of the biosecurity concerns associated with synthetic biology – in addition to the screening of DNA orders the licensing of DNA synthesizers and reagents was proposed. A white paper on biosecurity was prepared by the UC Berkeley SynBio Policy Group. Although this paper was intended as the basis for building a code of conduct for the synthetic-biology community, more than three dozen civil society groups criticized these proposals which led the scientific community to drop the paper. A subsequent study led by the J. Craig Venter Institute, MIT, and the Center for Strategic and International Studies, reinforced the trend to center governance options for SB on DNA synthesis technology, with a focus on commercial suppliers of gene-length DNA sequences. Some of the biosecurity governance measures developed in this report were subsequently taken up in proposals by groups of SB industry representatives. The first of these groups, the International Consortium for Polynucleotide Synthesis (ICPS), recommended a "tiered DNA synthesis order screening process". Members of a second group of mostly German-based DNA synthesis companies, the Industry Association Synthetic Biology (IASB), focused on a number of interrelated issues including *inter alia* the harmonization of screening strategies for DNA synthesis orders, the creation of a central virulence factor database, and the formulation of a code of conduct. Both of these groups then developed competing codes of conduct, which eventually informed the above mentioned HSS screening guidance.

Studies that have addressed *inter alia* the biosecurity risks of SB and contained proposals on how to address these have been conducted by the European Group on Ethics in Science and New Technologies, the "European Academies Science Advisory Council" and the United Nations Interregional Crime and Justice Research Institute. All these studies focused primarily on bio-threats resulting from state and terrorist group activities, or rogue individuals in an institutional research context. Amateur biologists – presumably due to the inferior infrastructure that they have at their disposal and the resulting lower likelihood to get their hands on items such as those on the select agent list – are not considered by these studies.

In addition to these more policy-orientated studies, efforts have been undertaken in the academic governance literature to systematize and categorize SB risks and governance or oversight responses to these. A broader-based review of policy problems for SB oversight has pointed out that in relation to safety and

security concerns, the open source movement within the SB community actually "could increase national health and security threats from SB. With increasing openness there comes a greater chance of information getting into the hands of individuals or organizations that have malevolent intents". It can, however, not be ruled out that these arguments are also (and even mainly) used as surrogates to maintain a system of intellectual property protection, threatened by an open access biotechnology. Some observers have had the impression that the security and safety concerns are partly motivated by cooperate interests to keep amateur biologist out of lucrative markets, currently protected by patents.

Conclusion

The development of SB has great potential to deliver useful applications for society. Unlike the traditional life science, the advance of SB also prompts engagements from those outside the professional community. Amateur movements have existed in many areas of science for a long time, yet their emergence in the life science is a new trend. The rapid pace of development of SB is accompanied by a de-skilling agenda that finds its expression in easy-to-use toolboxes of standardized procedures and methods that are likely to be available for everyone interested in becoming an amateur (synthetic) biologist. This creates new opportunities for activities at the community level. While we accept that most amateurs pursuing SB are overwhelmingly constructive and motivated to change the world for the better, it cannot be taken for granted that misconduct or misuse will not occur. It is thus essential to continue establishing proper norms as well as cultivating responsible behavior in the amateur SB movement. The amateur community expressed their willingness to develop the self-regulation on biosafety and other ethical issues. Some members from the professional community have got involved in sharing their experience with them. This is very a good starting point for a more comprehensive engagement by SB community in an institutional context, be it in academia, the corporate or the regulatory bodies. Such continuous involvement would help to prevent biosafety breaches and misuse. It is then equally important that regulatory bodies (government agencies and scientific advisory committees), remain constantly up to date on the progress of research and development in SB. They should keep cooperating with amateur biologists while allowing proponents to develop their activities further for the benefit of society as a whole. All stakeholders of SB should get involved to keep amateur research safe and responsible so the fruits of synthetic biology will be available to everybody.

REFERENCES

These seven criteria for biosafety concerns came out of the work of the Committee on Research Standards and Practices to Prevent the Destructive Application of Biotechnology, chaired by Gerald R. Fink – hence called the Fink Committee – and was a reaction to increasing concerns in the US that research in the life sciences might be misused for bioterrorist or biowarfare purposes.

The Technosensual Body
The Emergence of Fashion & Technology

ANOUK WIPPRECHT

INTRODUCTION // TECH & US

The relationship between the body and technology has become increasingly closer since the start of the 21st century as designers, artists, scientists, and engineers have begun combining their practices in the pursuit of intertwined goals. With every passing day electronics are being woven ever more tightly into the fabric of our physical world. Electronic systems can now be layered seamlessly onto textile materials or substrates, such as plastic or polyester. Embedded processors and sensors for transmitting and receiving information enable a vision of a cultural transformation that is both exciting and disturbing. The role of fabric morphs from its already established functions into a social tissue, which currently still has very little understanding of the persuasive potential of these new sensitive and sensory arrangements. We shape technology, but technology also shapes us.

Our present relationship with technology has evolved to the personal realm. Interfaces are increasingly affecting the ways we love, communicate and bond with one another. Potential explorations in these unexplored territories open up a discussion about where such intimate electronics will lead us. At times these discussions may suggest a narrative reminiscent of a science fiction plot. However, as systems increase in intelligence, technology – not so unlike science fiction –, technology will slowly and relentlessly seep into the very core of our existence.

What about the future state of reactive and interactive systems? Only by questioning the technologies currently part of our society can we examine the impact of how these enhance the human body and make statements to better

define the implications of techno-human interfaces in a nod to identify what differentiates us from machines. As we become increasingly detached from our bodies through the influence of technology, will wearable interactive systems widen the gap, or will they perhaps help us bond with ourselves again?

How Technology Shapes Our World

Human beings have a unique ability to shape the world they live in. Our innovations have given us the power to transform our environment, extend our life span, create vast, interconnected societies, and even explore the stars. Technology has made this possible – from the simplest wooden plow to the most advanced personal computer –, it has helped bring about fundamental economic and social change in our lives and society.

It was once said:

> "I think there's a world market for about 5 computers."
> (Thomas J. Watson, Chairman of the Board, IBM, circa 1948)

Technology has come a long way since. Just as the steam engine, the railroad, and the telephone created dramatic shifts in the way people lived in the 19th century, the digital information technology of today eclipses all innovations before it. Yet, with each new wave of innovation comes a new set of challenges...

New Ways of Understanding

Technology determines the space of human everyday life. Not only does it do so within the public realm, it also impacts and expands our intimate realms, like furniture and garments. Technology brings the physical world closer to us. But could we have foreseen this?

> "There is no reason anyone would want a computer in their home."
> (Ken Olson, President, Chairman, and Founder of Digital Equipment Corporation, 1977)

When Olsen made this statement in 1977 he was thinking of computers purely as specialized equipment for task-oriented work, not taking into account their potential for other social uses. This statement represents the purpose the

computer had after its invention: to provide a service. While the computer was being used to perform calculations, store information, retrieve data, and process information, we also started exploring other possibilities. The personal computer has since become one of the most instrumental devices in making internet usage possible. It created connections, networks and made us reshape our communication methods.

> *"Whenever a society develops an extension of itself, all other functions of that society tend to be transmuted to accommodate that new form; once any new technology penetrates a society, it saturates every institution of that society."*
> (Marshall McLuhan, *The Playboy Interview*, 1969)

But in what ways can we look at the changes technology has created for us?

TECHNOLOGY AS EXTENSION OF THE SELF

Marshall McLuhan, the Canadian philosopher who coined the concept of "technology as extension of the human body" had an interesting approach towards uses of technology. An extension of our body and/or of our senses occurs when we extend the reach of our embodied mind beyond our natural limited means. As examples: the shovel is an extension of our hands and feet as we dig a trench; the spade is like our cupped hand as we remove dirt from a hole; a microscope or telescope extends our vision to study smaller or larger dimensions. While we are accustomed to using everything that a human body has to offer, we demand even more of technology;

> *"...the electric age pushes us into a world in which we live and breathe and listen with the entire epidermis"*
> (Marshall McLuhan, 1995)

The epidermis, by which McLuhan means the outer layer of the human skin that protects the flesh, can be used as a metaphor in terms of tactile displays. As notes techno-fashion researcher Sabine Seymour (*Studies in Computational Intelligence*, 2008): digital displays from mobile and networked environment s are merging with the organic epidermis of our bodies. Hence, our bodies have also increasingly become interfaces, mediated through handheld, wearable, or embedded devices. This techno-organic epidermis constructs new entities with their own specificities wherein wearable technologies, objects or garments, become more than mere mediators of perception.

As the concept of the "epidermis" evolves to represent the meeting of body and technology, new kinds of technological experiences will emerge. What will this new "epidermis" mean for the relationship between technology and human beings? It makes me wonder: "Will we one day be dressed in technology?"

Part 1
The Technosensual Body
The clothed Human

Did you ever notice? Humans are born naked to make the transition through the birth canal a little easier, but when we die, we are fully dressed:

Wearing clothes is one of the distinguished factors of being an upright mammal, separating us from the animals. Humans wear clothing for protection, safety, task-oriented purposes, hygiene, gender differentiation, social status, to uphold tradition or to honor the past to name a few. Clothing is an integral part of culture and society. And, whether we like it or not; it's also [in most countries] a written part of the law.

Modesty | Decency | Morality

But covering up our bodies is more than for practical, forced and social purposes. Humans have a feeling of self-consciousness, an awareness of their appearance and manners. I therefore refer to the Social, and Emotional but also the psychological role that fashion has in our society. A new coat can induce not only happiness but also a radically revised sense of who you are, resulting in a transformation within the empire of the self. The new coat makes things possible, casting a new light onto yourself. You can start to explore the world in your new equipment, and everybody will want what you have. If you have the right one, at the right time, with the right attitude, it's magical. Not in just one aspect, it's the overall state of how your new purchase makes you feel.

> *"Emotions have a crucial role in the human ability to understand the world, and how they learn new things"*
> (Donald A. Norman, *Emotional Design*, 2005)

In the book "Emotional Design", Norman mentions how aesthetically pleasing objects appear to the user to be more effective, by virtue of their sensual appeal. This is due to the affinity the user feels for an object that appeals to him/her,

due to the formation of an emotional connection with the object. When an object appeals to a person (on a visceral level) the "behavioral level" needs to be reached which exists of the experience of the object, for example the comfort of a garment. The "reflective" level measures the impact the object had on you afterwards. Norman shows in his book that design of most objects is perceived on all three levels (dimensions).

For example, while fashion trends move mainly on the level of aesthetic comfort, emotional wellbeing and psychological satisfaction of the user is dependent on the importance of the garment towards the society (as displayed by the fashion system), the positive feedback it gets from the people that the wearer finds important (social circles, class, wealth) and the statement the garment gives (design of identity, individual expression); codes by the media are forming, or giving an extended value to our experience or the garment. This is the added value we pay (sometimes huge amounts) for.

A little Disease of Our Time, Called Neophilia

Neophilia, according to the dictionary, can be understood as the love and enthusiasm of human beings to new things. While most people have some element of this trait in their personality, neophiles love everything new and novel. Every marketer's dream.

Genetic problem | Social phenomenon

Neophilia seemed to be a feature of modernity, since modern fashion evolved at the beginning of the industrial revolution in the mid 18th century. During the medieval period fashion changed extremely slowly. Then with the industrial revolution, there was a sudden shift toward rapid fashion changes. Acceleration has continued in recent years. But whether this obsession is caused due to a possible social phenomenon or not, there is one thing that is certain; the general desire for novelties is a key component in our modern economy, and is the engine that makes popular cultures continue to develop.

We started to experience our world using garments, accessories and jewelry as our interface with the world, as a method of communication and expression. And while a mobile device has only one interface through which we communicate with the world, fashion has the possibility to bring several, continually changing every six months. Or six weeks. Or six days. ... and, sometimes even six hours or less. Fashion might define who we are; programmed to like and to

dislike. But things are changing; our culture used to be obsessed with buying stuff, but now we are in a time that sets "experiences" above material things. What changes will appear? How can the interfaces around us affect or help us?

Part 2
The Technosensual Body
The Coded Human

Humans condition themselves. Our whole cultural society is based on associated actions and conditioned behavior, programmed structures and manipulated environments since our capability to transfer cultural and theoretical knowledge between generations. We strive to teach ourselves the cultural defined etiquettes and restrain ourselves in making a Faux Pas. Through computing we, in return, learned about ourselves as humans by gaining knowledge through digitally shared information resources. From a society in which fear and anxiety of a computerized world was sensible, we today live in a society that can hardly comprehend a life without mobile communication and data transmission. We function less efficiently without the use of global internet, making us wander around in the complexity of a networked society in a world that never sleeps.

Humans are programmed. Systematically arranged in a comprehensive collection of "whats" and "what not's," we think in patterns, and are controlled in patterns from patterns we created ourselves, and our generations before us. Education taught us to think in rational terms through a facade of empirical, analytical data. Children have intuitive knowing and un-programmed perceptions, akin to the animalistic behavior regarding intuition. According to Piaget's model, children go through four stages of development: the sensory motor stage (birth to 1.5 or 2 years), the preoperative stage (from 2 to 7), the concrete operational stage (ages 7 to 11 or 12), and formal operations (between 11 and 15). During the evolution of the child to adulthood, educational institutions stifle the natural intuitive abilities. Systematic, logical thought patterns are demanded in excess, and children are taught not to listen to their "inner" voice, and hence become "programmed." With the start of education we train our mind to become a logical mind, and with that mind, create computers, losing our intuitive behavior in the process.

Part 3
The Technosensual Body
The Twisted Mind

"*I think there's a world market for about 5 computers.*"
(Thomas J. Watson, Chairman of the Board, IBM, circa 1948)

I come back to the statement above because technology exists in our lives to provide us with services. But we lost ourselves in the computer's myriad possibilities on many levels; the practical (perform tasks, provide information); the social (communication, connecting); and the emotional level (entertainment, interaction, expression). By letting this happen, not only the way we communicate and connect and interact with others has changed, we have also begun to attach ourselves to new kinds of relationships towards these new interfaces. Although people argue that robots will never replace humans in ways of emotional attachment, several studies show that in fact we are increasingly emotionally attached to technology.

Even if we're not aware of it as a robot, an object like a smartphone, has a high attachment score when talking about levels of importance and bringing an added value towards life. With the smartphone as the example, media became an extension of the body, and by letting it in, it created a soul. It's not only the desire for communication, but also the pleasure of the body that comes from pressing the keys and holding the object, or the "user experience". It becomes the utopian object which creates the pride of ownership and enhances your status in society when you use it. We are programmed through the signals it gives and the emotion it triggers; codes brought by the media are forming our new experiences.

Due to our relationship with computers, the fundamental task of computing has changed. It has evolved from the computer as a task-oriented device into a platform for simulation, navigation and social interaction. Where twenty years ago most computers were limited to typing commands, they are now "models of the mind", controlled by our own minds. It extends our limited capabilities by superhuman means, extending ourselves, as it were, through these millions of pivots.

"*We ask [of the computer] not just about where we stand in nature, but about where we stand in the world of artifact. We search for a link between who we are and what we have made, between who we are and what we*

might create, between who we are and what, through our intimacy with our own creations, we might become."
(Sherry Turkle, The Second Self, 1984)

About people confronting machines that seem to think and at the same time suggest a new way for us to think.

In *The Second Self,* Sherry Turkle looks at the computer not as a "tool," but as part of our social and psychological lives. She looks beyond how we use computer games and spreadsheets to explore how the computer affects our awareness of ourselves and our connection and interaction to others through the relationship we have with the world and the people in it. "Technology," she writes, "catalyzes changes not only in what we do but in how we think." Turkle asks us to reconsider two decades of computer culture – to (re)experience what was and is most novel in our new media culture, and to view our own contemporary relationship with technology with fresh eyes.

Her interviews reveal that we consider computers to be on the border between inanimate and animate, as both an extension of the self and part of the external world. Their special place betwixt and between traditional categories is part of what makes them compelling and evocative. In the introduction to this edition, Turkle quotes a PDA user as saying, "When my Palm crashed, it was like a death. I thought I had lost my mind." These words published in 1984 are still essential reading as a primer in the psychology of computation. And although the essay was written in (what can be called) the information society, it was a clear view into the prospects of the society that we reached today (relation/experience society) in where we see ourselves becoming robots because of the complex network our world has become, but at the same time accepting our machines as human-like extensions.

Why Technologically Enhanced Things Inspire Us

One of the most important human traits is curiosity. Had you not been curious by nature, you would not be reading this article right now! And since we are predisposed to seek new things, our curiosity is often answered in ways that reach far beyond the imagination. If we, as humans, were not already predisposed to be stimulated by novelty, a lot of the structures on which capitalism are founded would not exist. Which brings me to a statement of Marshall McLuhan: "We become what we behold. We shape our tools and then our tools

shape us." As a consequence of our admiration of the future, our exploration of the world, our drive to know new things, our hunger for innovation, we have become our tools.

PART 4
THE TECHNOSENSUAL BODY
OUR BONDS WITH TECHNOLOGY

The smartphone for example as named in above chapter, became an extension of the body. By letting it into our lives we created a soul for it. We gave value to it and the feedback that we got was to evaluate that value. Emotional intimacy without a physical connection defines new emotive relationships conducted via digital and networked interfaces. As the bonds between humans and technology become more present, better defined, more varied and rich, we increasingly "tighten" these established bonds through mobile technologies.

Pets & Humans

Animals and pets are a joy. More than half of U.S. households own a pet. In a study by the American Animal Hospital Association, over half of the respondents said if they were stranded on a desert island, they would prefer the company of their pet to a human companion.

In the book "Love & sex with robots", author David Levy investigates "loving our pets" through traditional, physical means (real cats and dogs) as well as the increasing popularity of virtual pets and the emotional relationships with electronic objects. First, animals came into our households to provide a service (cat – catching rats, dog – protection/guards) and got shelter and food in return. But nowadays we see pets as extensions of our family. As *beings* roughly on our level, they live with us and next to us and we mourn when they die, instead of throwing them away and getting a new one, without any sign of emotion as we might do with electronic devices. Beings – not as adults, but more like children. We don't want their service, we want their love and mutual affection. We started to treat animals like humans and they therefore function in our minds on the same level as people.

Through this consultation, David Levy foresees that we will tend to anthropomorphize machines/robots too. Although it's a bit of a provocative read, Levy gives an interesting look into how future bonds with technology are foreseeable.

Fashion as the Interface Into Our Worlds

What if these little interfaces around our bodies mentioned in the former chapters become reactive or responsive? Act instinctively, like the instinctive nature that we ourselves lost over time? Monitoring our heartbeats, signaling dangers or protecting our personal space? Therefore customizing themselves to the needs of their owner, and therefore away from mass produced looks and styles? Can it be an extensions of ourselves or a symbiosis with mankind?

It is not only with technology that we are are developing more intimate relationships; clothing is also playing an increasingly complex psychological and physical role in the display and construction of public (and personal) selves. Towards the end of the industrial age, both got combined; where the possibilities of new emerging technologies showed up and started the electronic age, wearable electronics are mentioned as future possibilities. Where clothes were originally designed for shelter and protection during the early times, towards the beginning of the modern age, technology began to transform the making of clothing as something futuristic and expressive, both in material and style. Interest during the post-war (possibility's of spy-ware) and mentioning in the early sci-fi literature, e.g. Isaac Asimov, *The End of Eternity*, gave wearable electronics visibility. Extensively theorized through the 1980s and 1990s designers started to notice a possible potential at the beginning of this century and discussions are being held by pioneers that show concern while suggesting to take electronic fashion to a new level. Wearable computing was developed by MIT during the 1980s and engineer Steve Mann developed the first wearable webcam which he used in conjunction with the Internet in performance-related projects. These idea's of the "future" shaped how popular culture envisioned clothing's new role.

Techno enhanced fashion is yet still a relatively new platform for exploration but merges naturally with our current mindset of a more sensitive world, one which values the "experiential above the materialistic". The time that dresses looked "pretty" will soon be gone. We will start to long for intelligent fashion that can add something more than a visual representation or an analog expression due to its looks and style; we want dresses that "do" something. Dresses with their own habits and characters, sensitive to our needs. A generation of garments that behave and misbehave will rise up.

But as fashiontech projects predictably can showcase their beauty, entertain the audience with flirtation and stories, enhance the body with a new layer of interactivity or simply embrace the poetics that electronics and mechanics have to offer; they also create a new platform from which questions arise. In a future where electronics are predicted to be embedded in everyday objects, like our surroundings and garments, what changes will appear? And, perhaps most pertinently, how will we socialize in our world when we are supervised by technology?

To convey emotions with design the design itself should also provoke these emotions – a setting in where the human senses get triggered by a combination of factors. During my efforts at trying to get a grasp of all these mindspins, I started to create designs based on the whole topic of the technologized body, in an over-saturated way. I would like to explain through these prototypes what effects can be reached; to convey different characteristics I choose to explain my works coining my research where I play with the inner core of intimate, personal, social and public spaces. These designs are a perfect way of examining human-machine complications as well as exploring interaction design from both the wearer and the audience's point of view. By elaborating some of the research and methods/strategies of my work I hope to explain the ways that I work.

Topic 1 // Sensoric & Responsive Systems

Different kinds of sensors and sensory motives are used within these projects. I state two directions. The first one is the outward sensor – a sensor embedded in the system / design that senses the surrounding intruders upon presence, approach, and behavior. The second direction would be the embedded sensor in the design / system sensing the wearer by means of heartbeat, transpiration, brainwaves and other bodily sensing possibilities.

The first project that I want to mention is a project in where social interactions determine the garments' level of transparency, based on an inwards system (reacting to heartbeats) creating a sensual play of disclosure that is uncontrollable to the wearer:

INTIMACY 2.0 garments become transparent with close personal encounters by Studio Roosgaarde and Anouk Wipprecht, 2010 [version 1.0] + 2011[version 2.0]

Developed by Studio Roosegaarde and designed by Anouk Wipprecht, in collaboration with V2_labs [NL] INTIMACY 2.0 is a pair of high tech dresses that use new technologies to blur the boundaries between what is private and what is public in a sensual way. The "undressed" body is sensationally exposed in midst of social interactions, transforming a space of "intimacy" into a socio-sphere of "extimacy," to borrow a neologism coined by Jacques Lacan. The wearer has limited control over the transparency of her garment coupled to her heartbeat. Constructed from opaque "smart" foils that become increasingly translucent upon personal encounters, Intimacy 2.0 provokes. It shifts the role of clothing as merely a protective shield from the natural world to emphasizing its social and cultural function. And, in a society that has more and more of its life intimately entangled with technology, it is not surprising that fashion has come to explore technology's effect on the most private and intimate parts of our lives.

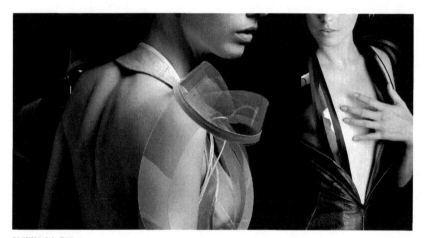

INTIMACY 2.0

Topic 2 // Personal Space

In most of these project I make use of the the rules of *proxemics*, introduced by Edward T Hall in 1966, measure the distance between intimate space (0 – 18 inches or 0-46 cm), personal space (1.5-4 feet = 46 cm-1.2 m), social space (4-12 feet = 1.2-3.7 m), and public space (12 feet = 3.7 ~ on)

A project with the aim to evoke social behavior by using intimate, personal, social and public spaces as her platform for interaction:

The DAREDROID 2.0 cocktail making robot dress // robotic performance
by Modern Nomads (Anouk Wipprecht, Jane Tingley, Marius Kintel), 2010

Deliberately designed to entertain a captive audience, the human host and robotic dress perform together offering guests a cocktail in exchange for a personal and intimate information. Using an inventive mélange of medical technology, custom electronics and sensors, the robotic dress detects your presence and kindly dispenses non-alcoholic liquid. But in order to get the additional shot of vodka, you will need to play a game of "truth or dare" (via the touch screen bracelet on the model) while your friends voyeuristically observe. The extraordinary impact of the performance is largely due to the the garment's other-worldly design and styling. The white, sculptural fabric appears, at the same time, clinical as it does seamlessly manufactured. The styling avoids the obvious tropes of looking futuristic or robotic. Instead it alludes to a "manufactured organic" and envisions clothing as an exoskeleton (with a limited nervous system) that covers bare human flesh. The DareDroid Cocktail making Dress is cinematic fashion at its best.The dress practically effaces the identity of the wearer using her body as its "host" and usurps the lead role in the theatrical performance.

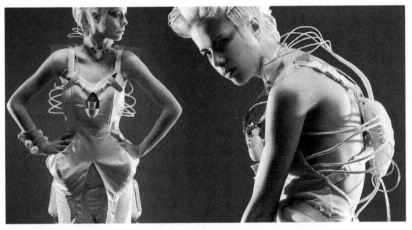

The DAREDROID 2.0

Topic 3 // Intimate Space

Fashion is used by means of communication and expression. Fashion has the direct connectivity with the intimate space of the wearer, thus fashion is adapted by humans into their intimate space. In interaction design, the intimate space of a wearer is not often explored. Fashiontech gives us the possibility to explore this space while connecting through it to surrounding personal, social and public spaces.

A project that deals with personal spaces and defense systems:

SMOKE DRESS // tangible couture "smoke screen" – covers body in a layer of thick smoke
by Anouk Wipprecht & Aduen Darriba, 2012

Fashion-Tech theorist and designer Valérie Lamontagne has describe the "Smoke Dress" as follows: "The dress is a tangible couture "smoke screen" imbued with the ability to suddenly visually obliterate itself through the excretion of a cloud of smoke. Ambient clouds of smoke are created when the dress detects a visitor approaching, thus camouflaging itself within it's own materiality. The "SMOKE DRESS," with its loose net of metallic threads and electrical wire, works at the scale of the magical illusionists trick, permitting a hypothetical magician's assistant to perform her own disappearing act."

SMOKE DRESS

Topic 4 // Behavioral Studies

Behavioral patterns as for example protection mechanisms that are copied from nature and animalistic behavior can be projected as "missing values" – intuitive behavior that within the human reign has been lost over time. By having systems suggesting certain behaviors it can give co-control of these lost values back to the person, which can come in handy in ways of communicating in a non-verbal level with physical and visual signs. In this way you can let technology perceive behavior, guide behavior or copy behavior in order to attract, connect and communicate.

The last example, is a project playing with the idea animalistic behavior and protection systems:

SPIDERDRESS // insectoid inspired dress defining and protecting personal space
by Anouk Wipprecht & Daniel Schatzmayr, 2012

As described at FASHIONINGTECH.COM by Syuzi Pakhchyan; "A robust performative and provocative design that deals with themes of 'personal space' and raises questions concerning control and privacy; the sinister robotic SPIDER DRESS is an animatronic piece that responds to external stimuli projected as an human-arachnid hybrid. Perched on the wearer's shoulders are animated robotic limbs that eerily crawl around the body. The robotic dress both incites the curiosity of passersby by coyly dancing around the wearer's body while at the same time protecting the wearer if somebody approaches too fast or comes to close. Sensing the approach of the invader, and sensing nearby movement, the unsettling arachnid limbs jerk and twitch – protecting its wearer if anyone comes too close by a series of attack modes. A self defending mechanism projected as host instrument on the wearers body transforming the space of the body into a stage where the garment becomes the leading actor."

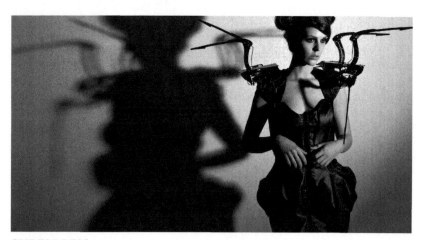

SPIDERDRESS

Combined with a good interaction and user experience design – we created for each design it's own habits and behavior, and stimulated therefore different kinds of reactions from both dress, wearer, as her audience. For example, the DareDroid is unique among technological couture in being a robust human/technological system, designed to be functional, and to leave the protection of the gallery. The DareDroid seduces an audience to play with it; interaction is crucial in order for the work to find meaning. The DareDroid elicits both fear and fascination as she moves through the room; people are drawn to her strange technological otherworldliness and overcome their normal social inhibitions in order to interact with her.

The strength of these projects lies in how they utilize various contemporary new media art forms, within a fine art framework of performance art, to engage in a public investigation of intimacy, comfort, trust, and privacy. These projects balance ideas informing art, technology, hybridity, fashion, and social inquiry to explore the way that technology mediates contemporary experience. The designs question the meaning of art as it leaves the gallery and moves into the social sphere, as well as examines very contemporary questions concerning technological augmentation of the human body, and issues surrounding control and privacy. Continually thinking about their means of communication. When design is exposed / confronted with a person – what does it evoke // communicate? As fashion is mainly out there to show off and please, these designs are there to do more, acting as intelligent agents to entertain, to protect, to nurture or feel, to express, to misbehave... the list is long. It's not action, but interaction that counts here.

Conclusions // Technosensual Worlds and the Emergence of Fashion and Technology

We shape technology, but technology also shapes us in more ways than we can imagine; it divines who we are as persons. But while our recent economy seems to have an overload of information (everything is possible, knowledge is one click away, i.e. the networked society) this often leads towards the stereotyped image of an exhausted, fragmented, alienated and dissociated Western civilization. We start longing for the very core of our nature; our bodies. We miss them. We live with them, but we might not seem to be in control over them most of the time. We will start rewriting our brain, but not in the sense of information but by experience and participation; our inner worlds. But since we are humans, and humans have the desire to upgrade everything possible, this transition will be mainly based on the human-centered integration of human and technology, as we use the objects around us as interfaces into our worlds. As sci-fi scenarios of machines taking over humanity would pop up in your mind by reading the last phrase, as stated before – in my opinion new types of technology will arise to "feel" with us.

With this movement in social interactions, our already established bonds with technology will morph into personal and intimate connections that we have with the interfaces around us. As technology impacts how we perceive the world, we need to get in co-control again in a natural way, and if we do, we can start creating narratives between our world and ourselves. Through this, I foresee a world in where technology and humans will blend into a symbiotic existence. A new nature that technology and human invented. And while artificial intelligence is based on recreating the rational human mind, we in a way should start to focus on technologically altering lost senses. As Science Fiction author J.G Ballard mentions in June 1993 during an interview for "Interzone" SF magazine; *"Fashion is the recognition that nature has endowed us with one skin too few, and that a fully sentient [ability to feel or perceive] being should wear its nervous system externally"* and we need to redesign that skin.

I spoke about technology as an interface with the world, and so are our garments. Fashion communicates through our bodies with the outside world, it is the interface through which we experience the world, it is still an analog one. Since the shift from a rational information society towards a society where experience plays a bigger role, consumers will no longer buy products, but rather lifestyles and the stories, experiences, and emotions products convey. In a way, communication-wise, techno enhanced fashion has the potential to mediate

a human in more ways than a human can mediate itself. Therefore, amongst other reasons, I am interested in how emotional, social and psychological processes can be influenced using electronics as an extension of the self.

Clothing and accessories will flow more to being the interfaces into our worlds. Being responsive through the use of technology, garments can be created so that they are aware of their presence and context. Garments that are sensitive, adaptive, and responsive to our needs, habits, gestures and emotions. Through globalization and emerging technologies our world is starting to open itself up towards connecting fashion and technology, and by this, letting technology be placed closer to the body. Sophisticated computational systems connected as host systems on our bodies with human-like behaviors and function render such "robots" in the form or intelligent fashion as potentially powerful forms of persuasive technology. Currently, there is very little understanding of the potential of these systems when worn on your bodies. As fashion-tech becomes a reality in our immediate lives and environment a better understanding of the mechanisms behind and the capabilities of their ability to influence becomes increasingly important. Tech-fashion has the potential to influence human beliefs, perception and behavior as well as fulfilling humans on an emotional, psychological and social level.

Garments that push the boundaries between the physical and psychological systems around the body that tend towards artificial intelligence, "playful exploration" of the ever-more intimate relationship between humans and machines which is making electronics an extension of the self. For me it is a playful exploration, where the body is the platform of interaction and expression. The position that technology has in our society (i.e. to "please" us) will get more and more intimate, and as technology crawls closer to the skin we will need to start to rethink and recreate the relation that we have towards technology. Technology combined with fashion creates new ways of communication between people, a new relationship between interface and the body, and a new connection of the body with technology

Creepy? Maybe. Sophisticated? Yes! I foresee a future where interactive fashion helps us bond with ourselves again. Reunites us with our lost souls and values. Do we want to watch fashion or watch fashion watching us and be adoring her silhouette, or do we want to experience and participate in her!

I start to cut provocatively close to the idea of "self aware destructive agents in a computer controlled world", and I am aware of this. But being realistic and rational about it – personally it feels less heavy to have a future prospect of attacking killer dresses instead of self-aware humanoid robot armies. The

wardrobe of the future is not an analog one – but digital. I am bored with the whole clothing system – I don't want to "wear" or "gaze" at fashion, I want to *experience in* and *interact with* it.

With a big thank you to Valérie Lamontagne (CA) of 3lectromode.com and Aduen Darriba (NL) for feedback & ideas.

Eliminated in a Hardly Noticeable Way

JOHANNES GRENZFURTHNER

A conversation with media researcher Hannes Auinger about dubbed movies, cultural forgery, and how to reverse engineer them.

JOHANNES GRENZFURTHNER: You've been doing research on the movie *Casablanca* for quite a while now. Why?

HANNES AUINGER: *Casablanca* is considered to be a classic as well as a cult movie. By classic, we mean that it is considered to be exemplary. But, and now we get to the cult part, *Casablanca*'s status as being exemplary is very controversial. The dispute over a movie's quality in the context of film history is always a part of its cult status. For some people they [cult movies] are a must-see, and for others they are overrated and to be viewed with caution. [Umberto] Eco once used *Casablanca* as an example to elaborate on cult movies. To him, an important characteristic of the cult movie is its imperfection with regard to the traditional set of aesthetic rules. On the basis of this argument, he concludes that "it seems that the boastful *Rio Bravo* is a cult movie and the great *Stagecoach* is not."

JOHANNES GRENZFURTHNER: As opposed to genuine classics...

HANNES AUINGER: Like *Citizen Kane*, for example, or – on a different level – the cinema of the Nouvelle Vague. Almost no one would dare to criticize films like these, because they have been officially sanctioned and approved of as being beyond all mundane reception both by movie history and partly also by pseudo-intellectual movie jabbering. Therefore, certain movies have been effectively shielded from the process of film criticism.

JOHANNES GRENZFURTHNER: What do you mean by that?

HANNES AUINGER: Well, as a random example I'd like to mention the Deleuze-based film analysis that's rather popular at the moment. Let's coin the term "to Deleuze" for this approach to simplify things. Well, according to the Deleuzians we tend to spend more time pondering if the people who are discussing something actually understand what they're talking about than we do thinking about the movie itself. Never before did a machine stand still with more beauty. But back to *Casablanca*: For people in the German-speaking areas of Europe in the 50s, the movie had a special political aspect.

JOHANNES GRENZFURTHNER: You mean the forgery; i.e., the revision of certain elements in the film to make it more agreeable to the sensibilities and historical identity of the German-speaking world?

HANNES AUINGER: Exactly. My research on *Casablanca* was part of a research project of the media section at the University of Vienna Department for Theater Studies. The name of the project was "FAKE". Our work covers all areas of popular culture, but at the moment, we are focusing on German-dubbed versions of Hollywood movies.

JOHANNES GRENZFURTHNER: Just a remark for all non-German speakers. All films in German-speaking countries (Germany, Austria, Switzerland) are dubbed to German. Not as in Scandinavian countries, where all foreign movies are subtitled. The German market is just too big, and therefore a functioning dubbing industry exists. All movies are shown in versions dubbed to German. Only few movie theaters and TV channels show movies in their original version. That means most German-speakers never see a movie in its original form.

HANNES AUINGER: Yes. And to avoid any misunderstanding, I will define our research's focus first. We aren't investigating the quality of the language in dubbing, as that's an entirely different field. One must point out that most puns are inevitably lost in the dubbing process, even if done with precision – which is rarely the case, because dubbing is usually done under deadline pressure and it shows.

JOHANNES GRENZFURTHNER: So you are not interested in this, even if the dubbing weakens the puns?

HANNES AUINGER: Not as long as the effect is restricted to the level of language incapacity. We are investigating forgeries of the content in dubbed films where we see a change in content compared to the original version. It might

well be the case – to get back to your question – that a pun is weakened or lost in the translation process, but beyond the language problem there are political abysses to be explored.

One example would be a short piece of dialogue from Frank Capra's *Arsenic and Old Lace*. A policeman is talking to his younger colleague and comments on the behaviour of Cary Grant's crazy brother: "He thinks he's Teddy Roosevelt. So what? There's a lot of worse guys he could think he was." In the German dubbed version (*Arsen und Spitzenhäubchen*) the policeman says: "He thinks he's Theodore Roosevelt. It would be a lot worse if he thought he was Stalin." The original joke is based on a comparison with something that remains undefined, and the dubbing turns it into a politically judgmental relation: it would be much worse if he thought he was Stalin. Thus, communism is put in the place where it belongs, according to the Western value system. Teddy also doesn't come off well with this translation, even though the dubbing studio refrains from using the rather jovial nickname. The expression "it would be a lot worse" suggests that Roosevelt isn't exactly an angel himself, which corresponds with the general judgement the German-speaking world has in store for politicians. They think of them as politicians, but they might as well think of them as mass murderers.

Going back to the term "forgery," we don't apply the term in the same way that it is used in the fine arts. The forger of a painting works in an object-oriented way. They create a seemingly unique specimen for a commercial market. Obviously, what they are striving for is the highest possible degree of congruity. The amorality that society ascribes to this act is not founded on the fact that a copy was made, but rather in the attempt to hide that an object is a copy. It's for this violation that the forger is punished. Forgery in the context of movie dubbing wants to be incongruent. The reproduction is not meant to correspond to the original, in terms of content. The reasons are manifold, and they are usually rooted in the societies of the respective target counties. Both methods of forgery – the congruous and the incongruent – ultimately happen for commercial reasons. An "Old Master" with its uniqueness is an anachronism in times of mass production, and therefore its exchange value is very high, which makes it especially interesting to forge. Inevitably, the act of copying the "unique item" secretively in an attempt to double the unique value is in itself dialectical.

JOHANNES GRENZFURTHNER: So how does movie forgery happen?

HANNES AUINGER: The history of forgery in movies in the German-speaking world starts with the occupation period. I'll sum this up very roughly. The Americans established their own movie industry in the occupied areas. This is the reward Hollywood got for the propaganda services it rendered during

the war. All these propaganda movies are now to be used in German-speaking countries – movies where the German is the bad guy. Well, the following is a simple economic question: will post-war Western Germany really enjoy watching movies where they are permanently displayed as a lying, fraudulent, murderous bunch and being constantly reminded of their mistakes and crimes, all things that are supposed to be covered up by a collective repression neurosis in order to render possible the economic miracle and to turn Western Europe into a future ally?

Fortunately, Germany didn't invest in its own movie productions, but chose to further develop its dubbing industry. This was also a controlled development. It was only logical – having to make a dubbed version of an existing movie anyway – to adapt the new version to the predominant social standards. What was forged in *Casablanca*? Well, in the German dubbed version that opened in German and Austrian theaters in the winter of 1952 – 10 years after the movie was made – there were no Nazis. And they weren't just dubbed out, but also cut out of the movie.

JOHANNES GRENZFURTHNER: No Nazis? But I remember them playing an important role in *Casablanca*.

HANNES AUINGER: The movie can't display what's no longer allowed to exist within society. The Czech resistance fighter Victor Laszlo, portrayed by Paul Henreid, becomes Viktor Larson (a Scandinavian scientist) in the German dubbed version. He seeks refuge in the forged version of *Casablanca* because he chose to deliberately destroy a wonder weapon he developed. Since National Socialism was removed from the plot altogether, the character of the Nazi Officer Major Strasser, played by Conrad Veidt, fell victim to the film editing. The Austrian movie magazine *Paimanns Filmlisten* notes in its December 2, 1952 issue – not without a certain irony – that "the newly-released dubbed version of *Casablanca* is correctly Germanized, and the scenes with the German General Conrad Veidt have been eliminated in a hardly noticeable way."

Before the war, Veidt used to be a big star, first of the German silent film, and later on in sound films as well. After his emigration he became very well known in England, too. This shows the extraordinary talent Veidt had as an actor. He was also not afraid to set a political example with his work. In 1934 he appeared in Lothar Mendes' *Jew Süss* based on the novel by Feuchtwanger. The subject had a certain political topicality due to the looming Nazi reign of terror. But during the last three years of his life in Hollywood he, like many of his fellow expatriate actors, had to impersonate Nazis, the people who had chased and deported them. This was not just due to the often quoted language barrier, an

argument which is especially questionable for Veidt, given his years of acting experience in England. It was also founded in a fundamental mistrust toward these people who had been the enemy during the last World War. So, ironically, the expatriate, who had fled Nazi Germany, was not only forced to impersonate the Nazi villain, but was eliminated from the film in its Germanized version.

JOHANNES GRENZFURTHNER: But now back to the so-called forgeries. Is *Casablanca* a solitary case? And, in the German-dubbed version of *Casablanca* that I saw, everything you mentioned as having been eliminated seems to be there again.

HANNES AUINGER: First, *Casablanca* is not a solitary case. There are numerous cases we've documented so far, but I have only mentioned some of them. Second, *Casablanca* was re-dubbed in 1975 by Beta Technik in Munich on behalf of TaurusFilm GmbH & Co. A new political atmosphere in Germany made a new version necessary. Somebody noticed that there was no dubbed version of *Casablanca* that was true to the original content. Wolfgang Schick, a.k.a. "Star Trek Schick', was to be in charge of the creation of a faithful version.

And at about the same time, some other movies of certain cinematic significance were re-dubbed too. *Notorious* is a notable example. In the forged version, the Nazi conspirators were turned into mysterious drug dealers. The rather appropriate title of the forged version was *Weisses Gift*, or *White Poison*. The reconstructed version is true to the original also in the new title – *Berüchtigt*. The transformation processes have not yet come to an end in dubbing. More recent examples for the way German dubbing studios treat German villains can be found in *Nighthawks* and *Die Hard*. In the 1981 movie *Nachtfalken* by Bruce Malmuth, Rutger Hauer portrays an international terrorist who was born in 1946 as Hemer Reinhard in Frankfurt, but whose alias is Wulfgar. Post-autumn 1977 [the "German autumn, when the left-wing militant group Red Army Faction created a national crisis with its operations], the German dubbing studio obviously preferred the ruthless terrorist be named Hamar Rinhard, a Dutch-sounding name, whose maniacal revolution saw the light of day in Amsterdam.

In *Die Hard*, the name of the leader of the commercially-oriented terrorists is Hans Gruber, and he and his group speak in a language we would probably call German. In the dubbed version he is Jack, yet only in speech, because in the closing credits we find the role name Hans Gruber next to the name of the actor, Alan Rickman. This fact probably went unnoticed by most people, given that hardly anyone ever reads the credits in cinemas here. The name Jack Gruber and the fact that the actor Alan Rickman is British, suggest that in the

dubbed version we are dealing with a British terrorist. And in the third part of the *Die Hard* series, things become really confusing. Now we are introduced to a new villain, Hans Gruber's brother. Because as a former officer of Eastern Germany he fits the enemy pattern of the West, the character remains basically unchanged in the dubbed version. But attentive German viewers with enough of a long-term memory will now ask themselves: Who is this Hans Gruber from the first part who is supposed to get his revenge here? Well, now they've got their answer.

Dissect

Hacking Feminism

STEFANIE WUSCHITZ

INTRODUCTION

The term *hacking* is here used to describe the practice of making a given entity one's own: by passionately deconstructing it, curiously exploring its structure, seeking to understand its inner dynamics. Yet the maker is only keeping those parts that seem relevant to further development. Hacking something in this context means to take what is relevant and adapt it to own ideas, needs, desires and demands. To hack feminism is therefore a way of showing respect and strong interest in the feminist movement and celebrating its achievements. At the same time feminism will be hacked and used in different ways than initially intended. This process can change the maker and her community.

BEGINNINGS OF MISS BALTAZAR'S LABORATORY

Since 2009 Miss Baltazar's Laboratory (MBL) tries to generate an environment in which women and trans can share their tech skills. The group was founded as a weekly event taking place at an Austrian hackerspace called *Metalab*. Metalab is organized as a living room for technology enthusiasts, hackers, nerds, creative tinkerers and coders. For about 200 members, Metalab serves as a shared living room. It is a platform to organize their lives in time and space and connect to peers. In 2009, Metalab's members were almost to 98% male. Female visitors often felt unable to use Metalab as a living room and platform. Some even expressed feelings of discomfort and insecurity inside Metalab. The experiences of the lab were strongly biased. MBL tried to change this individualized problem of feeling uncomfortable by creating a women-only group. MBL's main concern was to foster a feeling of belonging for women and trans who were new to Metalab, to feel more welcome within an

unfamiliar environment. This is how from the beginning MBL was targeted towards female participants only, while at the same time being located inside a male-dominated hackerspace.

Gender Clones

In 1977, Rosabeth Kanter published her theory on the *clone-effect* (or *homosoziale Reproduktion* as she called it in German). This theory suggests that people find it easier to enter social environments if they know that people similar to themselves are already part of this environment. She calls these people *clones*. Many females at Metalab who joined MBL at this time served as *clones* to women who joined in later. Knowing there was someone looking like myself helped to gain courage. At the beginning MBL participants had an art or political science background. Most had already decided for themselves that a generally male connotation of technology will not keep them away from using techie tools. They were eager to engage in all nerdy practices that they were interested in. There was no need to convince these clones of MBL's aims, there were however several conversations with male Metalab members who still needed to be convinced. Some were surprised or irritated about the new feminist activity within their lab and felt excluded. Other male Metalab members were tremendously delighted about the increasing number of women inside Metalab. It lead to supportive, but as well positively discriminating behavior towards MBL participants. This again was perceived as patronizing or harassing at MBL. The uncanny question raised by the mere existence of the MBL group was whether the community at Metalab was in fact more open and inclusive than the *outside* society, or whether structures of discrimination were replicated inside Metalab. MBL tried to explain the low number of females by suggesting that exclusions actually do take place in Metalab invisibly and that such phenomena get even amplified compared to the *outside*. Not only a low number of females, but also a low amount of diversity in general was criticized. Being *othered* inside Metalab was an experience also homosexual people, old people, people with migration background or newbies in the IT sector were experiencing.

Othering and Separatism

The process of *othering* (Simone De Beauvoir, 1949: 33) towards specific persons taking place in hackerspaces is following subtle yet quite common patterns of oppression. The space is reflecting the identity and visual language of

the majority. It seems that the hackerspace is reflecting parts of their identity, a cognitive self-reference (Thomas Metzinger, 2004: 8). Therefore patterns of identification follow patterns of ownership, which again are following patterns of dominance. If a person is different from the majority inside Metalab, this person will face subtle signals and gestures. As a result he or she might feel uncomfortable and not belonging to the community, sensing a lack of cognitive self-reference. This form of structural violence can be explained through the desire to construct identity narratives. They are the stories we tell ourselves, to construct a coherent self-concept. Identity narratives create a *personal order*. Collective identity narratives provide a collective sense of order and meaning. (Yuval-Davis, 2012: 14). If identity narratives are interrupted, this order is under threat. Creative, imaginative engineering of narratives could become an essential part in meeting such conflict situations. To create new narratives and perform them as identities, can help de-escalate. Mauricio Lazzarato points out in his essay on video philosophy, how othering can be met through avoidance of identification with the othered subject. New narratives can be negotiated when the othered persons form a collective. If they are forming a collective for the purpose of deconstruction, the deconstruction of a stereotype is achieved by the very people who are being othered. A new narrative can now be told. This is only possible in separatist groups in which the *othered* discover that they don't share any similarities that could legitimize becoming othered, hence quit tolerating the stereotypization. Erin Manning senses high political potential in separatist groups of marginalized agents when she describes in her article how joining together from different positions in order to fight a misconception offers new opportunities for non-essentialist alliances. Alliances that are fluid and improvised, but can open new partial perspectives. If none of the othered persons fits in, it becomes obvious that the stereotype must be an empty container. During this collective reality-check the stereotype's authority inevitably loses impact and melts away. This way a temporary collective of allies can enable itself to deconstruct a projected stereotype. Maurizio Lazzarato further points out that, similar to the human rights movement in the 70's, people protesting against being othered will be perceived as an aggressor by the discriminating party. This kind of paradox is caused by the fact that the party othering another party is not aware of the aggression their view is putting on the othered person initially. Individual members at Metalab perceived the indirect criticism implemented in MBL's aims as insulting. Instead of re-thinking offensive behavior, any criticism towards offensive behavior was seen as initial offense. The moment this mutual violence is directed attention too, (in our case in form of separatism) a reaction is triggered, ideally a change of excluding structures.

All of these dynamics are taking place within hackerspaces, but extremely slowly and never therefore almost never theorized nor discussed openly.

The group however continued to organize women and trans only workshops within Metalab for a year. The structure was simple. At each meeting a different person introduced a technology or technique in an informal and non-hierarchical framework. Sometimes workshops took place inside other institutions and organizations, like art events or at different art universities. The number of participants increased. Simultaneously the attention the MBL group attracted was increasing. The MBL group formalized its structures by becoming an organization (Verein) and moving into a new space at the commercialized art district called Museumsquartier. No more exposed to intense gazes, the group re-configured itself. At Museumsquartier MBL's self-perception changed strongly, since the new neighborhood consisted mainly of either media artist collectives or shops. Not meeting in a hackerspace, but within an art and commerce cluster with strong orientation towards tourism made MBL visible to art students and academics, yet female nerds, geeks and makers avoided the fancy space. The new fancy address helped on the other side to stage two festivals. Both were based on the principle of exchanging skills on Open Source Tech among women and trans non-hierarchically. The festival "Napravi Me" took place in Belgrade, where MBL collaborated with the local feminist group "Women at work". A little later they were invited to Vienna for the "Make me eclectic" festival. Online communication started to become an important tool of organizing without establishing an international organization (Shirky, 2008), hence connecting similar groups in the UK, Serbia, Canada, Netherlands, Belgium and the USA.

Feminist Hackerspace

In the 60s and 70s, in reaction to conservative mainstream thinking and repressive patriarchal structures, women started to meet regularly and create spaces with a specific policy. Since Judith Butler pointed out that gender is a performative act (Butler: 2009), these spaces can be interpreted as laboratories for new identities. Some spaces had the policy to be open only to biological women, later some were as well open to trans persons, some emphasized on feminist issues, others tried to increase visibility of lesbians and homosexual issues. Yet the common aim was and still is to fight exclusions occurring in every day life. Through this form of separatism individuals tried to share deeper discussions on identity, gender and marginalization.

So Vienna looks back on a rich history of women-only and safe spaces. Frauencafe, FZ-Bar (Frauenzentrum), Sunworks, Sprungbrett, Frauenhetz are examples of institutions that were among the first to trigger public discussions on feminism and domestic violence, equal rights and biases in the education

sector. They invented women-only-spaces and safe-spaces for Vienna, helped to install women shelters and the emergency call service (Frauen-Notruf). Inspired and challenged by these historical role-models, MBL wanted to found a big temporary autonomous space (Hakim Bey, 1991:1). The MBL group decided for a location that provided all infrastructure necessary to start a *feminist hackerspace*. With access directly on street level, large shopping windows serving as a display for generated projects and interface to the public, this location is more open and inviting than the space at Museumsquartier. The new place is located on a site in Vienna that is not as central and therefore well accessible for people from different ethical and economical backgrounds. Four days a week the doors are open to all genders, three days a week only to women and trans.

FEMINIST TECHNOLOGIES

The space is still based on the format *hackerspace* and equipped with workshops to produce interactive art. But more and more MBL is becoming aware and focusing on specifically feminist approaches towards technology. This term refers to technologies that take experiences owed to a female identity as an embarking raft for new inventions. Feminist technologies react to specific experiences originating in gender roles. Each feminist technology was developed in order to meet challenges caused by gender roles. This could be a voice technique as well as a software or secret code.

MBL wants to investigate how, through feminist technologies, the context of technological production is shifting. Interventions regarding the system of space, tool and agent inevitably changes *(1) technologies of production, (2) technologies of sign systems, (3) technologies of power, (4) technologies of the self* (Foucault, 1988) inside the lab. Each of these sections react sensitively to tiny alternations within the system. A new order triggers frictions within MBL's economy and allows agents to experience new potential in their position.

COMMON PROBLEM, COMMON SOLUTION

Individuals being exposed to similar exclusive structures will make similar negative experiences. People raised to think of themselves as female are often exposed to the same form of discrimination based on their sex. In short, persons with similar problems will try to find similar solutions. Reacting to experiences by developing a technology is offering a solution. This solution again can turn into a form of agency. No matter if the solution is a rather technical

development or an art work, a poetic solution or a tactic, they all can get shared. A feminist hackerspace can provide all means necessary to do so. Regardless of the fact that the agents involved in these sharing processes are not clones, (they simply made a common experience of discrimination) the articulation can represent and affect many. This is a very different interpretation of the term "feminist technologies" than e.g. Linda L. Layne gives in her book *Feminist Technologies*. There she derives feminist technologies from items that are used or consumed by biological women. She mainly describes and discusses technology designed to improve women's lives, not technology developed and shared in order to overcome discrimination.

Secret Code

An example of a technology developed to fight a common negative experience caused by shared discrimination is nǔshū. It was invented in China during the 15th century in Chinese villages. At that time women were deprived from the right to learn how to read and write. Parents chose a husband for their daughter without her consent. Getting married meant living isolated in the husband's household, not being allowed to leave and visit friends without permission. To resist this isolation women developed their own secret form of writing called nǔshū. To be skilled in the technology of writing and reading allowed them to keep contact with other women after their wedding. Worries and problems could get articulated and communicated through secret nǔshū letters. During religious gatherings among women nǔshū was the language used to pray and sing. In the end of her live a woman wrote down a letter telling the story of her life in nǔshū letters that got burned at her funeral. Nǔshū was invented and used all over the district Jiangyong in the south west of the Chinese province Hunan.

Today, not being able to use digital technology, to develop, to code or hack is as isolating as not learning how to read and write. Not being able to network, publish, communicate online makes people socialized as females obedient towards technology, looking at themselves as merely consumers or users of technology. They accept that technology was not developed for them and with their real desires in mind.

Literacy in the use and development of technology can only take place after a de-mystification. People raised as females need to lose respect towards technology, break it, take it apart and tinker with all elements, assemble still useful parts, re-program it, make it better, make it her own. Once technology gets embraced as a way to pragmatically resist repression, innovations in the way we communicate, collaborate and share will become powerful.

GAINING AGENCY BY INVENTING TECHNOLOGY

The pirate party's concept of liquid feedback will only start to work when these dynamics are addressed and taken care of. Environments that support to learn, fail and still take risks are rare. Agency is key to participation, but these processes need time. Alex Galloway described in his book *Protocol* (Galloway, 2004) how the aim of a technology is influenced by the identity and ideology of its developers. To develop feminist technology is therefore a political practice. In the end this has to inform the way the feminist hackerspace is organizing itself.

Every step and decision towards a specific profile, policy or orientation at MBL is debated over at a weekly panel. Concern and plans need to be discussed, a program must be proposed according to the demands of each member. And it takes a long while until the collective as a whole believes and agrees in a concept and chosen path.

OPEN, ART AND FEMINIST CULTURE

Being founded in a hackerspace, growing larger in an art environment and finally ending up as an autonomous studio space MBL underwent a quite peculiar development. Therefore MBL was picking up characteristics from all these different cultures. Open Culture, feminist culture and the contemporary art scene. All of the three cultures are connected through offering platforms of subversive practices, but in very diverging ways. MBL is a unique mixture of them all. It is no coincidence that feminist makers and artists are playing with tools that use licenses stemming from the Open Source Movement. That they are applying empowerment practices generated through feminist strategies and forms of collaboration usually applied by art collectives.

All these qualities help joining forces from each discipline and keep the process down to earth.

In the end what people feel confident and satisfied about is not the visual language of the space, the atmosphere in the group or the brilliance of our new program, but rather if they themselves had the chance to develop projects they otherwise would not have been able to realize.

Here MBL is clearly located within the fine arts field. Most projects spinning off MBL are interactive art installations.

Reactive Art(iculation)

It seems as if there was hardly an art-form in which the connection between tool, workspace and agent is closer related than within interactive art. The application or code generated to create a piece becomes an essential part of the art work. There is a continuous demand for knowledge, technology and access in order to be able to realize a concept. Therefore it is only natural that female artists in this field turn to tools that run under the GNU license or other FLOSS distributing systems. Open Culture offers an important community to relate to and identify with. But this community alone would not encourage and enable female artists to actually turn from consumer into user. In Open Source Software there are only 0,5 % female developers. Here, the thing that can stop the female artist from getting access to a software is her decision to make it her own or not. Mostly this decision is taken based on her self-concept: *Can I learn it? Is there someone like me who does it?* Feminist Culture and its radical critique on patriarchal identity politics gain in importance and seem to offer the key to overcome this form of exclusion. If habits and self-image are manifesting distinctions of class, agency becomes the main requirement for access to Open Source technology. But also access to politics, art and other fields of self-expression, a strong trust in the potential to change the own situation needs to be supported by clones of all ages and economic backgrounds.

MBL as Artist Collective

MBL contains visual and structural elements that are characteristics of an artist studio. Visually, when it comes to putting successful projects on display. Spatially when it is used as a gallery. Structurally, when it comes to sensitive collaboration and fair team work. In art collectives individuals are used to work closely and intensively together and deal with upcoming problems on the fly: Through one-to-one communication, trouble-shooting, improvising and cooperation on a high level of personal commitment.

All of these elements support the space in creating a feminist environment to grow in. However, fighting uncertainty towards technology, destructive identity narrations, self-doubts towards own skills is a never ending struggle.

The evolving connections between space, agent, tool makes Miss Baltazar's Laboratory a quite unusual environment. It makes it necessary to meet conflicts, incidents and changes instantly, on site and theorize processes and change on the go. It is not only necessary to share but also generate knowledge within the group and working process.

BECOMING A MAKER

For those people who enter the space in doubt about how they would fit in, MBL tries to make the decision easier. First of all by offering a safe and nurturing atmosphere, by living new self-concepts and inventing working processes, but most of all by dismantling the role-model "maker" from its male connotation. MBL enables lectures, reading groups, friendships and most of all hands-on workshops. The androcentric political system, supported by mainstream media exposes us continuously with repressive content. To seek an alternative demand shared critical thinking inside the collective. This conviction motivates the members to stick to the concept even in difficult situations. Again and again similar questions need to be talked about. What is a woman? Who is invited/allowed into the space at what time? Who is in charge and responsible? Is there a group hierarchy, if yes, why? Who is getting paid for working? Are we still excluding women from coming?

The revisiting and re-questioning of common ground with each new member brings about changes of social interaction and collective living. How can we provide child-care during workshops? How do we deal with different outside expectations towards our aims? How about individual concerns on authorship, competitive thinking, artistic careers? Perhaps feminist hackerspaces can generate practices that fight isolating positions caused by economic precariousness, self-employment or motherhood and help agents to embrace and apply the open source concept in different sectors of life.

CONCLUSION

With describing the short history of Austria's first feminist hackerspace I wanted to theorize how laboratory situations can become places of resistance. Separatist groups need a room of their own to grow and yield new structures of collective working. If successful, they make themselves redundant, which is the aim of MBL. Places in other countries are simultaneously exploring similar paths. There is e.g. MzTek (http://www.mztek.org) in London, offering Open Source Workshops to female artists and many other feminist tinker labs world wide. They are connected through the aim of creating unique environments that enable free articulation.

REFERENCES

Electronic Publications:

Schmitt, Sabine (2008). "Fakten zur Frauenschrift Nushu". Random House. URL: http://www.randomhouse.de/webarticle/webarticle.jsp?aid=9687& sid=1144 [30.01.2013].

Magazines:

Brigitta M. Schulte (2012). „Halbe Wahrheit. Kollaboration der Geschlechter?". Kommunikation und Seminar Magazin 21 (6): 1862-3131.

Books:

Butler, J. (2009). Die Macht der Geschlechternormen und die Grenzen des Menschlichen. Frankfurt am Main: Suhrkamp.

De Beauvoir, S. (1949). The Second Sex. New York: Knopf.

De Lauretis, T. (1987). Technologies of Gender, Bloomingtion: Indiana University Press.

Foucault, M. (1988). Technologies of the Self. A Seminar with Michel Foucault. Editor: Martin, L.H. et al London: Tavistock.

Galloway, A. R. (2004). PROTOCOL – How Control Exists After Decentralization. Cambridge: MIT Press.

Hakim B. (1991). T. A. Z. The Temporary Autonomous Zone, Ontological Anarchy, Poetic Terrorism, Brooklyn: Autonomedia.

Haraway, D. (1991). A Cyborg Manifesto: Science, Technology, and Socialist-Feminism in the Late Twentieth Century. New York: Routledge.

Lather, P. (1991). Getting Smart: Feminist Research and Pedagogy within/in the Postmodern, London: Routledge.

Metzinger, T. (2004). Being No-One: The Self-Model Theory of Subjectivity. Cambridge: The MIT Press.

McNay, L. (2000). Gender and Agency. Reconfiguring the subject in feminist theory and social theory. Oxford: Blackwell Publishers.

Petrescu, D. (2007). Altering practices: feminist politics and poetics of space, London: Routledge.

Shirky, C. (2008). Here Comes Everybody: The Power of Organizing Without Organizations. New York: Penguin Press.

Spivak, G. (2007). Can the Subaltern Speak? Postkolonialität und subalterne Artikulation, Wien: Turia + Kant.

Yuval-Davis, N. (2012). The Politics of Belonging, Intersectional Contestations. SAGE.

The Return of the Physical: Tangible Trends in Human-Computer Interaction

TANJA DÖRING

INTRODUCTION

Nowadays, computer technology increasingly gets integrated into objects, furniture, vehicles or buildings around us. Within computer science, this era is called *ubiquitous computing* (Weiser 1991) or short: *ubicomp*, addressing the ubiquity of computing power in the environment and its integration into all sorts of applications and social contexts, well beyond work spaces, where computers started their career back in the 1950s and 60s. In the beginning, they came in the shape of large mainframe computers that were used by a large number of employees each. With the birth of the personal computer in the 1970s and its success in the 1980s and 1990s, computers became available devices for anybody interested. They offered software, protocols and content for an increasing number of application contexts beyond text editing and spreadsheets like entertainment, information and communication. During the era of the personal computer the outer appearance of computing technology together with its interaction techniques basically did not change. Examples for this are the WIMP paradigm, denoting the combination of *windows, icons, menus and pointing device* as typical for the graphical user interface, and the mouse, already introduced 1968 by Douglas Engelbart and colleagues (Engelbart and English 1968). With the beginning of the ubicomp era, the variety of devices and interaction techniques exploded. Nowadays, computers take many shapes; we find many different forms from small jewelry or pocket devices to large interactive screens, furniture or even buildings; we use full body interaction, gestural interaction, objects to interact, touch interaction; even brain-computer interaction is a research topic within human-computer interaction (HCI).

This novel diversity of options for the design of interaction techniques offers opportunities to put the individual human's capacities into the focus: which parts of the body and which senses are best suited for the interaction with a technology device in a specific context? As a novel quality, next to research and industry, which have developed and determined how we interact with devices for the last decades (Myers 1998), a third community is growing and increasingly getting access to the design of interface technology of devices: the Do-It-Yourself (DIY) and open source community that organizes itself in open labs such as fab labs (Gershenfeld 2005) or hacker spaces (Baichtal 2011). This development, called the Maker movement as an umbrella term for diverse DIY communities worldwide, yields a potential to make the design of technology easier and more accessible to anybody interested. In this article, I will first introduce examples of novel interaction techniques and then discuss potentials the DIY Maker movement has to participate in interaction design.

NOVEL THEMES IN INTERACTION DESIGN

Among major recent trends in human-computer interaction is the return to the physical, the body and the senses. While until the 1990s, physicality and bodies were widely neglected in the design of interaction techniques with computers, we now find interactive objects, full body interaction or gestural interaction as well as other multimodal approaches realized within interactive artifacts. This goes in line with a wealth of technology developments like novel sensors that enable much more diverse, implicit as well as explicit ways to interact with computers and technology artifacts. I will introduce the terminology of four research areas depicting novel interaction techniques in the following.

Reality-Based Interaction

Jacob et al. (2008) addressed the lack of terms for currently evolving classes of *post-WIMP* user interfaces by introducing the *reality-based interaction* framework as a framework that allows to discuss aspects of the multitude of current user interfaces *beyond the desktop* in a structured way by identifying and analyzing aspects of reality and computational power that are useful for interaction. The authors' assumption is that "basing interaction on pre-existing real world knowledge and skills may reduce the mental effort required to operate a system because users already possess the skills needed" (Jacob et al. 2008:2004). Jacob et al. argue that interaction designers should always start from the knowledge

and skills humans have gathered in the real world. The authors suggest four themes of experiences and skills derived from reality: *naive physics, body awareness and skills, environment awareness and skills,* and *social awareness and skills*.

Naive physics includes all the knowledge and experiences humans have collected about physical laws, like gravity, friction, mass, stiffness, weight etc. The theme *body awareness and skills* comprises the knowledge about the own body: how it can be moved to achieve a specific movement or how a certain movement feels. *Environment awareness and skills* contains humans' knowledge and skills regarding orienting and navigating in the environment, e.g. humans are able to use landmarks to orient themselves. The fourth topic, *social awareness and skills,* addresses the knowledge and skills humans have in relation to other humans, e.g. different ways of talking to others (e.g. informal small talk, formal presentations) depending on the situation, different distances that are appropriate or not in specific situations, etc.

These reality-based themes can play a role within interaction design. To give some examples, e.g., friction as a principle based on gravity has been metaphorically applied to graphically presented data on touch user interfaces. I.e. when the user slides in the address book on an android phone for example, the sliding movement slows down, to make the movement experience more realistic (naive physics). Knowledge and skills how to move the own body, how to use kinesthetic and proprioceptive feedback, is important for full-body or hand movement interaction, e.g. realized in *Kinect* games. The human's capabilities to orientate and navigate in the environment are very important design factors for map and navigation applications (environmental awareness and skills). And, last, social awareness and skills play a role in social networks or in the virtual world of *Second Life* for example, where the users' communication still is based on their learned social skills.

Although most of the novel user interfaces are based on experiences from the real world to a stronger degree than it used to be, computer tools and applications would not be as powerful if systems were purely based on reality-based themes. Computers have many advantages, called *computational power* by Jacob et al., among which are *expressive power, efficiency, versatility, ergonomics, accessibility* and *practicality*. For example, when searching for a document where the title is known, it is much more efficient to search in digital documents by typing in search terms than browsing through a pile of physical documents (which would be the more reality-based way to do it). Thus, one of the central challenges of current user interface design lies in the combinations of and tradeoffs

between *computational power* and *reality*. Jacob et al. propose that "the goal is to give up reality only explicitly and only in return for other desired qualities" (Jacob et al. 2008:205).

Embodied Interaction

While human-computer interaction used to mainly focus on hardware and software as artifacts that are separated from the environment of their users, the concept of *embodied interaction* strongly relies on an integration of interaction between humans and computers into the material and social environment. This new quality of situatedness of interaction techniques with computers into our daily environment makes a new "perspective on the relationship between people and systems" (Dourish 2001:192) necessary. Dourish called this perspective *embodied interaction* and described it as follows: "Embodied Interaction is the creation, manipulation, and sharing of meaning through engaged interaction with artifacts." (Dourish 2001:126). He rooted the concept in the philosophical school of phenomenology, which had been introduced to HCI before by Dreyfus (1992) and Winograd & Flores (1986).

Phenomenology as a study of consciousness was founded by Edmund Husserl and further developed by other philosophers such as Heidegger, Schütz or Merleau-Ponty. It was especially Merleau-Ponty who focused on the role of the body and embodiment as central for perception: "Insofar as I have hands, feet; a body, I sustain around me intentions which are not dependent on my decisions and which affect my surroundings in a way that I do not choose." (Merleau-Ponty 1962:440). As such our situatedness in the world is the basis for all actions and all knowledge. For human-computer interaction this perspective marks an important difference to former Cartesian oriented approaches, where the mind was regarded as being separate from the body. This implies for interaction design for example, to be aware that computation is a medium and that meaning arises on multiple levels (Dourish 2001:166ff). For an interaction designer it is still challenging to design embodied interaction, as there are no established standards.

Tangible Interaction

The central idea of tangible interaction is to connect real objects with digital data and thus to enable the interaction with the data via interaction with the objects. The word *tangible* comes from the latin word *tangere*, which means "to touch, to grasp". Users can literally grasp data and manipulate it by

manipulating corresponding objects with their hands. Tangible user interfaces (TUIs) became popular in the research community with the work conducted by Ishii and Ullmer et al. at Massachusetts Institute of Technology Media Lab in the 1990s and 2000s. In their "Tangible Bits" paper in 1997, they describe the overall concept as part of ubiquitous computing where the whole world around us potentially becomes an interface (Ishii & Ullmer 1997). Ishii and Ullmer (2012:466) describe TUIs as follows:

> The key idea of tangible interfaces is giving physical form to digital information. These physical forms serve both as representations and controls for their interwoven digital bindings and associations. TUIs make digital information directly manipulable with our hands, and perceptible through our foreground and peripheral senses.

One often mentioned early prototypes with a tangible user interface coming from design and nicely presenting the basic ideas connected to tangibles is the *Marble Answering Machine* by Durell Bishop (mentioned in Ishii & Ullmer 1997 and Dourish 2001). The *Marble Answering Machine*, which was conceptually designed as part of a master thesis project at the Royal College of Art in London, is an answering machine, where incoming messages are presented in form of real marbles. If a message has been spoken on the machine, a marble rolls down a track where it stays together with other marbles, each of them presenting a message. At a glance, a user can see the number of messages and by manipulating them, either play a message (by putting the associated marble into a specific track in the machine), erase it (by putting it into a hole), save it for other family members (by putting it into a dedicated bowl), annotate it (putting it onto a "todo" shelf, adding further notes simply by writing with a pen onto the shelf), or calling back the person that left the message (by directly putting the marble into the telephone). This concept of a tangible user interface nicely shows how digital data, in this case the voice message, can be represented by graspable objects and how actions with this data can be triggered by manipulation of the real objects. This potentially leads to more meaningful ways to interact comparing to standard interactions like pressing on arrays of buttons that are arbitrarily mapped to certain functions.

Gestural Interaction

Gestural interaction is among the most popular trends within HCI but also already among UI design for products nowadays. The term *gestural interaction* comprises different kinds of interaction forms that all realize gestures, but in varying ways and settings. E.g., gestural interaction can be performed on

interactive surfaces as done in single or multi-touch interaction. These gestural interactions on surfaces can either be performed with fingers, but could also involve further objects as pens for example. Another approach to use gestures for interaction is to design mid-air gestures, this again could include arm and hand movement but also the integration of further active or passive objects like mobile phones or props. Furthermore, gestural interaction could even include larger parts of the body beyond arm and hand gestures.

Within human-computer interaction, gestural interaction has been of interest since the early days of the discipline. Also multi-touch gestural interaction, although widespread only since Jefferson Han's presentation of a self-built multi-touch surface (Han 2005) as well as Apple's first *iPhone* and the first Microsoft *Surface* table in 2007 (with a later version, the product name was changed into *PixelSense*), had been applied in a large number of research prototypes for many years; for an overview see (Buxton 2013). Among the advantages of gestural interaction is that bimanual interaction can be realized within human-computer interaction; especially in the context of multi-touch this has been discussed a lot. Guiard (1987) studied bimanual interaction and found "an asymmetric division of labor" in many tasks. This means, one hand sets the spatial referential frame for the other, e.g. we first fix the orientation of a piece of paper on a tabletop surface with one hand and then write with the other hand. Overall, gestural Interaction has often been praised as a form of *natural interaction* (Wigdor & Wixon 2011), which refers to being an interaction that feels to be direct and is intuitively understandable by users.

Having introduced these novel themes in interaction design, we will address opportunities to apply them and to engage in self-determined technology design in the following.

INTERACTION DESIGN AND DIY

The described strategies in interaction design allow a higher diversity of interaction techniques than we have seen during the last decades. This yields novel opportunities in many ways. First of all, user interfaces can be designed to best fit the needs of a specific user in a specific environment. They can be designed to best fit the skills of the old lady or the four year old boy; they can be designed to be useful for people with certain impairments and facilitate their life at home or at the workplace; or they can be designed for different experiences: to be primarily fun, efficient, entertaining, aesthetic, personal, outdoor or indoor compatible, and so on. These opportunities are especially important, as devices

get integrated into all aspects of life; and different situations afford different interactions. One example of an application area with safety related affordances is the car where interaction techniques for novel devices are needed that do not distract the driver from his or her main task. While this is a case where clearly experts are needed to design the user interface, many of the interaction techniques with devices could to a large extend in the future actually be designed by anybody interested. From an interaction design perspective, this is called "end user design" and spans from customization and personalization of devices (e.g. Schmidt, Döring & Sylvester 2011) to fully programming software and building appropriate hardware by the person that uses the device in the end. In the growing DIY and open soft- and hardware communities there already exist good examples how interaction with devices can be designed or hacked by basically anybody interested. The DIY community shows that devices and their interaction can be highly individualized and actually be designed for a market of one, a novel situation compared to the mass-produced electronic devices we are used to. This Maker movement is gaining importance and – although mainly a hobbyist practice – increasingly influences the landscape of interaction design and the agenda of HCI research and industries.

Within HCI research the DIY community has been started to be addressed in a number of publications, e.g. by Kutzentsov & Paulos (2010), who conducted a survey on the *expert amateurs* in DIY communities and their appropriation of human-computer interaction technologies. They found that DIY communities lower the barrier to enter a domain, that learning by "a give and take dialog" (Kutzentsov & Paulos 2010:7) is central, that the need to express individual creativity plays a big role and that open sharing is a core motivation and value. As design implications for HCI they suggest to support the integration of physical and digital domains, new forms of knowledge transfer and iterative studio cultures by novel tools and platforms. Wang & Kaye (2011) identified eight common themes in hacker practices as example for inventive leisure practices among which where *hacking as identity, skill, reputation and participation*. Tanenbaum et al. (2013) see a democratized technological practice and find especially *pleasure, utility* and *expressiveness* as important values for technology in the Maker movement. The authors suggest supporting the Maker movements' needs and values from an HCI perspective by designing for these values and providing infrastructures and platforms that enable creativity. Williams, Gibb & Weekly, David (2012) argue that much of the work conducted in the area of tangible interaction would not be possible or so much more complicated and expensive without all the efforts conducted within the Maker movement, e.g. the development of the relatively cheap and easy-to-use open source microcontroller *Arduino* (Kushner 2011), which became one of the major prototyping platforms for the HCI research community. The intertwining of these communities can

also be observed by the novel personal fabrication workshops organized at academic HCI conferences, as the "FAB at CHI workshop" (http://fabworkshop.media.mit.edu/) held at 2013 ACM SIGCHI Conference on Human Factors in Computing Systems or "PerFab 2013: Workshop on Personal and Pervasive Fabrication" (HYPERLINK "http://32leav.es/perfab/"http://32leav.es/perfab/) at the 2013 ACM International Joint Conference on Pervasive and Ubiquitous Computing (UbiComp 2013) conference. Additionally, craft and repair practices are topics of growing interest in interaction design research.

All these activities show that, although DIY movements have been around for much longer, the quality of the current Maker movement really has the potential to change the landscape of technology design. Taking user interface design as a fun and as well important example for shaping the technology around us, I argue that this is a good point in time with novel opportunities to taking the chance and getting involved into a self-determined design of technology.

Fostering DIY Interaction Design

In order to be able to better support DIY activities in user interface design, we should think about the necessary skills for these kinds of projects to shape technology. With a more general perspective on technology, the German philosopher of technology Günther Ropohl, who is known for his discussion of the German terms "Technik" and "Technologie" as well as for his writings about sociotechnical systems, distinguished between five different knowledge types of technology (Ropohl 1979, 1997). First, *technical know-how* denotes a mainly implicit knowledge, which is derived from practice, for example handling a tool. It is often learned during long experience with a certain craftsmanship and exists subliminally to a large extent. Knowledge about *functional rules* allows us to use a device, without knowing how it exactly works. Or – on a higher level – it allows us to configure and customize a user interface based on information derived from manuals or diagrams. *Structural rules* characterize the knowledge one needs to open the *black box* of a device, to identify its parts and to handle basic problems. This knowledge could be sufficient to repair a device or to build an own device from a toolkit, but does not include "having the full picture" – the knowledge one needs to really build an own device for personal needs. This highly developed technical knowledge, nowadays still mainly held by specialized professional engineers, computer scientists and designers, is called *technological laws*. Additionally, Ropohl introduces another

type of knowledge, which addresses technology comprehensively and puts it in relation to the natural environment and social practice: *socio-technological understanding*.

As Boeing (2012) argues, it is time to extend the access to technology. The creation of technical devices should not be left to big industries. It is time that we really start to shape the technical devices by ourselves and that we have the self-concept that technical artifacts can be understood and shaped, yes, even self-built according to our own demands and not what the industry wants us to use. In this sense, the ultimate goal would be the appropriation of *functional rules, technological rules* and *socio-technological understanding*. Now the question is, how could we get there? And what is already possible today?

I believe that participation in technology design should be fostered and supported on all levels of technology skills and knowledge. It needs to become a fundamental part of modern education but it also needs an infrastructure that allows everybody interested to acquire the skills and knowledge needed for an active participation in technology design. Important cornerstones in this infrastructure are *tools and toolkits* and *communities, places and platforms*.

Tools and Toolkits

Good tools and toolkits are extremely important for building novel devices. Especially within interaction design, tools influence to a large extent what kind of novel techniques are developed. For example, the 3d camera-based tracking device *Kinect* has facilitated to build user interfaces based on full body movements without having to deal with expensive tracking setups and complicated algorithms. As such, it allowed realizing many of the ideas as theoretically developed under the term *embodied interaction*. Another example can be found in the online documentations of fairly easy and cheap to realize multi-touch surfaces with vision-based tracking, which supported the rise of gestural interaction on interactive surfaces. In both examples, research, industry and DIY all played a role in fostering the technology. While the *Kinect* was developed by Microsoft (in cooperation with the company PrimeSense) it was hacked by the DIY community, which led to the release of a software development kit (SDK) that turned out to become a valuable tool in research institutes (c.f. Francese, Passero & Tortora 2012). On top of this, other open source frameworks for gesture recognition with the *Kinect* followed. In case of the multi-touch surface, the original idea to build it came from research. It was distributed via conferences and online videos. This led to the foundation of an open source community, the *NUI group* (http://nuigroup.com), which documented the hardware setup, developed open source tracking software and run an online discussion

forum. Their documentation and especially their tracking software are highly used by researchers, and as such, influenced research agendas in many HCI groups. At the same time both tools, the *Kinect* as well as multi-touch setups, are – compared to most previous tools used within HCI research – quite accessible to the general public: they are fairly cheap and documentation of hardware setups and software tools as well as discussion forums can be found online. This also means that much less expert knowledge is needed to use these tools compared to the past. Another nice example for a tool that makes interaction design accessible for basically anybody is *MaKey MaKey* (Silver, Rosenbaum & Shaw 2012), a controller based on the open source platform *Arduino* that was developed by Tech Students from the Media Lab at Massachusetts Institute of Technology and funded as a *Kickstarter* project in 2012. This tool uses a very easy mapping mechanism (i.e. the Human Interface Device, HID) and allows connecting anything that is conductive as a user interface for existing applications. Without any programming, just by connecting some cables and mapping different surfaces to keyboard events, a game like *Tetris* (or any other application) can be played by touching oranges, by touching other people, by running up and down stairs or by stepping into buckets filled with water, to give some examples. This way, novel interaction techniques like tangible and embodied interaction can easily be tried out by anybody interested. Tools like *MaKey MaKey* even facilitate technology design for people without much knowledge about *structural rules* and *technological rules* and as such lower the barrier to design your own interface. Moreover, this represents a very fun way to get involved with technology design.

Communities, Places and Platforms

While technology design used to exclusively take place in industry and research institutes, highly specialized but also often quite isolated, the DIY Maker movement provides an infrastructure that allows anybody interested to actively participate in shaping technical devices. This infrastructure consists of many different parts: be it online documentation and sharing platforms, discussion forums, magazines for makers, maker fairs and meet-ups or open labs. Especially these high-tech community labs, which include different types like hacker and maker spaces as well as fab labs for example, build important cornerstones in this infrastructure. We need places that enable that different people meet, learn from each other and construct their own devices. While some of these places indisputably still are quite geeky and thus do not appeal to all types of people, more and more places bring together really diverse people with different backgrounds or address specific user groups. Moreover, these labs often combine many different tools, from hand workshop tools to

computer-controlled machines, with all sorts of different materials including wood, plastic, fabric or food next to electronic parts or metal. Additionally, some labs even address technology in relation to the natural environment and social practice, what Ropohl introduced as *socio-technological understanding*, such that these labs provide a platform to comprehensively engage with technical devices and technology in context. As these labs are embedded into a *worldwide-connected community with sharing platforms like Thingiverse* (http://www.thingiverse.com/) or Instructables (http://www.instructables.com/), they provide a good starting point to get help and information for building your own device. And for interactive devices, interaction design is part of it. As described earlier, interaction design provides many novel and fun design opportunities that could be explored much further in the context of open labs. One nice example that evolved in the Maker movement, the BristleBot, a simple little robot that is made from a toothbrush, a vibrator motor and a battery (c.f. http://blog.makezine.com/2007/12/19/how-to-make-a-bristlebot/), was recently adopted and developed further into an actuated tangible user interface called *Touchbug* by a university research group (Nowacka et al. 2013). And there is still much more to explore.

REFERENCES

Baichtal, John (2011). Hack This: 24 Incredible Hackerspace Projects from the DIY Movement, Que Publishing; 1 edition (October 16, 2011).

Boeing, Niels (2012). Rip, Mix & Fabricate. In: Ilija Trojanow (Ed.) "Anarchistische Welten" (2012), Edition Nautilus, pp. 185-198.

Buxton, Bill (2013). Multi-Touch Systems that I Have Known and Loved. http://www.billbuxton.com/multitouchOverview.html [15.01.2013].

Dourish, Paul (2001). Where the Action is: the Foundations of Embodied Interaction, Cambridge (MA): MIT Press.

Dreyfus, Hubert (1992). What Computers still can't do: A Critique of Artificial Reason. Cambridge, Mass. MIT Press.

Engelbart, Douglas C. & English, William K. (1968). A research center for augmenting human intellect. In: Proceedings of the December 9-11, 1968, fall joint computer conference, part I (AFIPS '68 (Fall, part I)). New York: ACM, 395-410.

Francese, Rita; Passero, Ignazio & Tortora, Genoveffa (2012). Wiimote and Kinect: gestural user interfaces add a natural third dimension to HCI. In: Proceedings of the International Working Conference on Advanced Visual Interfaces (AVI '12). New York: ACM, 116-123.

Gershenfeld, Neil (2005). Fab: The Coming Revolution on Your Desktop–from Personal Computers to Personal Fabrication, Basic Books.

Guiard, Yves (1987). Asymmetric division of labor in human skilled bimanual action: The kinematic chain as a model. In: Journal of Motor Behavior, 19, 486-517.

Han, Jefferson Y. (2005). Low-cost multi-touch sensing through frustrated total internal reflection. In: Proceedings of the 18th annual ACM symposium on User interface software and technology (UIST '05). New York: ACM, 115-118.

Ishii, Hiroshi & Ullmer, Brygg (1997). Tangible bits: towards seamless interfaces between people, bits and atoms. In Proceedings of the ACM SIGCHI Conference on Human factors in computing systems (CHI '97). New York: ACM, 234-241.

Ishii, Hiroshi & Ullmer, Brygg (2012). Tangible user interfaces. In: Jacko, J. (Ed.), The Human-Computer Interaction Handbook. Fundamentals, Evolving Technologies, and Emerging Applications, CRC Press, pp. 465–490.

Jacob, Robert J. et al. (2008). Reality-based interaction: a framework for post-WIMP interfaces. In: Proceedings of the ACM SIGCHI Conference on Human factors in computing systems (CHI '08). New York: ACM, 201-210.

Kushner, David (2011). The making of Arduino: How five friends engineered a small circuit board that's taking the DIY world by storm. Available at: IEEE Spectrum. Oct. 2011; http://spectrum.ieee.org/geek-life/hands-on/the-making-of-arduino/0 [15.01.2013].

Kutzentsov, Stacey & Paulos, Eric (2010). Rise of the expert amateur: DIY projects, communities, and cultures. In: Proceedings of the 6th Nordic Conference on Human-Computer Interaction: Extending Boundaries (NordiCHI '10). New York: ACM, 295-304.

Merleau-Ponty, Maurice (1962). The Phenomenology of Perception. English translation of Phénoménologie de la perception (1945), London: Routledge.

Myers, Brad A. (1998). A brief history of human-computer interaction technology. interactions 5, 2 (March 1998), New York: ACM, 44-54.

Nowacka, Diana et al. (2013). Touchbugs: actuated tangibles on multi-touch tables. In: Proceedings of the ACM SIGCHI Conference on Human factors in computing systems (CHI 2013), New York: ACM, 759-762.

Ropohl, Günther (1997). Knowledge Types in Technology. In: de Vries, M.J. & Tamir, A. (Eds.), Shaping Concepts of Technology. From Philosophical Perspective to Mental Images, Dordrecht.

Rophol, Günther (1979). Eine Systemtheorie der Technik : zur Grundlegung der Allgemeinen Technologie. München/Wien: Hanser (Habilitation Thesis Universität Karlsruhe 1978, 2nd ed. 1999, 3rd ed. Karlsruhe 2009).

Schmidt, Albrecht; Döring, Tanja & Sylvester, Axel (2011). Changing How We Make and Deliver Smart Devices: When Can I Print Out My New Phone? In: IEEE Pervasive Computing10(4), 2011, 6-9.

Silver, Jay; Rosenbaum, Eric & Shaw, David (2012). Makey Makey: improvising tangible and nature-based user interfaces. In Proceedings of the Sixth International Conference on Tangible, Embedded and Embodied Interaction (TEI '12), New York: ACM, 367-370.

Tanenbaum, Joshua G. et al. (2013). Democratizing technology: pleasure, utility and expressiveness in DIY and maker practice. InProceedings of the SIGCHI Conference on Human Factors in Computing Systems (CHI '13). New York: ACM, 2603-2612.

Wang, Tricia & Kaye, Joseph (2011). Inventive leisure practices: understanding hacking communities as sites of sharing and innovation. In CHI '11 Extended Abstracts on Human Factors in Computing Systems (CHI EA '11). New York: ACM, 263-272.

Weiser, Mark (1991). The computer for the 21st century. In: Scientific American, September 1991, 94-104.

Wigdor, Daniel & Wixon, Dennis (2011). Brave NUI World: Designing Natural User Interfaces for Touch and Gesture. Morgan Kaufmann.

Williams, Amanda; Gibb, Alicia & Weekly, David (2012). Research with a hacker ethos: what DIY means for tangible interaction research. interactions 19, 2 (March 2012), New York: ACM, 14-19.

Winograd, Terry & Flores, Fernando (1986). Understanding Computers and Cognition. Norwood, N.J.: Ablex. 1986.

Can Someone Pause the Counting Please?
Encountering the New Gamified Reality of Our Times

DAPHNE DRAGONA

INTRODUCTION

The social media world is a world of numbers; it is formulated by counts of friends and followers, by scores of likes, views and shares. Numbers are there to show posts' acceptance and popularity and to prolong – if high enough – their presence in a constantly evolving info stream. Although users of social media do not directly compete with each other, yet they do pay attention to such numbers and they do know that they need to be active as well as considerate if they want their identity to stand out in the social media realm.

The info stream is today's ground of action. Shaped by users' status updates, it is a new form of user-generated collective narrative that is impossible to stop. Songs, images, links, videos and thoughts compete with each other for attention and the result depends on the network's algorithm. The number of contacts, the frequency of posts and the feedback score are decisive for what is present and what is not. Quantification takes over qualification as the measuring of our data equals having our online identities also measured. We, the users, seem to be addicted however to this new condition of online being, of having our friendships, interests and opinions measured. And this new mode of measuring everything goes beyond the social web. It expands to different everyday life activities from jogging to wandering in the city, and from cooking to going to the cinema. New technological platforms provide today the means, the motivations and the rewards for this.

An interesting form of gamespace seems therefore to be opening up where today's network users are invited to act – consciously or not – as players. Considering what their next "move" should be and checking the moves and scores

of others, they act in a space which looks and functions like a game but is not a game. It rather is the ultimate convergence of the real world with the online realm where real data are being used in a new peculiar game system. With the emergence of "gamification", as this new strategy is called, new forms of measurement are applied in our moves and interactions. But *why now? What are the reasons behind it? What changes does it really bring? And is there any way to disrupt it?*

DEFINING GAMIFICATION

Social media were competitive right from the start. One can recall the early years of YouTube when people could rate videos using stars, or the period that MySpace and Facebook had a top friends rank. Although friends and uploads were hitting much lower scores compared to today, the first signs of gamification were already there. The vivid and antagonistic character of these new participatory spaces was based on the rules and constraints set by the social networking sites on one hand and on the progressive integration of dynamics and mechanics coming from the field of games on the other. Social media appeared as complex but well functioning systems where data was exchanged while users were freely and playfully experimenting with their identity and sociability. But, while it might be known that games themselves can be seen as social networks and that playfulness can create the best possible conditions for sociability (Rao 2008, Timmermans 2010:209), gamification still goes way beyond what these two fields may have in common.

Gamification has been described as the application of a game layer on top of the world (Priebatsch 2010), as the use of game design elements in non game contexts (Deterding 2011) or as the penetration of our society with methods, metaphors, values and attributes of games (Fuchs 2012). Gamification is therefore not about games but about turning everyday life aspects into gamespaces and about encouraging the participants to act as players within this very environment. As a term it first appeared back in 1980 when Richard Bartle at the University of Essex used the word to describe "turning something that is not a game into a game" (Werbach, Hunter 2012:25). But it was not until recently, in 2010, when the term was reintroduced by a technology company, BunchBall. com, that wished to promote marketing as a game strategy (Ionifides 2011:8). The strategy of gamification since then invaded different areas of life, the goal always being to affect human behaviour towards specific goals. Using game

mechanics and dynamics such as points, levels, leaderboards and awards, affirmations and achievements, a broad spectrum of game-like experiences appeared with the aim to motivate and engage the targeted audience.

The idea behind gamification is not new. One could actually argue that in certain areas, like the military or education, elements of games were always apparent. With the development of digital technology however – especially in the fields of computer games, mobile telecommunications and the internet – a new condition emerged framed by Raessens as the "ludification" of culture (Raessens 2006:52). The term – which should be differentiated from gamification – refers to the broader range of technologies, references and metaphors deriving from the field of games which expanded to society, enriching it with game elements. Ludification preceded gamification, providing the context for gamified processes to appear. As Mathias Fuchs clarifies, a society is best prepared to be gamified when the lusory attitude, that is the game-like behaviour following Bernard Suits term, of the whole society is on a high level (2012). A gameful shift is therefore needed in the behaviour and the perception of the many for gamification to succeed.

The social web and especially the social networking sites very much responded to what both Raessens and Fuchs discuss. Not only were they based on technological structures embracing game like elements but they also allowed and encouraged users right from the start to have a lusory attitude when joining them and interacting with one another. And this to some extent could be seen as a micro-scale of the impact gamification could have to society. Game designer Jane McGonigal for instance sees a future in which games will build stronger social bonds and lead to more active social networks. "The more time we spend interacting within our social networks, the more likely we are to generate a subset of positive emotions," she argues and she strongly believes that at the end society itself can be restructured through gameful processes (2012).

But is gamification capable of revolutionizing our life as McGonigal argues, or does it rather promise a revolutionisation of the market and the business as Werbach and Hunter argue? At the other side of McGonigal's positivism lies the reality of profit for the market. Zicherman and Linder clearly describe gamification as the art and science of turning one's everyday interactions into games in order to serve business purposes (Zichermann & Linder 2010:20) while Ross Rader similarly argues that gamification marks a new game orientation which succeeds the traditional marketing orientation (Anderson & Rainie 2012). But can then gamification be considered a positive aspect for society?

To respond to this, the paper will look into the role of gamification in social networking sites in relation to a) the online self, b) the online sociability and c) the interaction within the urban environment. Within this concept, the ludified context, the gamified mechanics and dynamics and the potential playful use for the users will be discussed and differentiated.

THE GAMIFIED ONLINE SELF

The online self resembles an online avatar. The way users are building up their profiles choosing images and attributing features to them seems very close to processes of identity-building of the online gaming world. This freedom given to users to create a desirable image of themselves was especially highlighted in the first years of the social networking sites, around 2005. In the period of Friendster and the first social networking sites, the web appeared as a space open to diversity and multiplicity. Users could reinvent their identities and have control over them. Profiles could be fictional and playful, identities could be performed and managed; networks were the stage where users could play their part.

The notion of an online identity which is moderated, controlled and therefore performed connects to well known theoretical approaches from the fields of anthropology, sociology and philosophy. Rob Cover, who sees profile management as a form of identity performance, grounds his thought on Judith Butler's work discussing a self who is in a permanent process of becoming while boyd and Pearson turn to Erving Goffman's theory approaching identity as a performance which is constructed to fit one's milieu (Cover 2012:1-17, boyd 2006, Pearson 2009). What is highlighted in any case is the desire to control the impression of self-presentation given to a known or unknown audience. This according to Leary is a fundamental human dynamic, something which is also known from Hannah Arendt who considered the existence of a public sphere as a prerequisite for a person's performance (Leary 1996, Arendt 1999). These theories met in the case of the social networking sites; the social web provided users with new, disembodied, mediated and controllable spaces where not only could they perform their identities but they could also create their own staging and setting for their performances, based on their social and affective needs and skills.

Within this ludified context, game-like elements appeared. With the arrival of Facebook, LinkedIn and Google+, status updates, progress bars and different counters and metrics popped up on users' walls. The online self started more

and more to be fed by numbers; it became measurable. It started resembling a Sims character or a tamagotchi toy that needed to be taken care of in order to remain "alive". Otherwise, with no new data given, the online identity would be forgotten and be off the stage for the rest of the users. This is how, unavoidably, a shift occurred. The notion of the playful performative online identity gave way to a user generated gamified data body which connected more to reality. Networks became personalized reflecting the real features, desires, beliefs and associations of real persons. Fictional elements were eliminated especially in networks like Google+ which necessitated the submission of real names corresponding to profiles. And this link back to reality can be connected to other phenomena related to users' behaviour.

Clicktivism, the use of social media to support activist purposes, for example is close to gamification's mechanics and dynamics. Users tend to comment, to like and share posts about political, social and economical issues. News spread quickly but it is our online selves that take care of the action now. Users tend to leave their online profiles to "enjoy, laugh, believe in the right political causes and suffer…, thus relieving [one's] own real bodily self of all these sometimes unbearable duties and injunctions of being a decent human being" (Muhr & Pedersten 2010). As Jodi Dean notes, a new mindset has been reached where success is measured by numbers of friends and page hits rather than duration and depth of commitment (2009:17). Or, to follow Žižek's term, adopted by Robert Pfaller, it is rather a mode of interpassivity: the state where one postpones being affected and being active (1999). And this mode of reacting and being through clicking and liking can not really unify users as Dean notes; it cannot lead to collective action (2013:134). So rather than building active selves that can change the world, as McGonigal argues, we might also be faced with our lack of real action; tending to rely our online ourselves and fetishize them.

GAMIFIED SOCIABILITY

In social networking sites a user's friends is her/his audience. As boyd argues, it is the actual collection of friends that provides space for people to engage in identity performance (2006). Every post in a social networking site awaits feedback and friends are there to provide this. Their likes, their shares, their tags and comments allow identities to be performed and to be seen. The number of friends for this reason is indicative; it is important and this already had become clear from the period of Friendster. When users using networks were not as many as today, the ones aiming for high scores of friends could also create negative impressions. As their relationships were unavoidably to a great extent

superficial, they were called names by the others, even "Friendster whores" as Donath and boyd write (2004:80). Nowadays however, it is difficult to generalize as most users have reached high numbers of friends after a long period of time in the social network. These scores now rather indicate how open a user is to the continuous friend requests received. This, of course, does not mean that numbers don't matter. On the contrary, in today's highly populated networks one has to fight for her/his online presence through her/his activity. The bigger the network is, the bigger the challenge is to stand out and to be heard. The continuous flow of information demands constant participation. Identity performance now happens in front of a bigger audience and the stream of information goes amazingly fast. And in this context, metrics intensify questionings regarding users' sociality or rather sociability.

As Sherry Turkle writes based on interviews she conducted, the mediation of technology has affected users to a point that friends are now processed. Users have reached a point where one could argue that they are "alone together" (2011). When befriending, liking or tagging is possible, unliking, untagging and unfriending is also an option. As friends are continuously filtered, there is no longer a friends' network but rather an ephemeral crowd, a different and distinct type of community based on mechanisms of suppression and censorship applied by users themselves (Butera 2010:209). This community as boyd writes is formed in an egocentric way (boyd 2006), aiming to create a sense of uniqueness for every single user. No network is like another although different topologies may intersect and overlap (Dean 2013:134). The gamification of social relationships is therefore easy. It just takes advantage of the network topologies defined by connections of nodes – in this case friends – and it quantifies the interactions among them, creating hierarchies and values through them. Social relationships are not only filtered and processed therefore; they are also being capitalized. And this does not stop there. It is not only the interactions, the relationships; it is the "friends" themselves that have value.

In social networking sites, like in most networks, some nodes are more powerful than others. Some users are more influential, reaching a higher number of friends without putting in any effort. These people are what Andrejevic calls the "high quality" friends. They are not real friends, or friends of friends; they rather are unknown friends, people of a special interest that are worth being connected to. They are the ones users are befriending in order to upgrade their social status or to enhance chances of job opportunities. Just like it would be in a game environment, these characters can assist in leveling up in real life. In a period that more and more companies are checking the social media profiles of their potential employees, it is expected that the ones with expanded networks of "high quality" friends might be preferred as Adrejevic notes (2011:84).

Different metrics of friendship therefore form the metrics of power for a new social capital which is generated by the users, aggregated by the social networking sites and further exploited by third parties.

THE GAMIFIED CITY

The image of a city with a playful character, the notion of a ludic city is an old one. Going back to the 60s, one only needs to recall the writings of the Situationists and their vision of a city that would be created for homo ludens, the man who plays. Believing that play should invade the whole of life, they envisioned an urban space where ludic ambiances would prevail and inhabitants would wander following nothing but their own desires. Constant in particular talked of "a city of movement", the New Babylon, where citizens – liberated from work thanks to technology – would have dynamic relationships with their surroundings. Seeing the city as a network of units linked to each other and the inhabitants as the ones with the power to act upon the city, to transform it and recreate it, Constant talked of an architecture which was ludic and of individuals who were not workers but players (1974). With play, adventure and mobility being central in his thought, one can pause and question if this vision today can be associated to today's emerging gamified environment.

Location based social networking sites such as Foursquare or Gowalla promise moments of sharing, socialization and playing while moving around today's metropoleis. The use of game mechanics and dynamics in these networks is much stronger than in platforms like Facebook and Google+. Challenges, points and levels are introduced to enhance users' experience inviting them to join the networks with their mobile phones and to compete with their friends for achievements, awards and status recognition. For this reason metrics are important. In location based social networking sites everything is being measured; the platforms count how often a user goes out, how many different places she/he visits, how many different people she/he spends time with or how frequently someone visits her/his favorite spots. The reward system is built around such data and according to McGonigal such platforms offer a great opportunity to citizens to be rewarded while exploring their city and being social (2012). But on what cost one could also ask are these data being measured and therefore valued?

As Leighton Evans writes, the use of Foursquare creates a data trail of check-ins, tips and data entries that builds a giant resource for the application, and for other applications, providing specific information about the habits and

behaviours of the users (2013:191). Location based social networking sites are of course not just gathering data in order to reward users and make them happy. On the contrary, through game elements such as the check-ins, they can get valuable demographic data and access to targeted advertising.

Going back to the Situationists' vision of the city, one can't help but notice that this gamified development rather sounds like the ultimate ludic decadence and the saddest possible commodified scenario. Although Constant wisely predicted the exciting ludic behaviour technology would bring, little could he foresee the expropriation that would follow. And how could he expect such a realistic misrepresentation of his vision, where "Homo Ludens" who succeeded "Homo Faber" would at the end become the new playful worker fooled by the impression that game like gimmicks and interfaces could empower him over the city? A city of movement was at the end realized, but only based on the inhabitants' disposal, sociality and expropriation.

In the End It Is All About the Gamification of Data

Whether discussing the gamification of the online self, the online sociability or the mediated city interaction, one thing becomes clear. At the end it is users' data that is at stake. Data is the fuel for today's economy and the user is the main target (Next conference 2011). In social networking sites all our actions can systematically be turned back upon us as Andrejevic notes. "Every message we write, every video we post, every item we buy or view, our time – space paths and patterns of social interaction all become data points in algorithms for sorting, predicting and managing our behaviour" (2011:287). This way a new culture is being constructed in which "commercial surveillance becomes a crucial component of communicative infrastructure and the process is dual" (ibid). In some cases, as he specifies, the information is used directly by the companies to customize advertisements while in others it is bought and sold to third parties.

The strategy of gamification can greatly assist in this process. Gameful elements like the "like" button or the "check in" in social networking sites act as network switchers, facilitating access to information for the market. Useful information is being aggregated this way which can be used for formulating contexts of manipulation. Gamification therefore assists in what Richard Rogers calls "post-demographics" that is no more the traditional demographics of race,

ethnicity, age, income, and educational level but rather the new demographics of "taste, interests, favorites, groups, accepted invitations, installed apps", the demographics being shaped by online profiles (Rogers 2009:30).

In reality, gamification is in perfect accordance with the post-fordist condition in which we live in, with forms of production based on the knowledge, information, codes and affects that users/friends/citizens produce and exchange. Gamification invites us to produce more while we are being performative, interacting with our friends. It looks like there are no borders any more. We produce as we play. And we play as we – consciously or unconsciously – work. Thus, this new phenomenon is connected to what Julian Dibbell framed as ludocapitalism (2007), the new formation of capital based on play as well to what Julian Kuklich's named as "playbour" which refers to the unpaid work of gamers (2005). Gamification is the ultimate, and most depressing option of Wark's approach of the world as a gamespace (2007). The world might have always resembled a game, but never before did this resemblance manage to make such profit per se (Dragona 2011).

Realising gamification's connection to the market, game designers and researchers confronted the phenomenon with hesitation from the start. Described as "exploitationware" by Ian Bogost, or as "a tactic employed by repressive, authoritarian regimes" by Heather Chaplin, gamification was doubted for its aims, values and even the necessity of its existence (2011). Do users really need extrinsic awards, points and numbers to interact to present themselves, to be social and to wander around in the city? And if they don't, why doesn't gamification just fail?

How Gamification Really Functions

As Schell has argued, "society seems to be headed to the digital medieval city where value is created for the corporations while its citizens are playing games and kept happy" (Man 2011:10). Within this context, gamification is the mode, the way used to enable exploitation and control. And it happens most often unconsciously. Users might not always be realizing what and when something is being gamified. They might be in a state of unaware gaming as Fuchs puts it recalling Montola and Waern (Fuchs 2012). When freedom and passions are put to work, when motivation and affection are brought in, users' participation and contribution can easily and significantly increase (Man 2011). Networks then can rule through freedom simply by giving users a number of false impressions which are summarized below.

Firstly, users feel that they are in control. They believe that they can control their profile, their interaction with friends, their moves and check-ins in the city environment. They tend to forget that when participating in social networking sites they are actually playing on somebody else's territory, with all their interactions open to tracking and further use. They don't realize or they don't pay enough attention to the networks' mechanisms. And as Andrejevic has explained, exploitation today is not simply about a loss of monetary value; it also means losing control over one's productive and creative activity (Andrejevic 2013:154).

Secondly, a quantification of interactions does not equal the quality of interactions. The emphasis on the numbers of likes or comments can weaken the importance of the individuals behind them (Man 2011). One could even argue that gamification generates a new form of alienation, the alienation from one's own data. Paying attention to the metrics, the user sees numbers rather than friends. The only thing that matters is to get limitless opportunities for associations, exchanging and belonging; at the end the networks keep reminding users how many friends, photos or videos they have in common only to encourage them to look for more.

Thirdly, rewards can be relative. As Wark argues, gamification is mostly about "getting people to do things without paying them by offering them symbolic rewards in exchange" which usually are "a formal and abstract kind of token and ranking". Gamification for Wark is the latest and most sophisticated strategy of the "vectoral class", its aim being on one hand to manage networks and on extracting data on the other (Wark 2013:73-74).

Finally, gamification's metrics might deter collective will and power. Clicking and liking cannot really bring users together if needed. The lists and groups of social networking sites based on similar tests and interests cannot help anyone but the market; they cannot help in raising critical awareness on a collective basis. What the networks purposefully encourage instead is a feeding of a sense of uniqueness, of special individuality. Based on this, users feel they belong somewhere without knowing exactly where, as Dean explains. And as there are also no norms to imply or direct this belonging, users continuously "cycle through trends" trying to form their identities, with no need to really believe or turn towards some change (Dean 2013:137).

COUNTER-GAMIFICATION AND THE DISMEASURE OF ART

Can a gamified future be avoided? danah boyd (boyd in Andersson &Rainie 2013) replies that gamification will seep into many aspects of life without us even acknowledging it, becoming a central part of neoliberal ideology. On the other hand Susan Crawford argues that if "everything was a game, no one would have a reason to invent; [...] there have to be ways to explore, invent, create, and avoid – it can't be that we'll be adding up points for every salient element of our lives" (Crawford in Anderson & Rainie 2012). So how can such a process be impeded? Or, in other words, how can the measurement of contribution based on the affective and cognitive skills of the users be stopped and by whom?

If we follow Virno's thought, resistance can be found in art's dismeasure. "Art is about disproportion, about finding new standards of measure", the Italian political philosopher clarifies. And one can remember how the twentieth century "avant garde artists" from different movements and periods pictured resistance as a "revolt against the rule of the number", confronting commodification and capitalism (Virno 2012:21, Cafffentzis 2005:100). But Virno's writing is especially interesting because he connects this dismeasure to a moment of transition and change. Creativity for him lies in applying rules in different and unexpected ways, in these innovative moments that create "exceptional situations", as he calls them. "Mechanisms are subnormative and this means that we apply rules in a heterodox way, not that we can do without them". This positioning on art's disproportion brings playfulness back to the foreground. It reminds us of the role of play as the disruption of settled expectations (Sutton Smith, 1997:148), as the free movement within rigid structures (Salen & Zimmerman, 2004:306) that can become the force for transformation, and assist in pausing measurements and introducing new standards. Play can therefore be considered the source of a possible counter-power that can confront today's gameful side – deriving from art and creativity.

At the part that follows, different cases are being discussed as acts of creative and playful resistance which are based on dis-measurement, on stopping the processes gamification lies on, exposing them or confusing them in order to enhance users' understanding and empower awareness.

Hypertrophy
On Facebook, users, from the start, have been playing with tagging and linking, creating small acts of sabotage that were confusing the system and its numbers. Irrational, humorous and weird ideas and actions are being created such as irrational fun pages which succeed in breaking the productivity chain, impeding capital to be generated for the market. Sean Dockray, in his "Suicide

Facebook (Bomb) Manifesto" specifically writes that if we really want to fight the system we should drown it in data, we should "catch as many viruses as possible; click on as many 'Like' buttons as possible; join as many groups as possible; request as many friends as possible. Wherever there is the possibility for action, take it, and take it without any thought whatsoever. Become a machine for platforms and engines" (2011).

Exodus from the game-space
Another radical tactic that has been proposed, in a humorous way, is based on the reclaiming of a right to exit from social networks. As Spehr writes, when discussing networks, there must be a freedom to refuse to collaborate, an exit strategy. It should be possible for rules to be rejected, questioned and negotiated (Spehr 2003). The "Web 2.0 Suicide Machine" by the Moddr team and the "Sepukoo" of Les Liens Invisibles are examples of projects developed by artists in this direction. Developed in 2009, they enabled users to commit suicide, to delete their account permanently, something not allowed in most social networks. Using the mechanism of the game, they created a parody of social networking sites, presenting elements such as top lists of suicides and a network of happy users liberated from the constraints of the platform.

Obfuscation
Obfuscation is a counter logic that can protect one's data or provide false data, discussed by Brunton and Nissenbaum (2011). Some examples are the "Face-Cloak" that provides the initial steps towards an elegant and selective obfuscation-based solution to the problem of Facebook profiles (Luo et al., 2009), and "TrackMeNot", which was designed to foil the profiling of users through their searches. Interesting examples also come from the network of the *Unlike art* network, with projects investigating social media produced by Networked Media students at the Piet Zwart Institute of Rotterdam.

Over-identification
Over-identification is a form of resistance based on the appropriation of the sovereign ideology in order to criticize it. It is an aesthetic strategy that was initiated first back in the late '80s by the band Laibach and the art collective Neue Slowenische Kunst in Ljubljana (Pasquinelli 2010:3). In social networking sites, one could note that creators have often used similar tactics of appropriation to oppose the system in a playful and ironic way. A great example is the work of the artist Tobias Leingruber. As part of his "Facebook resistance" workshops he has designed several counter-tools and hacks, in collaboration with participants, that aim to impede the proper functioning of the system and

its rules. In 2012 he also proceeded in setting up a "Social ID bureau" producing Facebook identity cards, playing with the idea of the new online identity and data body offered by the medium itself.

Exposure
Other projects created by artists have appropriated the game mechanics social media use to expose their use and develop a critique. Such a case is the "Folded In" game by Personal Cinema & the Erasers. Based on YouTube video wars, "Folded In" highlighted the game elements used in the popular video platform and the way users are engaged by them. A more recent example is Ian Bogost's "Cow Clicker", an application developed for Facebook, inviting people to click on a Farmville-like cow every six hours, commenting on the phenomenon of clicktivism. Finally, another work worth mentioning is the "Facebook Demetricator" by Benjamin Grosser that purposefully succeeds in removing all counters from the Facebook page, addressing the question of their significance and value.

FINAL THOUGHTS – RECONSIDERING VALUES

Sebastian Deterding, one of the well-known scholars examining gamification today, claims that when discussing such phenomena we should ask what are the intentions, the effects, the values, virtues and aspirations behind them (2011). While this is important, when game mechanics and dynamics are being applied to non-game environments by companies, what values could one really hope to find?

Gamification, as it has been claimed in this paper, is the ultimate weapon of the market to aggregate and control users' data. It quantifies contributions, relationships, tastes and desires and it capitalizes them with our consent. Having the false impression that we are still in control of our online profiles, of our mediated social interactions and movements in the city environment, we tend to believe that gamification does not need to concern us. And we keep on contributing, counting and being productive, creating value for the social networking platforms.

For new values to emerge and for the counting process to really stop, counter-mechanisms and tactics are needed. Realising this need, the paper also presented initiatives and actions taken by users, programmers or artists who seek to render control impossible, to re-appropriate content and disrupt the strategy of gamification. Their work is significant as it exposes the functioning and

the purposes of a strategy that in reality has little to do with games, aiming to highlight the urge for critical awareness and understanding. They might be allusions, as Virno refers to contemporary forms of disobedience, to what real resistance could be (2004:70); yet they do capture the potentiality that exists. And at the end, we, the users, need to decide if we prefer to play in gamified networks or if we can turn towards new topologies and situations that might subvert the networked reality and set it free.

Acknowledgement

This research has been co-financed by the European Union (European Social Fund – ESF) and Greek national funds through the Operational Program "Education and Lifelong Learning" of the National Strategic Reference Framework (NSRF) - Research Funding Program: Heracleitus II. Investing in knowledge society through the European Social Fund.

References

Andrejevic, Mark (2011). Social Networking Exploitation in *A Networked Self: Identity, Community, and Culture on Social Network Sites*, ed. Zizi Papacharissi, New York: Routledge, 82-101.

Andrejevic, Mark (2011) Surveillance and Alienation in the Online Economy. *Surveillance & Society* 8(3), 278-287.

Anderson, Janna and Rainie, Lee (2012). *The future of gamification* http://www.pewinternet.org/Reports/2012/Future-of-Gamification.aspx.

Arendt, Hannah (1999). *The Human Condition*. Chicago: University of Chicago Press.

boyd, danah 2006. "Friends, friendsters, and top 8: Writing community into being on social network sites," *First Monday*, volume 11, number 12 (December), at http://www.uic.edu/htbin/cgiwrap/bin/ojs/index.php/fm/article/view/1418/1336, accessed 11 April 2008.

Bogost, Ian (2011). "Gamification is bullshit," *Ian Bogost, Videogame Theory, Criticism, Design* http://www.bogost.com/blog/gamification_is_bullshit.shtml [2.09.11].

Butera, Michael (2010). Gatekeeper, Moderator, Synthesizer in *Facebook and Philosophy* ed E Wittkower. Chicago: Open Court Publishing, 201-212.

Brunton, Finn and Nissenbaum, Helen (2011). "Vernacular resistance to data collection and analysis: a political theory of obfuscation" in *First Monday* Vol 16. N.5. http://firstmonday.org/htbin/cgiwrap/bin/ojs/index.php/fm/article/view/3493/2955 (accessed 10.5.12).

Caffentzis, George (2005). "Immeasurable value? An essay on Marx's legacy." *The Commoner* 10.21, 87-114.

Chaplin, Heather (2011). "I Don't Want To Be a Superhero," in *Slate* http://www.slate.com/articles/technology/gaming/2011/03/i_dont_want_to_be_a_superhero.html [2.09.11].

Constant (1974). New Babylon in *Not bored* http://www.notbored.org/new-babylon.html (accessed 2.8.2011).

Cover, Rob. (2012) "Performing and undoing identity online: Social networking, identity theories and the incompatibility of online profiles and friendship regimes" in *Convergence: The International Journal of* Research into New Media Technologies, Vol 18. No 2. 1-17.

Data Love Next conference http://nextconf.eu/next11/about/summary/.

Dean, Jodi (2009). *Democracy and other neoliberal fantasies: Communicative Capitalism and Left Politics*, Durham & London: Duke University Press, 17.

Dean, Jodi (2013). Whatever Blogging in in Digital Labor, The Internet as a Playground and a Factory. Ed. Scholz. New York: Routledge 127-146.

Dockray, Sean (2010). "Facebook Suicide (Bomb) Manifesto" in http://spd.e-rat.org/writing/facebook-suicide-bomb-manifesto.html, (accessed 10.8.2011).

Deterding, Sebastian (2011). "What your designs say about you" TedX presentation http://www.ted.com/talks/sebastian_deterding_what_your_designs_say_about_you.html (accessed 10.2.2013).

Deterding, Sebastian, et al. (2011). "From game design elements to gamefulness: defining gamification." *Proceedings of the 15th International Academic MindTrek Conference: Envisioning Future Media Environments.*

Dibbell, Julian (2007). "Notes toward a Theory of Ludocapitalism (O rly?)" on iDC list: https://lists.thing.net/pipermail/idc/2007-September/002833.html [accessed 10.5. 2012).

Donath, Judith, & boyd, danah. (2004), "Public displays of connection" in BT Technology Journal, 22(4). 71-82.

Dragona, Daphne (2011). "Re-conquering the gamified city. An old battle on a new urban ground" in ISEA 2011, http://isea2011.sabanciuniv.edu/paper/re-conquering-gamified-city-old-battle-new-urban-ground (accessed 10.2.2013).

Fuchs, Mathias (2012). "Ludic interfaces. Driver and product of gamification." In *G/ A/ M/ E Games as Art, Media, Entertainment* 1.1 (accessed 10.5.12).

Ionifides, Christos (2011). *Gamification: The Application of Game Design in Everyday Life.* MA thesis published as Ebook, Copenhagen, 8.

Kücklich, Julian (2005). "Precarious Playbour: Modders and the Digital Games Industry" in *Fibreculture* 5. http://five.fibreculturejournal.org/fcj-025-precarious-playbour-modders-and-the-digital-games-industry/.

Leary, M. R. (1996). *Self-presentation: Impression management and interpersonal behavior.* Boulder, CO:Westview Press.

Leighton, Evans (2013) How to build a map for nothing: Immaterial Labour and Location Based Social Networking in Unlike Us Reader: Social Media Monopolies and their Alternatives ed Geert Lovink and Miriam Rasch, Amsterdam Institute of Network Cultures, 189-199.

Luo Wanying, Xie Qi and Hengartner Urs (2009). FaceCloak: An Architecture for User Privacy on Social Networking Sites in www.cs.uwaterloo.ca/~uhengart/publications/passato09.pdf (accessed 10.5.2012).

Man, Philip (2011). *Playing the Real Life. The ludification of social ties in social media.* University of Amsterdam, New media theories, http://www.scribd.com/doc/53189712/Man-Playing-the-Real-Life (accessed 10.5.12).

McGonigal, Jane (2012). *Reality is Broken, Why games make us better and how they can change the world,* Vintage Digital (kindle edition).

Muhr, Sara Louise and Pedersten, Michael (2010). "Faking it on Facebook" in *Facebook and Philosophy* ed E Wittkower Chicago: Open Court Publishing, 265-275.

Pasquinelli, M. (2010). *Communism of Capital and Cannibalism of the Common: Notes on the Art of Over-Identification.* Abandon Normal Devices Festival, Manchester.

Pearson, Erika (2009). "All the world wide web is a stage: The performance of identity in online social networks" in *First Monday.* 14 (3) http://www.firstmonday.org/htbin/cgiwrap/bin/ojs/index.php/fm/article/view/2162/2127 [10.4.2012].

Priebatsch, Seth (2010). "The game layer on top of the world", TedX Boston talk http://www.ted.com/talks/seth_priebatsch_the_game_layer_on_top_of_the_world.html.

Raessens, Joost (2006). "Playful Identities, or the Ludification of Culture". In: *Games and Culture,* Volume 1 Number 1, January 2006, Sage Publications, 52-57.

Rao, Valentina (2008). "Playful culture and the glamorization of everyday (virtual) life: elements of play in facebook applications" in *Forum–University of Edinburgh postgradual journal of culture and the arts.* Special Issue 2. (accessed 10.5.12) http://www.forumjournal.org/site/issue/special/play/valentina-rao.

Rogers, Richard (2009) "Post-demographic Machines" in *Walled Gardens* ed.

Annet Dekker & Annette Wolfsberger, Eidhoven: Lecturis. 29-39.

Salen, K & Zimmerman (2004). *Rules of Play. Games Design Fundamentals.* Cambridge, Massachusetts: The MIT press.

Sutton Smith, B. (1997). *The ambiguity of play.* Cambridge, Massachusetts: Harvard University Press.

Spehr, Cristoph (2003). *Gleicher als andere,* Eine Grunlegung der freien Kooperation, Berlin: Dietz Verlag.

Timmermans, Jeroen Hugo (2010) *Playing with Paradoxes, Identity in the web era*, PhD thesis, Erasmus Universiteit Rotterdam.

Turkle, Sherry (2011). *Alone Together, Why we expect more from technology and less from each other*, New York: Basic Books.

Virno, Paolo (2012). "The dismeasure of art. An interview with Paolo Virno" (Sonja Lavaert and Pascal Gielen) in *Being an Artist in Post-Fordist times* ed. P.Gielen and P. De Bruyne 19-46.

Virno, Paolo (2004). *The Grammar of the Multitude*, Trans. Isabella Bertoletti,

James Cascaito, Andrea Casson Los Angeles/ New York : Semiotext(e).

Wark, McKenzie (2007) Gamer Theory, Harvard University Press.

Wark, McKenzie (2013) "Considerations on a Hacker Manifesto" in *Digital Labor, The Internet as a Playground and a Factory*. Ed. Scholz. New York: Routledge 69-75.

Webach, Kevin and Hunter, Dan (2012). *For the Win: How Game Thinking Can Revolutionize Your Business*. Philadelphia: Wharton Digital Press.

Zichermann, G., & Linder, J. (2010). *Game-based Marketing: Inspire Customer LoyaltyThrough Rewards,Challenges,and Contests*. Hoboken, New Jersey: John Wiley & Sons, Inc.

Žižek, Slavoj (1999). The Interpassive Subject, in www.lacan.com/zizek-pompidou.htm.

List of Works

- Cow Clicker http://apps.facebook.com/cowclicker/
- Facebook Demetricator, http://bengrosser.com/projects/facebook-demetricator/
- FB resistance workshops, http://fbresistance.com/
- Folded In, http://www.foldedin.net/
- Sepukoo, http://www.seppukoo.com/
- Social ID bureau, http://socialidbureau.com/
- Unlike Art, http://networkcultures.org/unlikeart/
- Web 2.0 Suicide Machine, http://suicidemachine.org

It's a Cyborg's World? Synthetic Bodies as "Social Engineering"

JUDITH SCHOSSBÖCK

A Cyborg Per Definition

What is a cyborg and how can she or he occur? Quite often we think of machine-like creatures, computers and steel. However, there might be other, earlier versions of cyborgs, depending on the definition. Quite often the term cyborg is applied to an organism that has enhanced abilities due to technology – which could also be applied to other materials than steel or computers. An example of such a figure is Pinoccio by Carlo Collodi (2001 [1883]). The waking-up process of the wooden cyborg or the puppet coming alive is illustrated in the reaction of his creator Gepetto: "Wooden eyes, why do you stare at me like this?" he asks. The uncanniness of the puppet coming alive is sometimes addressed in new interpretations of the story. Quite significantly, there is a blog where a user named "princess of shit" is working on an illustration of Pinoccio as cyborg (N.N.: Projekt Pinocchio 2013). In this new version of the web 2.0, Gepetto is working in a cyborg company named "Blue Fairy Technology". Other versions of the cyborg can resemble animals, like the Roboroach or Cockroaches in the Fifth Element, suffering a rather sad fate.

The term cyborg is used both in art and research and is an acronym of "cybernetic organism", describing an organism that is artificially amended or extended. Popular in science fiction, the origins of the term can be found in natural science (Hubatschke 2012:9). In 1960, psychologist Nathan S. Kline and Neurobiologist Manfred E. Clynes held a presentation at the symposium of astronautics named "Drugs, Space and Cybernetics", which was published in the magazine "Astronautics" under the title "Cyborgs and Space" (Clynes/Kline 1995:29). Many claim the cyborg was mentioned for the first time in this publication and Clynes and Kline thus coined the cyborg metaphor. Researchers argued

that space travel required the development of self-regulating human-machine systems and named them cyborgs, from cybernetic technology and organism. However, the term is not restricted to astronautics, and robot beings that blur the distinction between humans and machines inhabit a myriad of well-known science fiction novels and films such as *Star Trek* (1979), *Robocop* (1987), *Blade Runner* (1982), and *Terminator* (1984). Above all, cyborg derives its intellectual influence from Donna Haraway's "Cyborg Manifesto" (1985), which related it to theories of post-modern feminism. (Encyclopedia of Science, Technology and Ethics 2001 – 2006).

In this contribution I seek to provide an introduction to the fascination, potential and stereotypes of the cyborg with view to gender studies and postmodern theories. I will focus on synthetic or hybrid bodies and look at extensions of the human body by artificial constructs and information and communication tools. Regarding the question how to classify these extensions, they can be seen as surrogate or compensatory, addition or completion. In prosthetic theory, for instance, the prosthetic device is mostly seen as addition or replacement, as the ancient greek word prosthesis stands for an additional language, addition or attachment (Liddell and Scott 2013). Depending on how we see those is also our sense of self, our perception of what is human, and legal and ethical questions. Another differentiation is whether one can send or receive information with the artificial body parts. In medicine, there are two types of cyborgs: the restorative and the enhanced. In techno-scientific capitalism and postmodern conditions, (Lyotard 1984, 1988), the enhanced cyborg follows a principle: that of optimal performance and maximizing output. I will conclude with the presentation of ethical questions related to the increase of synthetic parts in our bodies and the questions of hierarchy and class in society.

Natural artificiality as a theory of completion as opposed to addition or subtraction was formulated by anthropologist Helmuth Plessner in *Stages of organics and humankind* (1981). In his theory, men are forced to execute self-completion of non-natural kind "by nature". As eccentric creatures, they need to complete themselves, and they do it with things they create. It is only through artificiality that mankind can free themselves from this nature. The next logical step is that we try to improve ourselves with the help of more or less external applications. With view to the related ethical questions about what is human, we have not reached any other point yet than defining those questions, e.g. in the area of neuroprosthesis, where companies are researching how to connect devices with the human brain or to extend it by mobile tools. As a general trend and often related to personalization tendencies in technology, the interfaces between body and machines tend to collapse, and mini-machines as implants (e.g. the VeriChip 2013 by Applied Digital Solutions) or human-implantable microchips

were already marketed in 2004. However manufacture was often discontinued due to privacy controversy and concerns regarding the potential abuse as a compulsory identification program by governments and lack of security features (e.g. regarding the risk of identity theft).

THE LURE OF INCOMPLETE BODIES

The fascination of hybrid and incomplete bodies can partly be explained by their anti-normative potential. Assuming that there lies a somewhat queer and emancipatory potential in the figure this can be expressed ironically, sometimes irritating, but also set a trend and point the way ahead. Both potentials and problems of the cyborg can be discussed with view to questions of hierarchy within society (gender and sexuality being one of them). On such subject is the representation of cyborg bodies in science fiction or future narratives.

Right now, it is not yet considered to be cool or ethical to give up control over synthetic figures by humans – not yet. The uncanniness of a machine independent from humans is also thematised in Franz Kafka's "In the Penal Colony": "Up to this point I had to do some work by hand, but from now on the apparatus should work entirely on its own." (Kafka 1996: 132). But still, we are fascinated by the giving-up of control and the take-over of a self-aware intelligent system. For example, Skynet in Terminator is a fictional, artificial intelligence system featuring centrally in the Terminator franchise. As the franchise's antagonist, it's operations are almost exclusively performed by war-machines, cyborgs (in the appearance of a Terminator) and computer systems with the goal of exterminating the human race. Possibly in anticipation of such fears, in the 80's some declarations appeared, declaring that there should be a clear difference between humankind and machines: For example, the "IBM Pollyanna principle" is an axiom that states "machines should work; people should think." (IBM Pollyanna Principle 2013). It can be interpreted as a statement of extreme optimism (machines can free people to think) or cynicism (machines fail to work and people fail to think).

However and luckily enough, the actual discussion has concentrated on the potential of more hybrid forms of existence and work forces, although it is often emphasized that distance to the machine is important for keeping up criticism. The visions and potentials to which synthetic bodies are related can be summarized as follows:

- Anti-normative/emancipatory potentials (gender-critical, post-structuralist view)

- Prosthesis as emancipatory device (cognitive science)
- Integration of artificial intelligence in our lifeworld (Cyberpunk genre)
- New philosophic and psycho-pathologic spaces (e.g. thought-reading)
- Simulation of the human and ability to reason (e.g. Turing, chess computer "Deep Blue", Jeopardy experiment 2011).
- Consciousness of digital human creations
- Transhumanism and posthumanism

The latter terms also refer to cultural movements that affirm the desirability of fundamentally transforming the human condition by developing technologies to enhance the human condition regarding aging and intellectual, physical and psychological capacities.

Whereas robots are clearly visible as artificial products, androids resemble human beings. In contrast, the cyborg is either extended or completed by a form of prosthesis or completely hybrid. The sympathy we have towards such a figure is, amongst other parameters, related to their level of human appearance. If a humanoid robot is clearly sensible and displaying human qualities, we experience it positively. The more human the body gets, the more sympathy decreases, as the observer starts to evaluate what she or he sees along human standards. However, if these deficits are very limited (like in a perfect human copy), sympathy will increase again. This process is called "Uncanny Valley" and might explain why some researchers have been pulling back from their research subjects, like in the case of Joseph Weizenbaum and his Eliza computer. It might also explain the sympathy we have towards androids and cyborgs who sometimes appear like an indistinguishable human copy. In particular regarding female representations of synthetic bodies, perfection, beauty ideals and erotic presentation still play a central role in the production process.

Lust as Programming

It is no coincidence that the first female android was produced by the sex industry ("Sex Objects Limited") and the term gynoid first used to describe a robot slave in futuristic china who was measured by its beauty (Gwyneth Jones 1985: *Divine Endurance*, zit. nach Tatsumi 2006: 213). In the figure of the gynoid we often find the principle of "lust as programming". Particularly robots and gynoids are often conceptionalised by this principle and the vision of the perfect women. Despite their closeness to the uncanny, the gynoids of today do not offer so many identification opportunities, partly due to the high tendency of displaying stereotypes. The models are currently used for simple works and

mostly in line with gender-specific beauty ideals, enhancing qualities and characteristics with a female connotation. In gynoids, we often find an "othering" of women in two scenarios: Either a focus on the needs women fulfil (objectification) or a focus on limited roles (fetishization). As a tendency, the technological bodies of gynoids depict sexism in a synthetic or unnatural context. The list of female robots and cyborgs available at *Wikipedia* proves such assumptions. (List of fictional female robots and cyborgs, Wikipedia 2013)

A rather well-known figure in this context is the "perfect secretary", a gynoid called "actroid 2003" by Sanrio. An extensive viewing of gynoid construction videos (available on youtube) is interesting, in particular regarding the perception of the technological bodies by a broader audience as found in the comment section of the videos. For example, the "Eve 1138 Android" features a bald head, but an otherwise very female appearance with breasts and a slogan focusing on beauty: "Eve is human, beautiful". Human appearance and beauty seems to go hand in hand here, despite the otherwise very clear construction. In the comments, a good proportion of users focuses on the attractiveness and gender-related features or characteristics of the gynoid, imagining sexual activities with her, e.g.: *"Does she come with a prefitted flesh light?; Does she have a hole? ;); She is so hot! Can it give blowjobs?; When do I get to fuck one?; Clean the house, take care of all my needs just the way I like it, won't bitch at me, & if you pro-rate out the overall cost it would be a lot cheaper. Well I can dream can't I, But (sic!) maybe in another 50 years my kids can buy one." (Eve 1138 Android 2013)*. Many comments can be related to a demonization of female sexuality or the female, like *"so this is how the robots take over. they give us handjobs then kill us"* or *"Yeah, She's Beautiful ... probably Strong Enough (sic!) to toss you out of a window too!".* Some users clearly expressed their dislike for the gender-neutral design of the head as the gynoid has no hair: *"yuck, bald headed women do not rock!".*

Some researchers have pointed out that seduction has always been an "indispensable accompaniment of the trade in automata" (Schaffer, 1996, p. 56). Repiee Q1 (Hiroshu Ishiguru) is a gynoid entering the market in 2005. A reporter encountering it at the World Expo in Japan described her in the following way: "She gestured, blinked, spoke, and even appeared to breathe... the android is partially covered in skin like silicone. Q1 is powered by a nearby air compressor, and has 31 points of articulation in its upper body. Internal sensors allow the android to react "naturally.' It can block an attempted slap, for example. But it's the little, "unconscious" movements that give the robot its eerie verisimilitude: the slight flutter of the eyelids, the subtle rising and falling of the chest, the constant, nearly imperceptible shifting so familiar to humans (Chamberlain, 2005).

Discussion continues to focus on the erotic potential of female androids or cyborgs. Also scholars seem to push the erotic potential of the female machine to the conclusion of robotic lovers and imagine a future sex scene populated with android sex machines (Levy 2007, Yoeman 2012). In these visions, different ethnicities, body shapes and ages, but also sexual features displayed by android prostitutes will be both aesthetically pleasing and able to provide guaranteed performance and stimulation (Intimate Machines 2013).

The fetishization of synthetic bodies, in particular related to incomplete figures, can also be observed in popular media culture. Ideals of beauty are represented, but also transformed along a prosthetic cult as, for example, visible in the work of Marilyn Manson or Lady Gaga. Here, the prosthetic cult often stands for a criticism of beauty ideals, and quite often, musicians taking on the subject are perceived as more gender-neutral than others. Another example of fetishised female bodies with prosthetic devices is the work of the Austrian artist and photographer Gerhard Aba. In his exhibitions, models quite often were wearing extraordinary high heels, making the difference between the prosthetic device and the natural leg more visible.

Cyborgs as Hypervalues

In the field of cultural studies and philosophy, a range of cyborg manifestos and statements have emphasized how binary oppositions as organism/machine or natural/artificial provide a reading raster that can be deconstructed by potent figures as the cyborgs or excessive bodies. From Donna Haraway's rather well-known "Cyborg Manifesto" (1985), "Bionic Ethic" (Channel 1991), Cyborg Politics and Hybrids (Latour 1993), Excessive Bodies and Citizenship as a Hypervalue (Gray, 1997) over theories from Kristeva and Deleuze (e.g. theories regarding the post-human body, the abject or monstrous bodies) to Foucault (in particular his biopower concept, Foucault 1998), the art manifesto "Bitch Mutant Manifesto" (VNS Matrix 1996), Stelarc's "Cyborg Manifesto" or the "2Magna Carta for the Knowledge Age", the consequences of technology and influence on the normative system by rejection of established western dualisms or dichotomies have been addressed. Many of these manifestos can be found and have been discussed online, some also in established scientific communities.

In her well cited article "A Cyborg Manifesto", Haraway attempts to create what she calls an ironic political myth. By combining postmodernism with social feminism, the cyborg as a hybrid of machine and organism is central to this

myth and a creature of both social reality and fiction. As an alternative reality and play of identity, the cyborg in Haraway's manifesto is seen as a resource mapping social and bodily realities and stands for shifting political and physical boundaries, in particular regarding what is perceived to be "natural". Haraway's manifesto suggests that we can learn from our fusion with both animals and machines how not to be man. The cyborg as symbolic creature of a post-gender world did not become practice. Quite the contrary, the cyborg became a synonym of repression and a myth of emancipation (Hubatschke 2012: 28).

Other theories coined in the 90's focus on the (less visible) distinction between things/the mechanical and humans/the natural. David Channels "Bionic Ethic" (1991), addresses the system's integrity, stability and diversity. A bionic ethic must take into consideration both the mechanical and organic aspects of cybernetic ecology to maintain this stability. Contrary to an either/or perspective, neither the mechanical nor the organic can be allowed to bring about the extinction of the other. In his theory, the current situation is seen as coming together of the old Western discourses and the machinic Clockwork Universe in a new "vital machine" as proposed in "bionic" ethics.

Bruno Latour's theory "Cyborg Politics" (Latour 1993) concentrates on the consequences of things and technology of artifacts. This theory is related to our perception of nature: One one hand, there is no longer a separate assembly of things and of humans. On the other hand, we find these hybrids and networks everywhere we go. We need to make their construction processes visible. In line with Channels, Latour is rejecting traditionally western dualisms with an approach closer to non-western cultures, but has also been criticized for an elite construction. Like Haraway, Latour wants to make an unintended blurring of identities and boundaries visible. According to Latour, modern technology has caused a "proliferation of hybrids", and queering nature counts, like for Haraway, as a possible escape of the logics of dominance and essentialism. If an individual acknowledges that the boundaries of our identities are constructed, they can re-construct them in a different way.

In "Excessive Bodies and Citizenship", Chris Hables Gray (1997), building on the theory of the hybrid of Latour, presents his vision of a cyborg society we already live in. Distinctions between natural/artificial or organic/machinic are subsumed by the ubiquity of systems that embrace both. According to Gray, Cyborg relations between humans and their constructions are also political. Building on existing cyborg theories and manifestos, Gray is proposing a "Cyborg Bill of Rights" and a new mechanism for determining citizenship based on the Turing test. As a type of cyborg writing technology, he defines constitutions as cyborg technologies and a combination of writing technology, legal codes, and human interpretation that might provide a satisfactory safeguard in

a time of new technologies and political change. The "Cyborg Bill of Rights" should protect our freedoms in the 21st century, and technologies are expected to complicate the definition of citizenship incredibly.

What Gray describes as hyper-bodies are extended and augmentic bodies. Humans in particular are being cyborged through the growing power of technoscience in the realms of medicine, war, entertainment and work that range from prosthetics through genetic engineering to the integration of humans into larger technical systems. Cyborg bodies being hyperbodies, excessive and more than normal, "they need hypervalues, new working values, instantiated in technologies such as constitutions and operational tests of citizenship". In this context, hypervalues may also mean hyper-protection for the individual within techno systems. In contrast to Latour, not everything out there can be an actor or actant, as systems can not exercise politics in a subjective way. However, accepting ourselves as cyborg can be liberating and empowering in the sense that we can choose how to construct ourselves. But in order to stay autonomous citizenship must be made a hypervalue, and any living intelligence as opposed to a quasi-object should be empowered.

There are ethical issues that have arisen in the field. One example is the possibility of extending life past its natural term via mechanical implants. Gray gives the example of his grandmother, who had a stroke, but whose mechanical pacemaker allowed her to survive. With reference to Channel's theory, he states: "Ironically enough, in a small case of Channel's bionic ethics, it was illegal to turn off the pacemaker. If the stimulation was coming from outside my grandmother's body then her will, which was to not prolong death through mechanical means, would have gone into effect and her body would have been allowed to die as her brain had already. But since she was cyborged intimately, then, no. She lingered. Her body was made to linger almost to the point of financial disaster for my family and then, finally, the pacemaker was overruled by the rest of her dying body and the heart failed as well." (Gray 1997). Whilst in Channels theory this was right and proper as the organic should not bring extinction to the mechanical, Gray argues that in this case, the mechanical serves the organic. What is important is where conscious and intelligence are, as opposed to a balance between the organic and inorganic. And if consciousness and intelligence are located in the mechanical part of a system, with the organic merely becoming an aid for that system, that is well and good as technologies can be seen as forms of life. According to Gray, this is part of the whole system that should be treasured (Gray 1997).

Often, cyborgs are seen as the cause and/or resolution to the worst case scenarios for the future in relation to human behavior. And whilst the performance of intelligent robots is impressive, many artificial intelligence researchers see them more as witnesses to the natural intelligence of their designers,

and anthropomorphisation of machines are seen as dangerous. However, one should bear in mind that even with our current engineering capabilities (like artificial joints, drug implant systems, implanted corneal lenses, artificial skin etc.), most of these technologies are limited and still seen as improvement, as opposed to a fully organic individual. Moreover, we still struggle with the creation of a bug-free piece of software for larger projects. In contrast, some researchers emphasise that the body is not a very durable structure and its survival parameters are slim. For instance, one of Stelarc's projects investigates the possibilities of a prosthetic head. A virtual head showed that without a consciousness behind the face, there could still be all the functions, and it is even misleading "to talk of thinking as of a 'mental activity'" (Stelarc 2005). Only if the body becomes aware of this position, we will be able to map post-evolutionary strategies. However, we yet have to connect these assertions to real-world scenarios such as reproduction in order to put post-human theories into practice.

REPRESENTATIONS OF THE POST-MODERN CYBORG

The political implications of cyborg theory (in particular regarding the overcoming of stereotypes and the development of alternative identity constructs or identification opportunities) are implicit. Mass media play a crucial role in presenting such identities and examples of modern cyborgs. In particular the film genre offers very visual representations of female or more gender-neutral fictional cyborgs that more or less reflect existing stereotypes.

One of the rather well-known cyborgs whose bodies are seen as a case of active power and agency are those of the Terminator series. However, the female body of Linda Hamilton aka Sarah Connor (Terminator 2, USA 1991) is still a smaller version of the terminator, subordinated under the body of Arnold Schwarzenegger. Another cyborg with a female appearance is the T-X, also known as the Terminatrix, who appears in the 2003 film Terminator 3. We find a cyborg assassin with a human female appearance and the ability to assume the appearance of other characters (therefore, it was portrayed by several cast members throughout the film). Unlike previous Terminator models, her design is more creative and powerful, but also sexually attractive. This is shown in the choice of her outfit: while Arnold is still in his black leather biker look from the previous films, the T-X wears a low-cut red leather outfit including high heels, accentuating her female qualities. While being very powerful, the term terminatrix is also reminiscent of a dominatrix-like demeanor. Another example for a similar powerful, but clearly female presentation of cybernetic

figures are the cylons from "Battlestar Galactica". The series has been called a "safe haven for chauvinist pigs". On the other hand, the representations of men in it have recently been linked to its more feminist side as well. The birth scenes in Battlestar Galactica are hypersexulised with "orgasmus-sounding gasping" (Newitz 2009), and when cylons die, their memories dowonload into a body on a resurrection ship. While this process happens off-screen for the male cylons, the female ones die by flying through a tube. After that she wakes up nude in a vat of goo.

Interesting with view to gender representation is the Nemesis series of Albert Pyun in the 90's. The protagonist Alex, played by the body builder Sue Price in "Nemesis 2 – Nebula" (part two of the series, USA 1995) is ambiguous and not presented as clearly distinct female body or gender. We find a genetically manipulated human being totally different to, e.g. Terminatrix. A series of shots is showing belly, legs and breasts, all athletically defined, with dominant muscles and anabolically modified (Ritzer 2013). In part four of the series ("Nemesis 4 – Cry of Angels", 1995) another Alex appears, presented by Sue Price. Not genetically manipulated as in part two or three, but as a hybrid body consisting of organic and mechanical elements, the mechanical parts of Alex are working against the limits of the body – an abject potential as described by Kristeva (1984). In an extensive sex scene between Alex and a male cyborg the penis is inserted into the muscly abdominal wall, before he is killed by Alex, who is also killing another cyborg with metal stabbing weapons coming out of her nipples. This phallic presentation of female characters is not limited to a monstrous presentation, but also counteracted by her rather female appearance in other scenes, like a Marylin Monroe dress outfit. The trained and muscular body of Alex thus transcends the passive feminine status of a rather male view. This figure is oscillating between traditional gender binaries and identity in transition.

POST-CYBORG: THE ETHICAL DILEMMA

Theories of the cyborg and the post-cyborg (Mann 2003, who sees the cyborg as constitutional norm of well-feeling, leading to a "sickness of reality for humans", the "feeling of being unplugged", and the political act of "de-cyborging") need to focus on the figure's potential and promises, but also on potential dilemmas, limits and new hierarchies, partly produced by a different understanding of human activities or beings. Often there is a significant gap between theorization and what we are capable of living or consider as practical or desirable. Looking at theories and manifestations of post-sex, for example,

stereotypes are still dominant in cyber-sexuality (compare investigations of digital pornography and the related lack of utopia). While some subcultures focus on the practical potential of a "less natural" and normative sexuality (think of the lesbian context, where the idea of using a prosthesis is widely acknowledged), research on sexual prosthetic devices still shows a very hetero-normative approach where the act of "natural" penetration and sexual characteristics are crucial. Prosthetic devices substituting sexual organs are seen as necessary, the re-evaluation of sexual norms stays on the very surface. A study of 2010 (Hoebeke 2010) claimed that there is still no good replacement for the corpus cavernosum. As the biggest study evaluating the implementation of a hydraulic erection device in 129 female-to-male transsexuals, researchers concluded that there is no perfect solution yet. These findings are in contrast to theories of prosthetics emphasizing the deconstruction of the constructed character of body norms (Harasser 2008). However, they have to be seen in the context of existing normative, which influence researchers opinions on the subject.

Other critical interpretations of the predominant enthusiastic tone cyborg criticize a "metaphorical opportunism". Smith and Morra (2005) postulate that our modern, Western cultures display a prosthetic impulse, and although theorists have found the prosthesis to be a useful metaphor for thinking about the human conditions, we have witnessed an increased use of the metaphor as a critical frame in the past decade. The rapid proliferation of prosthetics as a dream is often ignoring uneasy issues associated with (dis)ability or marginalisation. In the area of cognitive science and disability studies, researchers have emphasised that routine work is sometimes done better if a prosthesis is not noticed, but explicitly perceived as such (Sobchak 2005). Many people wearing prosthetic devices describe an extension of their body perception, but also speak against an optimistic or illusionary explanation of a highly individualistic phenomenon. However, in moving with the device, not incomplete body is experienced, as described by Sobchack: „I do not stand in front of you with the mind-set that I am not a two-legged dancer. [...] What you are seeing is the wholeness of this organism (Sobchack 2005: 56). However, whether a person feels empowered by prosthetic means will be different for each individual and many feel that the metaphor of prosthesis should not be used speculatively, despite its potential for describing the conditions of our society.

Other ethical problems of more hybrid human-machine relations in the future are related to data security, loss of control over interfaces and manipulation, medical risks, the mechanization of relationships and a change of identity. Many people see filter systems, the filter bubble or the phenomena like the increased publication of individuality as a first step to negative consequences

related to the role of the cyborg in our society. In the following, only two are highlighted: manipulation the self as well as changes in our health system related to changes in social hierarchy.

Social engineering is a discipline in political science that refers to efforts to influence social behaviors, a process that can also be carried out through modern communication technologies or interfaces. If in the future we stored personal information about people on an implant, we would be able to find out about the health condition of a person, and a patient could be hacked in the case of an unauthorized access of the device. Other security issues are related to secure data transport, as any wireless device is more risky. Possible technical solutions for this case could involve using certain frequencies for specific medical cases (Clausen 2006: 30). In the area of neuro prosthetics, risk of manipulation is discussed, as active devices can also collect data, process it and react according to it. And while some changes of identity might be okay, with brain computer interfaces in neuro prosthetics we have to find out which brain functions are so meaningful that they would lead to ethically problematic identity changes if we touch them.

Changes of identity could also be okay for some: regarding some brain coputer interfaces in neuro prosthetic we have to find out which brain functions are so meaningful that they would lead to ethically problematic identity changes if we touched them. Foucault's biopower concept (1998) highlights state regulation of subjects through an explosion of techniques for achieving the subjugations of bodies and the control of populations. His work can be related to practices of public health and risk regulation.

The increase of synthetic parts in our bodies could also lead to a new way of looking at health, related to questions of hierarchy and class in society and the human self-conception and image of humanity. According to the definition of health in the Charta of the World Health Organisation (WHO) health is a status of complete well-being, not only the absence of disease or disability. Health is also based on social context and has a cultural dimension, meaning that norms are not exceeded. Thus, health is defined by value judgements, and being sick usually isolates, as we do not want to go public with it. Consequently, our vision of health is seen as an improvement of abilities and power. Modern technologies can re-create lost potentials, but also – more and more – improve existing potentials. With body functions becoming a question of optimization, the relation of age and disease could further decrease, and we will probably not accept a disability in the future. With cognitive functions being replaced by technical components, human self-conception will change as we use technologies and products to enhance performance and cognitive functions, from caffeine and

amphetamines to electronic memory aids. The debate about enhancing our capabilities centers on the attempts to directly moderate brain electrochemistry or structure. Drawing on the body's own resources does not raise the same ethical challenges.

Another challenge is how to make future devices enhancing human capabilities accessible to all humans. There could be a significant split in society leading to two groups of people who also differ in the way they are humans: The wealthy ones with more vital and powerful body functions, but also more powerful knowledge, which could partly be achieved through implanted information systems enhancing brain memory (as opposed to a wisdom connected to higher age, like in the old model). The second class would then comprise a mass of people with a completely different body and brain memory disposition. The challenge will be to find new political measures to bridge this gap. Factors that have contributed to high differences in hierarchies in society (like gender) might become less important and be replaced by other differences of body conditions, new ideals and new diseases seen as technical solutions or problems.

Today, the limits and weaknesses of the cyborg concept have been acknowledged. The term cyborg, despite being widely discussed in research, could not unfold its full critical potential. However, strategies of cyborg politics are still relevant and should be re-activated. In the post-cyborg era we still need metaphors for the deconstruction of surveillance structures of state and economy, metaphors that are useful for focusing on political challenges of technology crossing fundamental boundaries. In this sense, cyborg politics can still distinguish itself from other critical approaches which predominantly stress the fears and risks of new technologies, offering a radical and progressive approach of a philosophy of technology. However, we will also have to find new figures, metaphors and deconstruction weapons – probably of a new, monstrous kind.

REFERENCES

Chamberlain, T. (2005): Photo in the News: Ultra-Life Robot Debuts in Japan. http://news.nationalgeographic.com/news/2005/06/0610_050610_robot.html (accessed 10 January 2013).

Channell, David 1991: The Vital Machine: A Study of Technology and Organic Life. New York: Oxford University Press.

Clausen, Jens: Ethische Aspekte von Gehirn-Computer-Schnittstellen in motorischen Neuroprothesen. IN: IRIE. International Review of Information Ethics. 2006, Vol. 5, 09/2006, p. 30.

Clynes, Manfred / Kline, Nathan (1995): "Cyborgs and Space". In: Gray, Chris Hables (Ed.): The Cyborg Handbook. New York / London: Routledge, p. 29-33.

Collodi, Carl, Paula Goldschmidt (Translation), Thorsten Tenberken (Illustration): *Pinocchio*. Dressler Verlag, Hamburg 2001 (Original 1883).

Foucault, Michel (1998) *The History of Sexuality* Vol.1: The Will to Knowledge. London: Penguin.

Gray, Chris Hables (1997): The Ethics and Politics of Cyborg Embodiment: Citizenship as a Hypervalue. http://www.chrishablesgray.org/ CyborgCitizen/cyembody.html (accessed 10 January 2013).

Haraway, D. (1991): A Cyborg Manifesto. Science, Technology, and Socialist-Feminism in the Late Twentieth Century. In: Simians, Cyborgs and Women: The Reinvention of Nature. New York: Routledge, p. 149-181 (Original 1985).

Haraway, Donna (1995a): „Ein Manifest für Cyborgs". In: dies.: Die Neuerfindung der Natur. Primaten, Cyborgs und Frauen. Frankfurt/M: Campus Verlag, p. 33 – 72 (Original 1985).

Harrasser, K. (2008): Extensions oft he working man. Von der Passung zum "passing". In: Heindl, G. (Ed.): Arbeit Zeit Raum. Bilder und Bauten der Arbeit im Postfordismus. Wien: Turia und Kant, p. 34-61.

Hoebeke, P. B, Decaestecker, K., Beysens, M., Opdenakker, Y., Lumen, N., Monstrey, p. (2010): Erectile implants in female-to-male transsexuals: Our experience in 129 patients, European Urology 57, p. 334 – 341.

Hubatschke, Christoph: Occupy Communication! Von Cyborgs und Nomaden im Zeitalter der Kontrollgesellschaften. Wien, Diplomarbeit, 2012.

Kafka, F. (1996): In der Strafkolonie. Erzählungen. Stuttgart: Philipp Reclam (Erstausgabe 1919).

Kristeva, Julia: Powers of Horror. An Essay on Abjection. New York 1982.

Latour, Bruno (1993). *We Have Never Been Modern*. New York, Harvester Wheatsheaf. Translation of *Nous N'avons Été Modernes* (Paris: La Découverte, 1991).

Levy, D. (2007). Love + Sex with Robots: The Evolution of Human-Robot Relationships. New York: Harper Collins.

Lyotard, Jean François: The postmodern condition: A report on knowledge. Minneapolis: University of Minnesota Press 1984.

Lyotard, Jean-Francois: The Inhuman. Stanford University Press 1988.

Mann, Steve (2003): The The Post-Cyborg Path to Deconism. Ctheory.net. http://www.ctheory.net/articles.aspx?id=368 (accessed 10 January 2013).

Newitz, Annalee (2009): The Men Who Make Battlestar Galactica Feminist. io9.com, Political Science, 7.3.2009 http://io9.com/5165920/the-men-who-make-battlestar-galactica-feminist (accessed 10 January 2013).

Plessner, Helmuth: Die Stufen des Organischen und der Mensch. IN: Helmuth Plessner. Gesammelte Schriften IV. Frankfurt am Main 1981.

Post, Stephen G.: Encyclopedia of Bioethics. 3. Edition. New York 2004, p. 1897.

Ritzer, Ivo (2013): Cyborg Warriors. In: Judith Schossböck and Günther Friesinger (Eds.): The Next Cyborg. To be published in Turia und Kant 2013.

Schaffer, S. (1996). Babbage's dancer and the impresarios of mechanism. In F. Spufford & J. Uglow (Eds.), Cultural Babbage: technology, time, and invention, London: Faber and Faber.

Smith, M. and Morra, J. (Eds.). (2006). *The Prosthetic Impulse: From a Posthuman Present to a Biocultural Future*. Cambridge, MA: MIT Press.

Sobchack, V. (2005): Choreography for One, Two, and Three Legs. (A Phenomenological Meditation in Movements). Topoi Vol. 24, No. 1, p. 55-66.

Stelarc: Prosthetic Head. Intelligence, Awareness and Agency. In: Arthur and Marilouise Kroker (Eds.): 1000 Days of Theory: td018. 10/19/2005. http://ww.ctheory.net/articles.aspx?id=490 (accessed 10 January 2013).

Tatsumi, T. (2006): Full Metal Apache: Transactions between Cyberpunk Japan and Avant-Pop America. Durham NC: Duke University Press.

Yeoman, Ian and Michelle Mars (May 2012). Robots Men and Sex Tourism. Futures Vol. 44: pp. 365-371.

Internet Links

Encyclopedia of Science, Technology, and Ethics: Cyborgs. Macmillan Reference USA 2001-2006. http://www.bookrags.com/research/cyborgs-este-0001_0001_0/ (accessed 10 November 2013).

Eve 1138 Android. http://www.youtube.com/watch?v=lTGOjWv9fcQ&feature=fvwrel (accessed 10 January 2013).

Henry George Liddell, Robert Scott, A Greek-English Lexicon. http://www.perseus.tufts.edu/hopper/text?doc=Perseus:text:1999.04.0057:entry=pro/sqesis (accessed 10 January 2013).

IBM Pollyanna Principle. http://en.wikipedia.org/wiki/Pollyanna_principle (accessed 10 January 2013).

Intimate Machines. A socio-cultural blog about social robots & human-robot interaction. http://glendashaw-garlock.blogspot.fr (accessed 10 January 2013).

List of fictional female robots and cyborgs: http://en.wikipedia.org/wiki/List_of_fictional_female_robots_and_cyborgs (accessed 10 January 2013).

Projekt Pinocchio. http://princessofshit.blogspot.co.at/2010/04/projekt-pinocchio.html (accessed 10 January 2013).

VeriChip. http://en.wikipedia.org/wiki/VeriChip#cite_note-2 (accessed 10 January 2013).

VNS Matrix (1996): The Bitch Mutant Manifesto. http://www.obn.org/reading_room/manifestos/html/bitch.html (accessed 10 January 2013).

World Health Organization (WHO): Definition of Health. http://www.who.int/about/definition/en/print.html (accessed 10 January 2013).

NC State University. Ethics in Computing. Information Literacy. Study Guide. What is a Cyborg? http://ethics.csc.ncsu.edu/risks/ai/cyborgs/study.php (accessed 10 January 2013).

Rebuild

Appropriation of Vacancies – by Capital or by People?

MARA VERLIČ

INTRODUCTION

Urban vacancies are a publicly debated – even contested – topic in contemporary urban development. Current debates evolve around interrelated issues like squatting, temporary uses, urban renewal, inner city vitalization, neighborhood upgrading and gentrification. In Vienna, as in other cities of the Global North, changes related to the organization of production and retailing have centered the debate on visible vacancies in ground floor stores in inner city areas.

This article is based on results and findings from a research project we conducted at the Vienna University of Technology on potentials of urban vacancies (cf. Frey 2011 and Hertzsch & Verlič 2012) in cooperation with *IG Kultur Wien*, the cultural political lobby of artists in Vienna, and financed by the cultural department of the City of Vienna.

In this article I will address the question if artists and cultural or creative producers have a certain kind of subversive potential regarding the commodification of space in their appropriation of vacant ground level stores. I will do so by first outlining two differing perspectives on urban vacancies that became apparent by analyzing the different discourses on vacancies in Vienna. The two perspectives differ in their definitions of the problem at hand: coming from a more spatial-focused side the problem can be defined in lying in the visibility of urban vacancies and therefore the city administration must find ways to eliminate those vacancies. But there is also an alternative way to look at urban vacancies by concentration on the involved actors and their needs and on questions of social inequality: in this perspective the problem may be defined as the inhabitants of a city that have an unmet need of space, i.e. people who seek space for living and working but are unable to gain access to the real estate market. Following this, I will show how those differing perspectives have been merged together in re-activating strategies for vacant shopping streets by

temporarily offering vacant stores to artists and cultural or creative producers. I will continue with arguing that although co-optations to market logics by the so-called *creatives* take place, the appropriations of space can be seen as reverse engineering procedures and therefore maintain a subversive element. Finally I will discuss this subversive potential in the context of a fragmented terrain of urban social movements fighting the commodification of space.

1. Perspective 1: Vacancies Are the Problem

In the course of our research project we analyzed the discourse on vacancies and their (re-)use in Vienna interviewing various actors from city administration, urban planning, cultural and social work and business representatives. In these interviews it became apparent that in the field of urban planning perspective 1 is dominant, where the problem of vacancies is defined as first and foremost a spatial one and which aims at erasing visible vacancies. A similar approach can also be found in many city development guidelines in other European cities like Berlin or Amsterdam. In those guidelines vacancies are described as unpleasant features of a neighborhood: as visible signs of economic decline, as contributing to labels like "problematic areas", as encouragement for crime and vandalism (following Kelling & Wilson 1982 and their broken windows theory) and as creating an overall atmosphere of insecurity and hopelessness.

This perspective of seeing vacancies as a spatial problem that can and should be fixed by eliminating them has also found its way into urban development strategies in Vienna. In 2000, Vienna's strategic development plan declared a paradigmatic shift in urban planning towards management strategies that should rely in great parts on activating self-organizational potential of the inhabitants. In the same development plan the center for multiple and temporary uses (*Koordinationsstelle einfach-mehrfach*) was launched as a strategic project of the City of Vienna. It was the first time that the concept of temporary uses was introduced to a strategic plan in Vienna, although it was mainly focused on flexible uses of voids for sports and other youth activities. The plan also declared a shift in the city's general orientation towards a *City of Culture, Science and Technology* (cf. Hamedinger 1999) leading to rising attention on artists and creative economies as an asset for creating a certain image of a "City of Avantgarde" (Strategieplan für Wien 2000). At the same time the first publicly funded temporary uses of large-scale vacant sites occurred: At the *Kabelwerk*, the *Museumsquartier* and the *Stadtraum Remise* temporary cultural uses were introduced to brand the places before rebuilding and transforming them into established cultural institutions and housing estates respectively.

Appropriation of Vacancies – by Capital or by People? 137

The 2004 Strategic Plan for Vienna introduced the revitalization of shopping streets as a strategic project of importance. The project aimed at reinforcing local stores and attracting new investments to inner-city areas in and outside the *Gürtel* with high vacancy rates on the ground floor and empty storefronts (Cf. Strategieplan Wien, Verzeichnis strategischer Projekte 2004:141.). In recent time the City of Vienna has launched or funded a number of projects targeting single streets where shops are given away for temporary "alternative uses". Initiatives like *Lebendige Straßen* ("Vital Streets") are initiated by the City of Vienna in cooperation with the Austrian Chamber of Commerce and private investors and are implemented by local area managements (*Gebietsbetreuungen*) with planning methods of activation and participation on a local scale (cf. HP *Lebendige Straßen*).

An aspect that significantly set these kinds of initiatives apart from other governmental strategies of dealing with vacancies before is their spatial concentration on certain areas or single streets. While temporary cultural uses of buildings before re-construction are aimed to create a certain branding and popularity of a place, re-activating strategies target larger urban areas and aim at attracting investments. When store fronts are seen as the business cards of an area or building (Schütz 2012), their importance for an investment decision becomes clear: as outlined above visible vacancies are perceived as signs for economic stagnation or decline – eliminating vacancies is therefore a strategy of attracting investment in an area. It can be argued that public or private-public programs to re-activate vacancies target especially areas with high rent gaps (Smith, 1979) because capital revaluation by investment is profitable there.

2. Perspective 2: People's Need for Space Is the Problem

As introduced above there is also another way of approaching the topic of urban vacancies by focusing on people's need for space in a city. In our research project in particular interviewees from the field of social and cultural work argued that they see a fundamental contradiction in the coexistence of vacant space and people who are in need of housing or working spaces.

To grasp the dimension of this unmet need in a city the most obvious possibility is to look at the numbers of homeless people to estimate the unsatisfied need for housing. This kind of argumentation has been used for example by the Right to the City Alliance in a vacant condos count conducted in New York in 2010. As Peter Marcuse (2010: 2) writes there: "It is a scandal that there is housing that could easily be available for occupancy and it is held empty only

for speculative purposes, while whole families are in desperate need of housing that they can afford." The number of people in need of space can also be defined in a broader sense by encompassing the following elements: homeless people; households that pay a large share of their income for housing (as they can be considered to be in need for more affordable housing) (cf. ibid), people living in low-quality housing, people seeking workspaces and people seeking space for cultural, social and sportive activities.

Coming back to the example of Vienna, numbers for the first points are rather easy to acquire: in 2012 there have been 9.000 people living in homeless shelters in Vienna (a number that doubled since 2006 according to Reiter (2012)). There is no up-to-date representative data on the percentage of income people pay for housing but a study from 2010 (working with a small stratified sample) came to the conclusion that in average Viennese people pay 43% of their income for housing and one third of the people pay even more than that (IFES, 2010). While these figures already point to the fact that there is indeed an unsatisfied need for (affordable) housing in Vienna, it can be estimated that numbers rise even more when taking people that seek workspaces and social and cultural activities into account. Although this need is hard to grasp quantitatively, interviews we conducted with people from the fields of cultural and social work indicate that there are indeed problems for certain social groups to find affordable space in Vienna. As groups with the most pressing need for space our interviewees mentioned social initiatives, cultural workers, artists, creative industries and other small enterprises. It seems important to mention that mainly, but not only, financial reasons deny these groups access to the real estate market; we have also been told about discriminatory practices against people of certain appearances.

Despite the contemporary conditions on the real estate market and the wide range of people seeking space (in Vienna) a certain group seems to have found a solution for their unsatisfied need for space. They transform vacant groundfloor stores into spaces of work in the form of offices, workshops and galleries. It is people often referred to as part of the "creative economies" (e.g. Howkins 2001) or the "creative class" (Florida 2002), with low economic but high social and cultural capital, who have started to reuse mainly visible ground floor stores by playfully picking-up and including some of the old-fashioned elements of the former uses (e.g. the name, signboard, machines etc.) – a phenomenon that can also be found in nearly all other European Cities. In our research project – taking a study edited by *Senatsverwaltung für Stadtentwicklung Berlin* (2007) as a starting point – we attempted to define a number of characteristics of this special kind of re-uses of vacant space and came to the following four points: these transformative uses are often made possible by alternative rent agreements (like temporarily rent-free or graduated rent); they are alternative uses in the sense that they differ from the originally intended use of the space and/

or are not primarily aimed at profit-making; they are characterized by a certain do-it-yourself-spirit or other form of self-administration and they are often short-dated due to special rent arrangements already mentioned.

What can be concluded from these characteristics is that there is a certain group in many European Cities that is re-using and transforming vacancies in a way not completely corresponding to common capitalist market logics and with the potential of critically questioning them by means of appropriation of space.

3. Re-activating Shopping Streets with the Help of Artists and Cultural Producers

In the last two sections two differing perspectives on the urban vacancies have been presented: the first one being a system-conform take concentrating on the elimination of visible vacancies, and the second one focusing on people in need for space to live and work in and their (possible) alternative appropriations of space non-conformative to dominant market logics. In reality the two conflicting approaches have been merged together in the form of urban upgrading strategies incorporating artists and cultural producers. A first indication can be found in the Strategic Plan for Vienna from 2004 that directly links the strategic project of revitalization of shopping streets with another core topic of the plan: the promotion of creative industries as a cluster strategy for historical urban areas with high "urbanity, density and diversity" (Strategieplan für Wien 2004, 137).

This special kind of urban renewal strategy has become particularly connected with the city image of Berlin (Löw 2008), a city that had historically a lot of vacant spaces after 1989. Due to a traditionally strong squatters movement and political-strategical tumultuous times after the German reunification, informal and bottom-up uses of vacant buildings and wastelands popped up everywhere in the city throughout the 1990s leading to a certain self-made charm that has in recent years been picked up by marketing strategists of the city of Berlin (leading to the famous slogan "Berlin – arm, aber sexy", i.e. *Berlin – poor but sexy*). Alternative and cultural or creative uses have been incorporated in an attempt to create a positive image for run-down urban areas in Berlin as in case of the agency for temporary uses (*Zwischennutzungsagentur*). The agency has been a strategic public initiative between 2004 and 2011 focusing on reactivating ground floor vacancies in one of the (at the time) most socially deprived areas of Berlin Neukölln. The agency operated on a very local scale as a facilitator between the owners of vacant stores and artists, cultural producers

and social initiatives aiming at negotiating short term reduced rent arrangements. On a smaller scale Vienna pursued the same strategy in recent years with projects like *Lebendige Straßen, SOHO Ottakring* and *Making it*. Incorporated in the attempt of creating a positive image for run-down urban areas in cities everywhere, young creatives and their reverse engineered spaces have become a favored social group for initiatives aimed at reactivating vacancies.

At first glance this might seem to be a win-win situation in which on the one hand artists, cultural producers and social initiatives gain space to work in and on the other hand the city is able to reactivate vacancies. But – as elaborated above – urban vacancies are not seen as being problematic in themselves but as signs for deprivation and decline of an urban area. Thus re-activating strategies have the secondary agenda of initiating social upgrading developments: artists and creative workers are being instrumentalized to create a hip urban area where – according to the idea of "capital flows, where attention goes" – private and/or public investment should follow causing the socio-economic upgrade of an area. The transformation of cultural products into locational assets has become even more popularized by authors and practitioners like Richard Florida (2002) and Charles Landry (2000) proclaiming the "age of creativity" where the "creative class" is rising and cities have to become "creative cities" in order to position themselves in a global urban competition. An urban planning paradigm that has been simultaneously widely implemented and heavily criticized (cf. Peck 2005 or for Vienna cf. Köhler 2005) for discursively obscuring increasing social polarization and gentrification in favor of a city's competitive capability.

As can be witnessed all over (and not only) cities of the Global North, social upgrading strategies attracting investment to an area combined with a neoliberal housing market may eventually not benefit the socio-economic deprived people living there but rather lead to an upgrade of the area by displacing those people (for gentrification gone global cf. Smith2002). Processes of gentrification also affect artists and cultural producers themselves who are often infact among the first "victims" of social upgrading due to their short term rent contracts. The displacement of pioneers of gentrification by socio-economic better-off gentrifiers has already been captured in early stage models of gentrification (e.g. cf. Berry 1985, Friedrichs 1998) and has been heavily discussed ever since (e.g. cf. Smith 1993, Ley 2003). Their double role of activating and popularizing a neighborhood and therefore pioneering a process of gentrification on the one hand and being forced to move out of gentrified neighborhoods due to rent increases and therefore falling as victims to gentrification on the other hand has been coined "pioneer's dilemma" (cf. Holm 2010).

The question arises whether those artists and creative producers have co-opted into a process of commodification of space because it offers them (if only temporarily) access to work and living space otherwise denied by the real

estate market. The next section will address this question by arguing that the act of transforming vacant space into new forms of uses per se can be seen as a form of reverse engineering and therefore as a potentially subversive practice.

4. Transforming Vacant Space as a Form of Reverse Engineering

Reverse engineering is a concept originally established in mechanical engineering that has recently been applied to digital technology describing a process of re-building an artifact by deconstructing its original make-up. As Schneider and Friesinger argue in the introduction to this volume, it can be seen as a subversive process not limited to technology but applicable as a critical approach to cultural and social phenomena questioning their seemingly naturalness and immutability.

> It [reverse engineering] is the demand, the claim of the users to be able to open, to explore, to modify according to one's own requirements, to expand and develop new characteristics and adapt everything to the ever-changing technological framework. Only in this way are we no longer confronted with our means of production and reproduction as complete and closed (segregated) systems. We thereby acquire and appropriate the technology with which we (have to) live and work, to which we are referred, which shapes our every-day life and which thereby constitutes us as those beings which we can be within the scope of our technological possibilities.
> (Schneider/Friesinger 2014:10)

Reverse engineering operates in three steps (ibid.) that apply in a lot of ways to the characteristics of re-using vacant space laid-out above – people who reuse vacant space have to first find a way to gain access to the space (open), then to understand how it works or how it used to work, i.e. to familiarize themselves with the space (dissect) and finally to use it and to transform it according to their own demands (rebuild). Schneider and Friesinger (2014) mention amongst others three important aspects of reverse engineering as a critical practice that can be applied to the process of reusing vacancies: Empowerment is a crucial element of the concept of appropriation of space when reusing vacancies. Appropriation is a term referring to a behavior different from the simple use of space but rather implies the transformation of space according to one's own needs and demands (Chombart de Lauwe 1977). It can be a subversive practice:

space is shaped in a certain way according to dominant social values and power relations (Lefebvre 1991 [1974]) – by opening up space and learning about its characteristics one might deconstruct the implied social dimension and redefine it by using it in a different way. Questioning the power of definition is another crucial aspect of reverse engineering that is also implied in the process of appropriation of space when seen in a broader socio-political dimension: by opening up vacant space and reusing it one might come to question popular definitions like what is high-quality use of space – a very popular term in the dominant discourse on urban vacancies. It might become obvious that what is often called a high-quality use of space is strongly limited to commercial uses and to a few tolerated social and cultural usages. Depicting processes of alienation is another goal of reverse engineering that can apply to reusing vacancies – as in many other areas of our lives capitalist market forces have alienated people from space by making it impossible to think about it other than in terms of property – a product of the process of commodification of space (Lefebvre 2008 [1970]). Our use of space in society (and this is especially true when it comes to urban space) is determined by the idea that every parcel of space belongs to someone – be it a private owner or the public (which in no way should be confused with everybody). When thinking about the practice of re-using vacant space ownership is a very crucial element defining the limits of usage by having the right to answer questions like: Who is allowed to keep space vacant? Who is allowed to use space? Under which conditions can space be used?

As has been argued there is a subversive element in the appropriation of space by artists and cultural or creative producers when re-using vacant ground floors that exists independent of the intention of the individual actors and of the process of valorization they might initiate under certain circumstances. The question if these so-called *creatives* can therefore be linked to urban social movements explicitly aiming at subversively questioning the commodification of space will be discussed in the final section.

5. A Common Claim in Fragmented Needs for Space?

Building on Manuel Castells' (1977) definition of urban social movements as groups capable of transforming urban meaning by aiming their actions at collective consumption, community culture and political self-management, Margit Mayer (2009) speaks of the increasing fragmentation of social movements in post-Fordism. Mayer (ibid.) sees urban social movements becoming more and more particularized concerning the spectrum of their goals and the intensity of their demands reaching for example from radical anti-globalization

activists attacking global corporations for fostering urban inequality as well as local governments for their complicity to middle-class movements claiming participatory rights in the creation of their neighborhood park.

Looking at the development of urban social movements active around urban vacancies in Vienna, there seems to be a similarly fragmented spectrum of actors and groups. In a historical study on the development of uses of vacancies in Vienna in the course of our research project, we identified four forms: squats, institutionalized socio-cultural uses (former squats), strategic temporary uses and re-activating strategies. While squatting is – compared to other cities – a rather unestablished practice in Vienna it is nevertheless a persistent form of using vacant space since its first occurrence in the late 1970s. As Dieter Schrage (2011) analyzed squatting in Vienna has only two possible outcomes: immediate eviction or institutionalization – a strategy of "social-democratic pacification" (Schrage 2011) or as Novy and Hammer (2007:213) put it: "Red Vienna [...] focused more on satisfying basic needs than empowering social movements." Therefore – if not immediately evicted – a lot of former squats have been transferred into institutionalized cultural facilities (like *Amerlinghaus*, *WUK* or *Arena*). Publicly funded they gained the legal right to stay put but are also brought under governmental control. As outlined before, since the 1990s the City of Vienna also employs strategic temporary uses for branding a building or area before re-constructing it and temporary uses of ground level stores in re-activation strategies. These four types of uses of vacancies indicate that there is a fragmented spectrum of people articulating their need for space in Vienna as they show differing degrees of co-optation to market logics and the political system. While squatting movements often demand a self-governed "free space", institutionalized cultural centers (former squats) already have to make cut backs in order to receive public funding. Temporary uses of vacancies as part of re-activation strategies finally imply being used for popularizing and valorizing a place in exchange for a precarious rent contract.

Uitermark (cf. 2004:688) argues that the fragmentation of urban social movements has led to a common pattern in which urban movements are partly co-opted by governmental strategies leaving a very limited role to play for the radicalized segment of urban movements fighting for universal rights. He diagnoses an overall effect of "movement meritocracy":

In all cases [of his study of Amsterdam's squatting scene, ed.], a process of 'unmilitant particularization' (compare Harvey, 1996) is evident: as some segments of the movement or cultural groups are granted special incentives by the government, it becomes increasingly difficult for the remainder of the movements to mobilize resources and to claim universal rights. What we see is the emergence of a movement meritocracy. (ibid.: 697)

In this context of a fragmented and particularized spectrum of urban social movements Novy and Colomb (2012) search for the potential of cultural producers and creatives for resisting neoliberal form of commodification of urban space. They find that this group – which is often condemned for their role as pioneers in gentrification processes – has also the potential of critically analyzing their contribution to valorization processes and the ability to speak out against their instrumentalization. Novy and Colomb (ibid.) draw on the examples of creatives voicing their protest in the course of the occupation of Hamburg's *Gängeviertel* and the struggles against Berlin's waterfront development *Media Spree* to illustrate how in recent years artists and cultural producers started to express their discontent with being exploited as locational factors under the banner of the "creative city". David Harvey (2001) pointed out that the turn in urban planning towards culture also reflects the incorporation of cultural products into capitalism by their transformation into commodities. Nevertheless he analyzes that this process also bears the possibility of uncovering internal contradictions of capitalism:

> By seeking to trade on values of authenticity, locality, history, culture, collective memories and tradition they open a space for political thought and action within which socialist alternatives can be both devised and pursued. Here lies one of the key spaces of hope for the construction of an alternative kind of globalization. One in which the progressive forces of culture can seek to appropriate and undermine those of capital rather than the other way round.
> (Harvey 2001:411)

To utilize the possibility of "mobilizing the political and agitational powers of cultural producers" (Novy/ Colomb 2012:6) in a broader social movement against the commodification of space a common ground needs to be established. I want to propose that the need for space might be a unifying momentum for social movements which becomes particularly explicit as a political problem when re-using urban vacancies: if a building or space is vacant, the question of why people in need of space should not be allowed to use it becomes more tangible and private property rights can be more easily questioned. It can be argued that when the use value of a building is reduced to a minimum, the exchange value and its alienating effect become more apparent. What has been argued here is that amongst differing values and demands there is one crucial aspect unifying social movements when it comes to urban vacancies: they all share a certain appropriation of space that has an intrinsic subversive element in questioning dominant market forces and the commodification of space – a common claim of a right to vacancies?

References

Berry, Brian (1985). "Islands of Renewal in Seas of Decay". In: Peterson, Paul (ed.) (1985). The New Urban Reality. Washington: Brookings Institution.

Castells, Manuel (1977). The Urban Question. A Marxist Approach. London: Edward Arnold.

Chombart de Lauwe, Paul-Henry (1977). "Aneignung, Eigentum, Enteignung. Sozialpsychologie der Raumaneignung und Prozesse gesellschaftlicher Veränderung". Arch+ Zeitschrift für Architekten, Sozialarbeiter und kommunalpolitische Gruppen 34: 2-6.

Florida, Richard (2002). The Rise of the Creative Class. And How It's Transforming Work, Leisure and Everyday Life. New York: Basic Books.

Frey, Oliver (2011). Perspektive Leerstand. Erster Teil einer dreiteiligen Studie zum Themengebiet Leerstandsnutzung, Zwischennutzungen, und Freiräume. URL: http://www.igkulturwien.net/fileadmin/userfiles/Studien/Studie_Perspektive_Leerstand_Teil1.pdf [04.02.2013].

Friedrichs Jürgen (1998). "Gentrification". In: Häußermann, Hartmut (ed.) (1998). Großstadt. Soziologische Stichworte. Opladen: Leske + Budrich: 57-66.

Hamedinger, Alexander (1999). "Stadtentwicklungspolitik. Das Unternehmen Wien?". *Kurswechsel* 2: 92-102.

Harvey, David (1996). Justice, nature and the geography of difference. Oxford: Blackwell.

Harvey, David (2009). "The Art of Rent. Globalisation, Monopoly and the Commodification of Culture". Socialist Register 38 (38). URL: http://socialistregister.com/index.php/srv/article/view/5778 [04.02.2013].

Hertzsch, Wencke; Verlič Mara (2012): Perspektive Leerstand. Zweiter Teil einer dreiteiligen Studie zum Themengebiet Leerstandsnutzung, Zwischennutzungen und Freiräume in Wien. http://www.igkulturwien.net/fileadmin/userfiles/Studien/perspektive_leerstand/studie-perspektiveleerstand-part2.pdf [04.02.2013].

Holm, Andrej (2010). Berlin. Pionierdilemma an der Spree. URL: http://gentrificationblog.wordpress.com/2009/07/13/berlin-pionierdilemma-an-der-spree/ [04.02.2013].

Howkins, John (2001). The Creative Economy. How People Make Money From Ideas. London: Penguin.

HP *Lebendige Straßen*. URL: http://www.wien.gv.at/stadtentwicklung/projekte/lebendigestrassen/ [04.02.2013].

IFES (2010): AK-Wien. Studie Mietenbelastung. URL: http://www.arbeiterkammer.at/bilder/d118/Mietenbelastung1.pdf [04.02.2013].

Peck, Jamie (2005). "Struggling with the Creative Class". International Journal of Urban and Regional Research 19(4): 740-770.

Köhler, Bettina (2005): "Kreative Stadt". *Malmoe* 25. URL: http://www.malmoe.org/artikel/funktionieren/875 [04.02.2013].

Lefebvre, Henri (1991 [1974]). The Production of Space. Oxford: Blackwell.

Lefebvre, Henri (2008 [1970]). The urban revolution. Minneapolis: University of Minnesota Press.

Ley, David (2003): "Artists, aetheticisation and the field of gentrification". Urban Studies 40 (12): 2527-44.

Löw, Martina (2008). Soziologie der Städte. Frankfurt: Suhrkamp.

Marcuse; Peter (2010). "Foreword". In: New York City Chapter of the Right to the City Alliance (ed.) (2010). People without homes & homes without people. A count of vacant condos on selected NYC neighborhoods. URL: http://www.urbanjustice.org/pdf/publications/People_Without_Homes_and_Homes_Without_People.pdf [04.02.2013].

Mayer, Margit (2009). "The 'right to the city' in the context of shifting mottos of urban social movements". City 13 (2): 362-74.

Novy, Johannes; Colomb, Claire (2012). "Struggling for the Right to the (Creative) City in Berlin and Hamburg. New Urban Social Movements, New 'Spaces of Hope'?" International Journal of Urban and Regional Research. doi: 10.1111/j.1468-2427.2012.01115.x.

Novy, Andreas; Hammer, Elisabeth (2007). "Radical Innovation in the Era of Liberal Governance. The case of Vienna." European Urban and Regional Studies 14 (3): 210-222.

Kelling, George; Wilson, James (1982). "Broken windows: the police and neighborhood safety". Atlantic Monthly 249(3): 29–38.

Reiter, Markus (2012). Obdachlosigkeit in Wien. Interview. URL: http://derstandard.at/1353208278309/Obdachlosigkeit-in-Wien-Taeglich-werden-Dutzende-delogiert [04.02.2013].

Schneider, Frank; Friesinger, Günther (2014). "Technology vs. Technocracy. Reverse Engineering as an User Rebellion." In: Günther Friesinger, Jana Herwig (eds.) (2014). The Art of Reverse Enineering. Bielefeld: transcript: 9-22.

Schütz, Theresa (2012). Leerstand in Wiener Erdgeschoßen. Interview. URL: http://derstandard.at/1353207082507/Leerstand-in-Wiener-Erdgeschossen-Es-braucht-eine-kleine-Revolte [04.02.2013].

Schrage, Dieter (2011). Interview. Im Zuge des Forschungsprojekts Perspektive Leerstand 1. URL: http://www.igkulturwien.net/fileadmin/userfiles/Studien/Studie_Perspektive_Leerstand_Teil1.pdf [04.02.2013].

Smith, Neil (1993). The new urban frontier. Gentrififcation and the Revanchist City. London: Routledge.

Smith, Neil (1979). "Toward a Theory of Gentrification: A Back to the City Movement by Capital, Not People." Journal of the American Planning Association 45(4): 538-548.

Senatsverwaltung für Stadtentwicklung Berlin (2007) (ed.). Urban Pioneers. Berlin: Jovis.

Uitermark, Justus (2004). "The Co-optation of Squatters in Amsterdam and the Emergence of a Movement Meritocracy. A Critical Reply to Pruijt." International Journal of Urban and Regional Research 28 (3): 687-698.

Cyberpeace, Not Cyberwar

SYLVIA JOHNIGK

This paper introduces the dilemma of an arms race in cyberspace at a time when there is no consensus on the definitions and differences between cyberterror, cybercrime or forms of online protest. With cyberoffense seeming "easy", i.e. easier than cyberdefense, cyberweapons have become tempting for governments who seek to protect their own soldiers from risk. The notion of cyberpeace is introduced which, among other things, aims for de-escalation, decentralization, disclosure of critical vulnerabilities, renouncement of first strike and offense in cyberspace, and for the negotiation of a Digital Geneva Convention that safeguards IT systems that are vital to civil infrastructures and which defines and renounces war crimes in cyberspace.

This article is the translation of an original text appearing in: Collaboratory AT – Netzpolitik in Österreich. (date of publication: June 2013, www.collaboratory.at). Cyberpeace is an initiative by FIfF – Forum InformatikerInnen für Frieden und gesellschaftliche Verantwortung (Forum Computer Scientists for Peace and Social Responsibility).

1. INTRODUCTION

We are witnesses to an arms race in cyberspace which has been going on for several years. Ever more nations are setting up military cyberwarfare units made up of IT specialists and aimed at securing IT systems or defending systems against "enemies".

The military build-up with offensive cyberweapons puts civil societies at risk. In the course of the world's increasing interconnection and digitalization, the dependency and vulnerability of IT increases. In the digital realm, national boundaries, responsibilities and competencies begin to blur. Anyone can be foe or enemy, anyone can be ally or affected party. As a result, conflicts are difficult to contain and to fight using national strategies.

We must find answers in a policy of peace and de-escalation. IT security risks can be reduced through decentralization of critical infrastructure, decreasing of dependencies and through general availability of defensive technology, e.g. by means of transparency and free licenses.

2. Motivation – Why Cyberpeace?

Anyone can become a victim; state, businesses or citizens – deliberately, by accident or as collateral damage. Ten years ago, the terminal devices used for Internet communication were almost exclusively PCs and laptops. Today, smartphones, tablets, SmartTVs and the first Smarthouses communicate on the net as well.

Society as a whole is highly dependent on electricity, water supply, transport, etc. These industrial facilities have come within reach, more or less purposefully, through SCADA (Supervisory Control and Data Acquisition) and can be contacted from anywhere. As a consequence, even those who only use the Internet indirectly are affected.

"Cyberweapons" are freely available. Attack tools can be found on the Internet, at home or at work. Any terminal device that is connected to the Internet can be reached and damaged. Cyberweapons are cheaper to obtain than conventional weapons. The reservations to use such weapons are lower, as potential harm remains abstract. Knowledge and handling can "easily" be acquired.

Standardization of hard- and software makes attacks easier and more effective (vulnerable monocultures). Components in IT products come from various suppliers (barely controllable or traceable). Along with the complexity of systems and applications, the frequency of vulnerabilities, misconfigurations and indeterminate behavior increases as well.

3. Cyberwarfare – a Reality?

In about 140 countries, there are initiatives for the setup or the expansion of military cyber units, most of which have offensive character. From a military perspective, cyberwarfare appears tempting:

- No putting-at-risk of one's own soldiers
- Tracking the aggressor with absolute certainty is impossible, origin and identity can be forged / can not be resolved without any doubt

- Low hanging fruits: soft, civil targets weaken the opponent
- Offense is much simpler then defense

German military ("Bundeswehr") has been involved since 2009 and has by their own account been ready to strike since 2012.

In recent years, the term "cyberwar" has been used ever more frequently, even though to date there haven't been any acts of war within the meaning of the Geneva Convention. Yet in the future, similar cyber attacks can provoke a war or can be used in a war in combination with other weapons. In international law, cyberwarfare has hitherto been insufficiently defined.

As a consequence, the international attacks of recent years are hard to classify. This becomes even more difficult if the amount of damages increases and a country decides to pursue combat with conventional weapons.

Titan Rain was a series of attacks on US American computer systems, including, among others, groups of the armament industry and NASA. Allegedly, these hacking attacks upon US systems could be traced back to China.

In 2007, Estonian governmental websites became the target of a DDoS (Distributed Denial of Service) attack. This was supposedly a politically motivated attack, based on a conflict concerning the handling of a monument for Russian soldiers.

In 2008, several attacks were reported in Georgia/South Ossetia: Web defacement, DoS attacks against Georgian governmental websites and media in order to prohibit the distribution of information in the times of a military conflict.

Stuxnet is a malware for the specific sabotage of centrifuge machines in uranium enrichment facilities in Natanz (Iran). Development costs were estimated to be in the seven digits in US dollars. Several zeroday exploits – i.e. attacks that aim at security vulnerabilities on the very same day that these become known – were developed. Following a report by the New York Times, *Stuxnet* was part of a US American-Israeli cyber attack spanning several years of constant development and testing (Operation *Olympic Games*).

Flame, a typical piece of espionage software, spies out affected computers/users and collects data. The trojan is aimed geographically at the Middle East and has a sophisticated deletion routine, making it impossible to track after its mission has been accomplished.

Duqu is (most likely) based on *Stuxnet*-Code; it has no geographic preferences and no attack or damage component. It merely spies out affected computers.

Gauss spies out banking data on behalf of governments mainly in Israel and Lebanon. It is based on *Flame* and has putatively been developed by the USA and Israel.

This is merely a small selection of attacks that have become known which in the future will most likely increase if a rethinking comes to nothing.

4. Forum InformatikerInnen für Frieden und Gesellschaftliche Verantwortung FIfF (Forum Computer Scientists for Peace and Social Responsibility)

The Forum Computer Scientists for Peace and Social Responsibility (FIfF e.V.) is a coalition of people who critically scrutinize the effects of the employment of computer science and technology upon society.

The people involved in FIfF, which was founded in 1984, are committed to a technological development that respects human dignity and facilitates the protection and further development of democracy, fundamental rights and peace. Within the context of their professional ethics, they advocate the peaceful coexistence of all humans and seek to promote cordial relations among all nations.

Our members operate in many technological and non-technological parts of society. Their responsibilities include public relations, consulting and the compilation of expert studies. FIfF is the publisher of a quarterly journal, *FIfF Kommunikation*, and cooperates with other civil rights organizations.

5. Criticism Put Forward by FIfF

Cyberwarfare has set off a new and dangerous armament spiral. By developing and using cyberweapons for attack, one also legitimizes their employment by the opposite party.

With opponents who are unable to keep up technologically, a trend towards asymmetric warfare is reinforced. The employment of high tech provokes a defense by assassination and guerilla warfare.

Military security interests pose a threat to the freedom of the Internet and of society. The development of security and surveillance technology is pushed by governments; security laws and surveillance are tightened and the investigation and disclosure of security vulnerabilities is thwarted.

We live in a world without boundaries. Across national borders, businesses work together in one Intranet. Networks and systems of international enterprises are managed by administrators in emerging countries. Products are developed in supplier locations in multiple countries and deployed globally.

Infrastructures (electricity, gas, oil) are produced, distributed and consumed beyond national borders. Standards are drafted and implemented on an international level.

These international challenges to IT security are often set against measures of purely national orientation, such as the German cyberdefense centre (Nationales Cyber-Abwehrzentrum).

Cyberattacks are only possible if vulnerabilities are kept secret. Vulnerabilities that are not known cannot be fixed and can thus also be exploited by the opponent. For example, once a national cyberdefense centre has developed a cyberweapon that is based on a vulnerability, this very vulnerability must be kept a secret from one's allies, as the probability that the vulnerability becomes known increases with the number of confidants, which would make the weapon unusable. Even one's own civilian population or domestic industries cannot be informed about the risk.

The US-American cybersecurity policy was made public in 2011 (to be precise: only its defensive component). What is problematic is the vague definition of an attack which, in terms of the policy, threatens national security: DoS attacks, sabotage of military and civil systems (especially of critical infrastructure), manipulation and theft of information, industrial espionage, theft of intellectual property, and hacktivism.

Cybercrime and cyberwarfare are too little differentiated and as a result, any cyberattack can potentially be interpreted as a threat to the USA's national security.

Because the USA have, in the light of their offensive deficiencies, reserved the right to respond to cyberattacks with conventional weapons, the vague definition of an attack entails the risk of an escalation of IT security problems into a war at a low threshold.

We think that it is a mistake to take the actions of lone perpetrators or script-kiddies as a cause of war. Criminally motivated cyber attacks occur everyday in huge numbers; war would thus become the normal state. Such a broad definition of a cyberattack should not become a casus foederis within the NATO.

6. What to Do?

We have formulated demands which we are continuously expanding and upon which we will elaborate in the future.

- Renouncement of first strike and offense in cyberspace: Nations should publicly renounce preventive use of cyberweapon for offense.

- Purely defensive security strategy: Nations should commit themselves to not develop offensive cyberweapons, let alone use them.
- Digital Geneva convention: Vital infrastructure for civilian populations such as electricity, water, health care, etc, may not be attacked. A violation of this convention shall be consider a war crime.
- Recognition of the fundamental right to civil disobedience and forms of online protest on the Internet: Such actions may not be criminalized, much less serve as a cause of war.
- Economic interests such as an infringement on intellectual property are no legitimate cause of war.
- Conventional weapons may not be used in response to a cyberattack.
- Government agencies, businesses and citizens must be required to disclose vulnerabilities (derived from the fundamental right to integrity which the state is obliged to protect).
- Operators of critical infrastructure must be required to protect themselves, having the responsibility to design, implement and operate their IT systems securely instead of calling upon the state or even military.
- Competent, transparent examinations and tests must be a requirement for an operating license.
- We demand the uncoupling and decentralization of critical infrastructure (such as e.g. DE-CIX).
- Disarming political language: Clear distinction between cyberwar, cyberterror, cybercrime, ethical hacking, forms of political protest.
- Democratic control, separation of powers, parliamentary debate on cybersecurity strategy and its implementation.

At the FIfF's annual meeting in Fulda, which took place in November 2012, a workshop was conducted. A small group was formed, and a mailing list created. To learn more, go to http://www.fiff.de.

7. References

Aljazeera (2011). "Iran military 'downs US drone'". URL: http://www.aljazeera.com/news/asia/2011/12/20111241599102532.html.

Beauftragte der Bundesregierung für Informationstechnik (2011). "Cyber-Sicherheitsrat". URL: http://www.cio.bund.de/DE/Politische-Aufgaben/Cyber-Sicherheitsrat/cyber_sicherheitsrat_node.htm.

Darnstädt, Thomas (2012). "Cyberwar: Der Wurm als Waffe". Spiegel Online. URL: http://www.spiegel.de/netzwelt/netzpolitik/experten-suchen-nach-kriegsrecht-fuer-den-cyberwar-a-836566.html.

Darnstädt, Thomas (2012). "Völkerrecht: Ist Cyberwar ein Krieg?". Spiegel Online. URL: http://www.spiegel.de/netzwelt/netzpolitik/ist-ein-cyberkrieg-ein-krieg-a-841096.html.

Government Communications Headquarters (UK), URL: http://www.gchq.gov.uk.

Hauck, Miriam & Johannes Kuhn (2011). "Computervirus Duqu entdeckt. Wie gefährlich ist der Stuxnet-Bruder?". Sueddeutsche.de. URL: http://www.sueddeutsche.de/digital/computervirus-duqu-entdeckt-wie-gefaehrlich-ist-der-stuxnet-bruder-1.1168324.

Heise.de (2011). "Bericht: US-Regierung erwog Cyberwar gegen Libyen". URL: http://www.heise.de/newsticker/meldung/Bericht-US-Regierung-erwog-Cyberwar-gegen-Libyen-1362698.html.

Heise.de (2012). "Der kleine Bruder des Spronagetrojaners Flame". URL: http://www.heise.de/newsticker/meldung/miniFlame-Der-kleine-Bruder-des-Spionagetrojaners-Flame-1731263.html.

Heise.de (2012). "Saudi Aramco: Cyber-Krieg im Nahen Osten". URL: http://www.heise.de/tp/artikel/37/37594/1.html

Heise.de (2012). "Super-Spion Flame trug Microsoft-Signatur". URL: http://www.heise.de/newsticker/meldung/Super-Spion-Flame-trug-Microsoft-Signatur-1590335.html.

Heise.de (2012). "Supertrojaner Flame gibt Geheimnisse preis". URL: http://www.heise.de/newsticker/meldung/Spionagetrojaner-Flame-gibt-Geheimnisse-preis-1709709.html.

Kaspersky, Eugene (2012), "Sicherheit im Internet. Der Cyberkrieg kann jeden treffen". http://www.sueddeutsche.de/digital/sicherheit-im-internet-der-cyber-krieg-kann-jeden-treffen-1.1466845.

Kremp, Matthias (2011). "Blaue Armee: Elite-Hacker führen Cyberwar für China". Spiegel Online. URL: http://www.spiegel.de/netzwelt/web/blaue-armee-elite-hacker-fuehren-cyberwar-fuer-china-a-765081.html.

Kremp, Matthias (2011). "Online-Spionage: US-Geheimdienst will chinesische Hacker identifiziert haben". Spiegel Online. URL: http://www.spiegel.de/netzwelt/web/online-spionage-us-geheimdienst-will-chinesische-hacker-identifiziert-haben-a-803396.html.

Nationales Cyberabwehrzentrum (BRD), URL: http://www.bmi.bund.de/DE/Themen/IT-Netzpolitik/IT-Cybersicherheit/Cybersicherheitsstrategie/Cyberabwehrzentrum/cyberabwehrzentrum_node.html.

NATO Cooperative Cyber Defence Centre of Excellence, Estonia, http://www.ccdcoe.org.

Sandro Gaycken (2011). "Cyberwar und seine Folgen für die Informationsgesellschaft". re:publica XI April 2011. URL: http://archiv.re-publica.de/2011/12/04/cyberwar-und-seine-folgen-fur-die-informationsgesellschaft.

Schneier, Bruce (2008), "Dual-Use Technologies and the Equities Issue". Schneier on Security. URL: http://www.schneier.com/blog/archives/2008/05/dualuse_technol_1.html.

Singer, David (2012). "Obama Order Sped Up Wave of Cyberattacks Against Iran". URL: http://www.nytimes.com/2012/06/01/world/middleeast/obama-ordered-wave-of-cyberattacks-against-iran.html.

Spiegel Online (2009). "Spionage- und Hackerabwehr: Bundeswehr baut geheime Cyberwar-Truppe auf". URL: http://www.spiegel.de/netzwelt/tech/spionage-und-hackerabwehr-bundeswehr-baut-geheime-cyberwar-truppe-auf-a-606096.html.

Spiegel Online (2012). "Bericht der Bundesregierung: Bomben gegen Cyber-Krieger". URL: http://www.spiegel.de/netzwelt/netzpolitik/cyberkrieg-bomben-gegen-cyberkrieger-a-861002.html.

Spiegel Online (2012). "Digitaler Truppeneinsatz: Bundeswehr meldet sich bereit zum Cyberwar". URL: http://www.spiegel.de/netzwelt/netzpolitik/cyberwar-die-bundeswehr-kann-nun-auch-cyberkrieg-a-836991.html.

Steinke, Ronen (2012). "Cyberwar und Völkerrecht. 'Ein Gegenschlag ist nicht legal'." Sueddeutsche.de. URL: http://www.sueddeutsche.de/digital/cyberwar-und-voelkerrecht-ein-gegenschlag-ist-nicht-legal-1.1430089.

Telepolis (2011). "Keylogger-Virus in den Computern zur Steuerung von Drohnen entdeckt". URL: http://www.heise.de/tp/blogs/8/150592.

The Economist (2010). "Cyberwar. The threat from the Internet". URL: http://www.economist.com/node/16481504?story_id=16481504.

The Jerusalem Post (2011). "Prime minister announces new cyber defense taskforce". URL: http://www.jpost.com/Defense/Article.aspx?id=221116.

U.S. Army Cyber Command (USA), URL: http://www.arcyber.army.mil.

US Department of Defense (2011). "Strategy for Operating in Cyberspace". URL: http://www.defense.gov/news/d20110714cyber.pdf.

Johnigk, Sylvia & Kai Nothdurft (2012). "Cyberwarfare". FIfF-Kommunikation, 1 (2012), 41-45.

Johnigk, Sylvia (2013). "Cyberpeace statt Cyberwar". In: Clara Landler (ed.): Collaboratory.AT. Netzpolitik in Österreich (June 2013, www.collaboratory.at).

Asking the Girls Out? Reverse Engineering and the (Re-)Writing of Austrian Film History

THOMAS BALLHAUSEN, KATHARINA STÖGER

> *How are we perceived, if we are to be perceived at all? For the most part we are invisible.*
>
> Derek Jarman: Blue

> *And fuck the seasons too.*
>
> Arthur Rimbaud: Letter to Ernest Delahaye

INTRODUCTION

This text aims to illustrate the practical benefits of an expanded concept of archives as exemplified by the current, archive-based research and preservation project *Shooting Women*, which has been initiated by the Austrian Film Archive and is based at its Department for Studies and Research. The notion of an expanded archive, which draws on recent theoretical concepts and intentionally differs from a classic archival science, means the conception of archives as intellectual logistics, as an ethical and political attitude of commitment to both the material and the public.

It is of particular concern to us to emphasize the thinking of archives as a *techne*: in a true commitment to their collections and the public archives must intentionally make the performance of their manifold duties hard on themselves. It is the productive schizophrenia of labour resulting from the concurrent support of serious work in the present and long-term, intergenerational preservation of heritage that shapes the activities of archives and calls for a

carefully considered ethical stance. Especially in times of technical innovations and developments – which archives must be open to, but which certainly require a constructive and critical examination – it is important to envision the historical realities, challenges and options. But an active opening of archives in favor of public access should by no means entail the abolition of experts or even the disappearance of archives as a specialized form of intellectual logistics. Particularly in times of increasing digitization both the issue of long-term preservation and the vehement challenging of archives being limited to the role of mere suppliers to scientific research must receive attention. Therefore, the imparting work of archives must not only consider the content and media-specific creation of awareness in the context of the respective agendas of educational work, but must also stand up against undermining, exploitation and the mistakes of neo-positivist source mania.

The subsequent rejection of a model of a linear progression of history and historiography necessitates a productive discussion of the making of and reflection on history and historiography, which can be described coherently as a practice of "reverse engineering for the humanities". On the basis of the specific example of an archive-based investigation of Austrian female filmmaking between 1969 and 1999, the possibility of a new, or renewed reading as well as a rewriting of film history is presented. As the text also means to invite readers to do their own reverse engineering, it is divided into three main parts: a description of the project and the historiographic models it negotiates, a selected filmography covering the historical period in question and a list of references intended to seduce the reader into further reading and thinking.

1. REVERSE ENGINEERING FILM HISTORY: THE PROJECT *SHOOTING WOMEN*

With the special program *Shooting Women*, the Austrian Film Archive, Diagonale and the Austrian Directors Association initiated the first comprehensive examination of Austrian female filmmaking between 1969 and 1999 more than three years ago. Using the internationally established *New Austrian Cinema* from 1999 onwards and the well-earned success of its exponents as a "marker point", we trace works of Austrian directors in the preceding decades which have been forgotten, (too) rarely discussed or considered lost. The historical special programs of Diagonale 2011 and 2012, which had been attuned to basic issues and the aspects of reflective methods of the non-fictional, were followed by other retrospectives, DVDs, talks and publications that were great

public successes – not to mention the continuation of a research project at the Austrian Film Archive which has identified more than a thousand individual works by Austrian directors from the period under investigation. All of these efforts are united by their critical examination of historical developments and historiographical principles in the context of preservation, archive-based imparting of film and historiography. Apart from a purely aesthetically oriented and ideologically ill-concealed historiography, which in its elitism and selectivity probably does not merit such a designation, the balance between commitment to the preservation of cultural heritage and commitment to the public can be achieved by an expanded and enlivened conception of the term "archive".

1.1 Bodies, Material, Evidence

The above-mentioned turning point in 1999 has been chosen neither randomly nor casually. In fact, Barbara Albert's feature film *Nordrand* (1999) is a point of departure which was preceded by a continuous emancipation from a (not always unproblematic) aesthetic history of film production in Austria. In retrospect, the road to a *New Austrian Cinema*, as Robert Dassanowsky aptly termed it in 1997 and which had already been interpreted as an emerging maturity of Austrian film on an international level in the widely read *The Hollywood Reporter* in 1997, was very stony. An essential proportion of positive developments, such as a more comprehensive understanding of the medium of film in transnational contexts, the conditions of its production and reception as well as the new self-concept of Austrian filmmakers, is owed to the previous, pioneering efforts of female filmmakers before said turning point. But, to briefly dwell on literalness, we cannot call these efforts to mind without the knowledge of names. So who lies buried by film history, who has been marginalized and who is, at least partially, familiar to us? The list of the protagonists is long – surprisingly and almost shockingly long. They were marginalized or pushed to the sidelines by the production conditions; simply forgotten not least because of their off-mainstream position that went beyond simple rights exploitation.

Archive-based processing and preservation of source material can illustrate the winding course of history, but to make this non-linear development the only justification for such a reappraisal would be inadequate. Equally, the focus must not lie on an uncritical adoption of obsolete notions of difference, such as the wavering gender gap or the challenging of clear-cut notions of identity. Rather, there should be a close examination which considers historical perspectives and illustrates the complexity and diversity of positions and attitudes. Austrian film history should be investigated in regard to female pioneers, they should be recovered and made visible. Exponents such as Luise Fleck have

recently been researched again, but the period of Austrian film from the end of the 1970s onwards, with its tendencies of self-organisation and replacement, still has to be revalued. A focus on innovative, idiosyncratic and at least partially independent poetics not only raises the question of the attribution of female filmmaking, but also makes the critical perspective that is inscribed in the works to various degrees accessible. This perspective is often more than just tentatively opposed to a film cosmos dominated by patriarchy. Strategies of undermining and queering meet tradition and conformity, allow a critical reflection on the frequently bitter conditions of both work and participation in a broader discourse. The development and appropriation of what ultimately is a space of society as a whole generated heterogeneous works, both in form and content, which should be put into contrast in regard to their aesthetic, formal and conceptual diversity. Should no homogeneity be found in the considerable number of films that are attributable to the outlined field of interest, then a focused examination can only be concerned with the highlighting of guidelines. Any kind of show-and-tell-principle that is based on similar preservation (work) will have to cope with this additional challenge. But the necessity of selection also bears the opportunity to emphasize and to cast light on relational conditions without being taken in by a prefabricated canon.

The challenges in the examination of concepts such as preservation, expectation, patterns of interpretation and social normalization manifest themselves in the relationship of feature film, documentary, TV production and avant-garde experiment. In the confrontation with role models, women's rights and issues of representation, the directors are not spared. Rather, their work – as well as their own, sometimes tragic fates – illustrates the full pressure of social norms as well as presupposed conformity and subordination. The rejection of such patterns retrospectively offers us the opportunity to overcome visual prototypes and a refreshing shift in critical perspectives. Transgressions, transgressive and transformational moments can be observed not only in the aesthetic diversity but also in the often humorous handwriting of the artists. In the transgressive mode of female filmmaking, which occasionally makes a false step or even stumbles, we find opportunities to expose, be they intentional or simply ideologies of the respective period. The uncomfortable questions that must be asked are evident, as body, politics and society are being captured by what is clearly a discerning gaze, as conventional patterns of perception and production are being reconfigured or disrupted. In the equally noticeable and understandable desire to be perceived in their established autonomy lies the risk and the appeal of both accepting the respective works with all the proverbial rough edges and of re-contextualizing them.

1.2 Mapping Political and Historical Spaces

Documentary film, the field of the non-fictional that has gained importance also for Austrian film, allows counter-historiographies, the depiction of lifestyles and provokes the appropriation of space – the writing of *herstory*. The tangibility of events shows us the arrangement, the structuring of the world, the inscribed tense relation of the real/the depicted and the creative addition/process. But it is this new tangibility which helps to open up and explore both an ethical and a political space. Doubt, even ambivalence, accompanies the examination of the *spectres* and the multi-layered landscapes that unfold here. From the paradoxical state of shelved oblivion, which is too easily and also falsely attributed to archives, the non-fictional must be discussed as a challenge of activity, interactivity, perhaps even interference. History has a special role to play, in particular for female Austrian documentary film. The tension, so aptly described by John Ellis, between the difficulty of defining the non-fictional as unambiguously as possible and the (supposedly?) comparatively simple identifiability of the documentary image without underestimating or denying the many facets of the non-fictional is cushioned by the (queer) historical developments of the genre and its aesthetic set(ting): in the course of film history the reconstructive nature of the non-fictional is transformed into a new position of observation and directed activity under the increasing presence and use of new technologies and media and it no longer excludes the possibility of increased commentary.

The quite plausible three-phased model of the development of documentary film is valid both for past and future preservation: after the first phase of cinematic documentation focused on reconstruction, there is both a noticeable re-evaluation of observation and its contexts and a repositioning necessitated by the possibilities (and limitations) of TV from the 1950s onwards. The emerging shift in expectations of documentary film and the (advancing and advanced) creation of media events promote the possibility that documentation creates scenes/reality. In addition, new strategies for dealing with source material and the flexibility within the field create a critical investigation and outstripping of definitions à la John Grierson, which are sometimes perceived as too narrow. Technology – that is technology implemented on a wide societal level – is becoming more centralized and facilitates both production and reception. Playing with feasibilities, the intentional maxing out of the expected or the overlap with experimental film as attested by Catherine Russell goes hand in hand with a new self-confidence of those asking the questions, regardless of what is (technically) possible. There are first and second steps towards the changes of the photographic image since the 1990s. The digital further raises our doubts about images, recordings and their authenticity. In a negative interpretation,

editing processes and the reproducible nature of the material (and with it also the multiplication of opinions prior to completion of a project) further call the validity of the non-fictional into question. Authenticity, authorship and – not to be neglected or concealed – autonomy demand to be emphasized further, to the advantage of all of us.

Documentary film as film(ing) without narrative, even an unintentional one, seems questionable, or at least worthy of further discussion. The necessity of imparting history can also be understood as the inevitability to narrate history. Drawing on Erving Goffman, John Ellis correctly questions the terms and framing of documentary work and reception. Without having a final answer (or indeed ever being able to have one), we have to state that the non-fictional is more than narration as entertainment or conversation. Documentary film before 1999 cannot be conceived of without taking the changed, post-modernist conception of history and its epistemological openness into account, without reflecting on the tendencies of a constructive and critical rethinking of history and historiography – which always also uses fictional instruments. Indeed, which perhaps must use them. But it is not only about using the fictional, for instance, in counter-historiography, a filling-up of visual gaps, a history *from the bottom up* – no, it is also about identifying and naming it. How to deal with the threat of a normative political instrumentalization and the linearity of restrictive, determinative hermeneutics?

1.3 Hack History, Hack Historiography

In this time of daily impositions, we must fully commit to the unbroken power of film and cinema, to assure ourselves of their existence, their life, and indeed their vitality, perhaps now more than ever. With a healthy heartbeat of 24 frames per second and an unbridled, chaotic life force, history – this oscillation between confrontation and continuity – is being manufactured and memory is created. Here (and now) we live on the successful escape of the arts from the custody of compliant representations to the challenging field of autonomy and sovereignty in the 18th century. Now (and here) we should not only celebrate turning points retrospectively but also note and acknowledge current crossroads. So what can the sixties and seventies of the 18th and 20th century do for us today? While 1968 brought a renewed cinematic rejection of classical narrative principles and political exploitation as well as a re-examination of social and legal frameworks and a change of methods in the humanities, the beginning 21st century brings the resumption of unanswered questions (about history).

Pop and subversion, stories and history begin to circulate and illustrate the power of cinema. The continuity of topics collides with the perspectives of later generations, with the plurality of positions between resignation and constant pushing towards the subversive potential of the medium and its emancipatory capabilities. The challenges of the popular, its powerful effect and the continuous effort to tame it through commercialization and economic exploitation point us to the fact that the classics too started out popular, perhaps even small. The story/history written by film in the acceptance of its inheritance as a respectable source is, to draw on Jacques Rancière, a story/history of the power of historiography. It is the writing / filming of an independent history, a history that, with its breaks and fractures, seems to escape all prediction. History is simply not linear, it is not smooth, but rather it is winding, crossed by fractures. The how of historiography, the examination of the development of historiography, leads to a decision in favour of perspective, of a modus operandi and a questioning of often offhandedly accepted conditions that is equally valid for film. This must be the credo of a further exploration of the themes outlined.

2. Selected Filmography

2.1 General Filmographic Methodology for the Period of Investigation

In the course of preservation work, more than 1200 works by about 200 filmmakers have so far been registered for the period of investigation from 1969 to 1999. Here, a rapid increase in production activity can be observed after 1980, which is approximately six times higher than in the previous decade. For the purpose of better manageability, the films have been divided into the two categories short film (under 60 min.) and long film (over 60 min.). This has been followed by a categorization into the genres feature film, documentary film, experimental film, animation, media art and other short works. At the present stage of research, the following tendencies can be observed and described in regard to the general filmography: short films account for approx. 85% of all productions and thus constitute the biggest fraction of female filmmaking. This category is dominated by documentaries as well as experimental film and animations. Long film is particularly predominant in the category of feature film, where it accounts for around 80% of all productions. Roughly half of these long films have been identified as TV productions. Of all avant-garde works only 10% fall into the category of long film and another 20% have been

categorized as documentary films. Overall, fictional film is the least represented category of work, whereas documentary works, experimental film and animation are each about three times as numerous as feature films. Despite the surprising quantity of films, which includes several interesting new discoveries and re-discoveries, work is far from completed at this point. Possible next steps of the ongoing research project will be the transition from identification to collection and, in consequence, the restoration of accessibility on various levels (library service, editions, detailed investigations, etc.).

2.2 Structure of the Selected Filmography

In regard to the selected filmography as described in the following, it was of particular importance to us to make a conscious selection with the creation of awareness for the examined topic as primary goal. For the chronological selected filmography we chose films which, apart from all efforts of canonization, are on the one hand representative of certain parts of the overall period under investigation and which on the other hand stand in a calculative/thematic relation to the general filmography described above. The structure of the single entries on unambiguously identified minimal sets in this list is based on the descriptive elements of the European metadata standard EN 15907. The single entries of the chronologically ordered selected filmography aim to allow for easy identification and categorization. Thus, they are separated into two parts: the first line specifies the film's title, the director's name and the release date. The second line describes the categorization into short and long film (identified by s for short film and l for long film), the film's runtime (given in minutes and seconds) as well as a categorization into genres (using the following identification codes: f for feature film, d for documentary, x for avant-garde/experimental, a for animation, m for media art and v for various other forms).

2.3 Chronologically Ordered Selected Filmography

Walk in, Moucle Blackout, 1969
s, 6 min., x

Reflexion, Edith Hirsch, 1969/70
l, 93 min., x

Chairs, Maria Lassnig, 1971
s, 4 min., a

Selfportrait, Maria Lassnig, 1971
s, 5 min., a

Die Geburt der Venus, Moucle Blackout, 1972
s, 5 min., a

Couples, Maria Lassnig, 1972
s, 10 min., a

Remote...Remote, VALIE EXPORT, 1973
s, 12 min., x

Ein Bruder so wie du – das "rauhe Leben" des Arbeiterdichters Alfons Petzhold,
Edith Hirsch, 1973
s, 30 min., d

Baroque Statues, Maria Lassnig, 1974
s, 16 min., a

Unsichtbare Gegner, VALIE EXPORT, 1976
l, 100 min., f

Zwielicht, Margareta Heinrich, 1979
s, 28 min. f

Menschenfrauen, VALIE EXPORT, 1979
l, 124 min., f

Anna, Linda Christanell, 1980/81
s, 40 min., x

Zechmeister, Angela Summereder, 1981
l, 79 min., f

Souveniers, Lisl Ponger, 1982
s, 12 min., x

Karambolage, Kitty Kino, 1982
l, 100 min., f

Das gläserne Wappen, Susanne Zanke, 1982
l, 108 min., f

Fingerfächer, Linda Christanell, 1982/84
s, 10 min., x

Genossinen, Margareta Heinrich/Ullabritt Horn, 1983
s, 50 min., f

Lebenslinien Part 2: Marianne – ein Recht für alle, Käthe Kratz, 1983
l, 90 min., f

Federgesteck, Linda Christanell, 1984
s, 3 min., x

For you, Linda Christanell, 1984
s, 8 min., x

Küchengespräche mit Rebellinen, Karin Berger/Elisabeth Holzinger/Charlotte Podgornik/Lisbeth N. Trallori, 1984
l, 80 min. d

Atemnot, Käthe Kratz, 1984
l, 90 min., f

Schon eingeschossen auf Franz, Inge Graf + ZYX, 1984
s, 20 sec., v

Grauer Raumtransmitter, Inge Graf + ZYX, 1984
s, 19 min. 44 sec., m

Museum of private arts vol. 1 U4, Inge Graf + ZYX, 1984
s, 45 min. 20 sec., m

Untergang der Titania, Mara Mattuschka, 1985
s, 3 min. 10 sec., a

Super-8 girl games, Angela Hans Scheirl, Ursula Pürrer, 1985
s, 2 min., x

Die Praxis der Liebe, VALIE EXPORT, 1985
l, 90 min. x

Die Nachtmeerfahrt, Kitty Kino, 1985
l, 70 min., f

Parasympathika, Mara Mattuschka, 1986
s, 3 min. 45 sec., a

Eine Minute dunkel macht uns nicht blind, Susanne Zanke, 1986
l, 110 min., f

Mein Amazonas, Susanne Zanke, 1986
l, 70 min., f

Geld, Sabine Groschup, 1987
s, 4 min. 20 sec., a

Mein Kampf, Mara Mattuschka, 1987
s, 2 min. 35 sec., a

Es hat mich sehr gefreut, Mara Mattuschka, 1987
s, 2 min., a

Les Misérables, Mara Mattuschka, 1987
s, 1 min. 55 sec., a

Die vollkommene Bedeutungslosigkeit der Frau für die Musikgeschichte (Musikerinnen), Mara Mattuschka/Hans-Werner Poschauko, 1987
s, 5 min. 30 sec., x

Die papierene Brücke, Ruth Beckermann, 1987
l, 95 min., d

Einstweilen wird es mittag, Karin Brandauer, 1987/88
l, 90 min., f

Haus, Sabine Groschup, 1988
s, 2 min. 30 sec., a

Liebe, Sabine Groschup, 1988
s, 2 min. 30 sec., a

Train of recollection, Lisl Ponger, 1988
s, 6 min., x

The abbotess and the flying bone, Angela Hans Scheirl/Dietmar Schipek, 1989
s, 18 min., x

Verkaufte Heimat – Brennende Lieb' (1), Karin Brandauer, 1989
l, 115 min., f

Der Einzug des Rokoko ins Inselreich der Huzzis, Mara Mattuschka/Andreas Karner/Hans-Werner Poschauko, 1989
l, 103 min., x

Loading Ludwig, Mara Mattuschka/Michael Petrov, 1989
l, 62 min., a

Die Skorpionfrau, Susanne Zanke, 1989
l, 100 min., f

Grenzüberschreitungen, Christa Biedermann, 1990
s, 27 min. 47 sec., x

Danke für die Blumen, Christa Biedermann, 1990
s, 6 min. 49 sec., x

Semiotic ghosts, Lisl Ponger, 1990
s, 17 min., x

1 Häufchen Blumen 1 Häufchen Schuh, Carmen Tartarotti, 1990
s, 45 min., d

Sidonie, Karin Brandauer, 1990
l, 87 min., f

Eingeschlossen, Christa Biedermann, 1991
s, 4 min., a

Nudelfilm, Christa Biedermann, 1991
s, 4 min., a

Kugelfilm, Christa Biedermann, 1991
s, 4 min., a

Hart & weich, Christa Biedermann, 1991
s, 4 min., a

Kobalek oder das Sichtbare und das Verborgene, Susanne Freund, 1991/92
l, 61 min., d

Das Heimliche Fest. Ein Porträt der Österreichischen Schriftstellerin Dorothea Zeemann, Susanne Freund, 1992
s, 45 min. 47 sec., d

Definitely Sanctus, Sabine Hiebler/Gerhard Ertl, 1992
s, 4 min., x

Maria Lassnig Kantate, Maria Lassnig/Hubert Sielecki, 1992
s, 7 min. 35 sec., a

Robertas Sohn, Karina Ressler, 1992
s, 27 min., f

Rote Ohren fetzen durch Asche, Angela Hans Scheirl/Ursula Pürrer/Dietmar Schipek, 1992
l, 84 min., x

Sie saß im Glashaus und warf mit Steinen, Nadja Seelich/Bernd Neuburger, 1992
l, 90 min., d

My moviestar, Linda Christanell, 1993
s, 10 min., x

S.O.S. Extraterrestria, Mara Mattuschka, 1993
s, 10 min., x

Geraubte Kindheit – und damit leben lernen, Sabine Derflinger/Bernhard Pötscher, 1994
l, 82 min. d

Totschweigen, Margareta Heinrich/Eduard Erne, 1994
l, 88 min., d

Vorwärts, Susanne Freund, 1995
l, 80 min., d

Die Frucht deines Leibes, Barbara Albert, 1996
s, 27 min., f

Flora, Jessica Hausner, 1996
s, 25 min., f

Passagen, Lisl Ponger, 1996
s, 12 min., x

Ägypten, Kathrin Resetarits, 1997
s, 10 min., d

Speak easy, Mirjam Unger, 1997
s, 20 min., f

Sonnenflecken, Barbara Albert, 1998
s, 25 min., f

Inter-View, Jessica Hausner, 1998
s, 45 min., f

Gfrasta, Ruth Mader, 1998
s, 11 min., f

Dandy dust, Angela Hans Scheirl, 1998
l, 94 min., a

Fremde, Kathrin Resetarits, 1999
s, 28 min., f

Schminki 1, 2 +3, Fiona Rukschcio, 1999
s, 8 min., x

Carmen, Anja Salomonowitz, 1999
s, 23 min., d

Mehr oder weniger, Mirjam Unger, 1999
s, 18 min., f

Ceija Stojka, Karin Berger, 1999
l, 90 min., d

Abschied ein Leben lang, Käthe Kratz, 1999
l, 91 min., d

3. RECOMMENDED LITERATURE

Thomas Ballhausen: Kontext und Prozess. Eine Einführung in die medienübergreifende Quellenkunde. Wien: Löcker Verlag 2005.

Ohne Untertitel. Fragmente einer Geschichte des österreichischen Films. Herausgegeben von Ruth Beckermann & Christa Blümlinger. Wien: Sonderzahl Verlag 1996.

The Routledge Companion to Research in the Arts. Edited by Michael Biggs & Henrik Karlsson. London: Routledge 2010.

Ernst Breisach: On the Future of History. The Postmodernist Challenge and its Aftermath. Chicago: The University of Chicago Press 2003.

Warren Buckland: Film Theory. Rational Reconstructions. London: Routledge 2012.

John Burrow: A History of Histories. Epics, Chronicles, Romances and Inquiries from Herodotus and Thucydides to the Twentieth Century. New York: Alfred A. Knopf 2008.

Michael Chanan: The Politics of Documentary. London: BFI 2007.

James Chapman: Cinemas of the World. London: Reaktion Books 2003 (Globalities).

Elizabeth Cowie: Recording Reality, Desiring the Real. Minneapolis: The University of Minnesota Press 2011 (Visible Evidence 24).

Mark Cousins: The Story of Film. London: Pavillon Books 2011.

Mark Currie: About Time. Narrative, Fiction and the Philosophy of Time. Edinburgh: Edinburgh University Press 2007 (The Frontiers of Theory).

Alexander Demandt: Philosophie der Geschichte. Von der Antike zur Gegenwart. Wien: Böhlau Verlag 2011.

Jack C. Ellis & Betsy A. McLane: A New History of Documentary Film. New York: Continuum 2005.

John Ellis: Documentary. Witness and Self-revelation. New York: Routledge 2012.

Arlette Farge: Der Geschmack des Archivs. Göttingen: Wallstein Verlag 2011.

Giovanna Fossati: From Grain to Pixel. The Archival Life of Film in Transition. Amsterdam: Amsterdam University Press Verlag 2011 (Framing Film).

Caroline Frick: Saving Cinema. The Politics of Preservation. Oxford: Oxford University Press 2011.

Walter Fritz: Kino in Österreich 1945-1983. Wien: Österreichischer Bundesverlag 1984.

Rosalind Galt: The New European Cinema. Redrawing the Map. New York: Columbia University Press 2006 (Film and Culture).

Beryl Graham & Sarah Cook: Rethinking Curating. Art after New Media. Cambridge, MA: The MIT Press 2010.

David Couzens Hoy: Critical Resistance. From Poststructuralism to Post-Critique. Cambridge, MA: The MIT Press 2005.

Thomas Elsaesser: European Cinema. Face to Face with Hollywood. Amsterdam: Amsterdam University Press 2005 (Film Culture in Transition).

Louis C. Gawthrop: Public Service and Democracy. Ethical Imperatives for the 21st Century. New York: Chatham House Publishers/Seven Bridges Press 1998.

Gegenschuss. 16 Regisseure aus Österreich. Herausgegeben von Peter Illetschko. Wien: Wespennest 1995 (Wespennest-Film).

Keith Jenkinks: Re-thinking History. London: Routledge 2003 (Routledge Classics).

The Postmodern History Reader. Edited by Keith Jenkins. London: Routledge 2005.

David L. Martin: Curious Visions of Modernity. Enchantment, Magic, and the Sacred. Cambridge, MA: The MIT Press 2011.

Cinema and Social Change in Germany and Austria. Edited by Gariele Mueller & James M. Skidmore. Waterloo, Ontario: Wilfried Laurier University Press 2012.

Martha C. Nussbaum: Not For Profit. Why Democracy Needs the Humanities. Princeton: Princeton University Press 2012.

Visual History. Ein Studienbuch. Herausgegeben von Gerhard Paul. Göttingen: Vandenhoeck & Ruprecht 2006.

Frauen und Film und Video. Herausgegeben von Claudia Preschl. Wien: Filmladen 1986.

Robert A. Rosenstone: Visions of the Past. The Challenge of Film to Our Idea of the Past. Cambridge, MA: Harvard University Press 1995.

Karin Schiefer: Filmgespräche zum österreichischen Kino. Wien: Synema 2012.

Der neue österreichische Film. Herausgegeben von Gottfried Schlemmer. Wien: Wespennest 1996 (Wespennest-Film).

Spiele und Wirklichkeiten. Rund um 50 Jahre Fernsehspiel und Fernsehfilm in Österreich. Herausgegeben von Sylvia Szely. Wien: verlag filmarchiv austria 2005.

A Companion to the Philosophy of History and Historiography. Edited by Aviezer Tucker. London: Blackwell Publishing 2009 (Blackwell Companions to Philosophy).

Theorising National Cinema. Edited by Valentina Vitali & Paul Willemen. London: BFI 2006.

Robert von Dassanowsky: Austrian Cinema: A History. Jefferson, NC: McFarland & Company 2005.

New Austrian Film. Edited by Robert von Dassanowsky & Oliver C. Speck. New York: Berghahn Books 2011.

Brian Winston: Claiming the Real II. Documentary: Grierson and Beyond. New York: Palgrave Macmillan 2008.

Playing with Glass Beads

NICOLE PRUTSCH

> These rules, the sign language and grammar of the Game, constitute a kind of highly developed secret language drawing upon several sciences and arts, but especially mathematics and music (and/or musicology), and capable of expressing and establishing interrelationships between the content and conclusions of nearly all scholarly disciplines. The Glass Bead Game is thus a mode of playing with the total contents and values of our culture; it plays with them as, say, in the great age of the arts a painter might have played with the colours on his palette.
> Hermann Hesse, The Glass Bead Game.

Nicole Prutsch's work poses questions around human identity and its perception through performance and video installation. The focus is determined by historical and contemporary discoveries in biomedical science and the exponential progress of technological possibilities that impact on society and the individual.

In her performances, Prutsch researches perceptions of the body in the vacuum of anticipation where the physical body is getting reduced to a certain, still position through the use of new media, laptops, smartphones, internet. Like a mirror, the interface (internet video phoning, Facebook, etc.) functions as the image of the body – not from a point where the body is located, but in front of it. New media offer the potential to capture the body as an image which doesn't exist without this technology. However, the interface doesn't show an illusion of the body, but opens up an illusory space for the imagination of the body. Because of the absence of the real body, which is, after Lacan, fragmented in the mirror (Lacan 2001:5), the individual somehow seems to have a necessity for self assurance. The latter is performed, for example, in internet platforms of social networks via tagging him/herself at certain local points and therefore saying "I'm here". The subject, in a way, is functioning as a sculpture and found isolated in front of the interface – in parallel exposing her/himself in the cyberspace.

Self assurance is not a contemporary phenomenon, but has always been a motive to measure and categorize in terms of heritage, sex, body appearance, intelligence, social status, education, etc. However, the compulsion to measure seems to appear in a new popularity. Through the exponential progress of technologies in biomedical science, it is now proposed to measure the individual in terms of decoding the human genome and "reading it". Recent studies propose a couple of genes responsible for the morphology of the face (cf. Kayser et. al. 2012), and some companies even suggest to find the right partner through analyzing the genetic pattern of the individuals at first. The progress of technology can be useful for detecting certain dispositions or healing of diseases, but it also opens up critical questions for human kind and society as for example preimplantation diagnostics is used in some countries to abort female embryos.

After Marcel Duchamp and the Dadaists, Futurism and Kubism at the end of the 19th century that reflected new findings in science such as Albert Einstein's general theory of relativity, the movement "art and science" finds a new popularity and perhaps necessity in contemporary art. The control of the human body/the individual and the topic of transiency shows up in ephemeral installations but also through the medium of performance and body art that represents a new search for feeling physical appearance in the era of Internet and Cyber identity.

Through a set of interventions, Prutsch stages a series of games that play on reality, experience and anticipation, via a scopophilic view of the human condition.

BANG ON TARGET

2009 / Installation, Kunstraum Praterstraße 15, Vienna

Based on the question if mechanisms of attraction between two persons are analytically determinable on the cellular or genetic level, the following study was designed: In experiments, founded on the principle of the so called invasion assay and gene chips, the compatibility of a test person in relation to nine other study participants was investigated.

Invasion assays are a method in biomedical research. Cells are seeded in special chambers and stimulated with certain messenger substances to migrate through a membrane and invade a special matrix. A fluorescent staining visualizes the cells afterwards. Through multiple charges, differences between the individual probes can be determined statistically. The principle of gene chips

is based on the so called hybridization. The genome of a proband dissolved in a solution is inserted into the chip. As in the way of a zip fastener and since biochemical pairing only occurs by molecules which fit exactly together: adenine and thymine, guanine and cytosine, chains of the proband are connecting with their complementary chains on the chip (cf. Lashkari et. al. 1993).

Genetics gets more and more popular. The structure of DNA was first described in 1953 by the American James Watson and the British Francis Crick (cf. Crick&Watson 1933). In 2003 the decoding of the whole human genome was proclaimed, however, there is no answer two all the questions, since new ones are arising repeatedly. In fact Websites as "Genepartner.com" are promising a higher rate of success in terms of relationships if one determines compatible gene profile first.

The power of genes = the power of love? BANG ON TARGET!

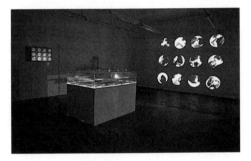

BANG ON TARGET

The Human Market

2011 / Performance, 1 hour / Ragnarhof Vienna

Trisomy 21 (Down Syndrom). 90% of parents decide for abortion after this diagnosis. Within a new quicktest the whole genome of the fetus can be decoded already in the 10th week of gestation, by using the fetal cells circulating in the mothers blood. The genetic control is near. What will be the next "Genes of Interest"?

The performance constists of a number of individuals staged in a market situation, each of them representing a certain genetic advantage. A pricelist according to the several subjects is found at the entrance. The viewer is invited to walk through the market and to choose and buy a candidate.

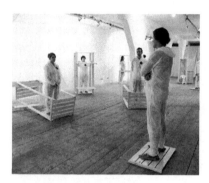

THE HUMAN MARKET

Begreife/Catch

2011/2012, Performance, 30 min / Made of Contemporary, Grundsteingasse Vienna (2011) / Galerija Jakopic Ljublijana (2012)

The performance happens in a situation of complete transparency and isolation in parallel. A sterile clean room bench from the scientific laboratory is the object in the performance. The artist steps onto this bench and stay there naked for 30 minutes. 8 neoprene gloves are leading into the clean room which the viewer is invited to "catch". The performance deals with contemporary ways of social contact paralleling the loss of physical closeness based on technical transformation.

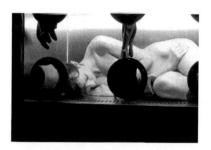

BEGREIFE/CATCH

Playing with Glass Beads 181

ANTHROSCOPE

2011, Videoinstallation, Black cube with holes and lenses
"Things that talk", Vienna Art Week 2011, Museum of Natural History Vienna

The anthropological exhibition of the Museum of Natural History Vienna (NHM) was closed at the end of the 1990s. The reason was the questionable exhibits that made a comparison of the so called "human races". The body measurements can still be seen in a "Filmarchiv Austria" documentary in the NHM. Departing from the question of how measurement might be made in the era of genetics, preimplantation diagnostics and reproductive medicine, the "Anthroposcope" was designed for the pleasure of observing and measuring various homunculi.

ANTHROPOSCOPE

MIRROR STAGE

2012 / Six-Channel Video Installation / „Panopticon", The Nunnery, London

> The Panopticon is a machine for dissociating the see/being seen dyad: in the peripheric ring, one is totally seen, without ever seeing; in the central tower, one sees everything without ever being seen.
> (Foucault 1977:9)

Originally an 18th century concept proposed by philosopher and theorist Jeremy Bentham, a Panopticon allows one conducting surveillance over all inmates of an institution to create a sense of instability and uncertainty in those being

discreetly observed. Initially, this was utilized as a mechanism of control but in recent times the paradigm has shifted, since control mechanisms have also become a tool for evoking a sense of safety and security.

"Mirror Stage", a series of performances on London buses, references Jaques Lacan's theory of the „Gaze", in a work that exaggerates the psychological effect of the loss of autonomy, through the realization that to be objectively visible causes one to act differently. The work also draws influence from Marina Abramovic's "Art Must Be Beautiful Artist Must Be Beautiful" but translated to our time by being rather a quick "getting ready" and staying on the surface.

People are hardly taking notice. Two times the bus drivers tells the artist to stop: ‚Please don't stand in the bus', ‚Lady on the top floor: Stop that please.' One time people are laughing when watching the artist on the screen downstairs. The rest of the time nothing happens.

MIRROR STAGE

Self Portraits

2012 / Video Installation / „Trompe-l'oeil / interpassive", Vyner Street Gallery, London

"Self Portraits" is conceived out of sequences recorded by the integrated camera in webbrowsing devices, whilst experiencing a range of stimuli. As a philosophical interpretation of the Trompe-l'oeil, the "interpassive practice" (Pfaller 2008) describes the practice of delegating feelings and behaviours on to external objects, persons or things. This represents a subtle form of escapism from anxiety raised by the confrontation with one's own pleasure.

Prutsch watches these sequences: Artist Interview (Emin), Sitcom, cooking show, kissing couple (Andy Warhol's "Kiss") and Pornography.

SELF PORTRAITS INTER-FACE

Inter-Face

2012 / Multi Media Performance / Collaboration with George William Price

The initial idea for *Interface* were the daily performances of women on the London Underground applying their make up. Watching them, one can ask why this personal ritual is brought into a public space. Seeming to be aware that they are being watched, they behave as if they do not care about being observed. Instead the surrounding people become invested by actively avoiding direct eye contact. Within this "performance" the gaze is transposed back to the voyeur from the now female aggressor.

Prutsch and Price sit next to each other in front of computers, connected via the internet. Cameras capture and record their portraits that are projected in real time, layered on top of one another. In sequence they apply our make-up, announcing each step beforehand. A dialogue built upon intimate ritual.

 Contact between two subjects enabled via internet videophone. Instead of reducing the distance between the two subjects this technology in fact exacerbates this reality due to temporal distortion. The artists attempt to highlight this distortion through our physical proximity, playing with intimacy, distance and tension.

References

Hesse, H.: The Glass Bead Game: (Magister Ludi) A Novel, Picador, 2002.

Lacan, J., "The Mirror Stage as Formative of the Function of the I", in Écrits: a selection, London, Routledge Classics, 2001.

Kayser M. et. al., „A Genome Wide Association Study Identifies Five Loci Influencing Facial Morphology in Europeans", PLoS Genet. 2012 September; 8(9): e1002932. Published online 2012 September 13.

Lashkari DA, DeRisi JL, McCusker JH, Namath AF, Gentile C, Hwang SY, Brown PO, Davis RW (1997). http://www.ncbi.nlm.nih.gov/pmc/articles/PMC24262/ "Yeast microarrays for genome wide parallel genetic and gene expression analysis". *Proc Natl Acad Sci USA* 94 (24): 13057–13062.

Watson, J.D. & Crick F.H. (1953): http://www.nature.com/physics/lookingback/crick/index.html Molecular structure of nucleic acids. A structure for deoxyribose nucleic acid. In: http://de.wikipedia.org/wiki/Nature Bd. 171, Nr. 4356, S. 737–738.

Foucault, M.: *Discipline & Punish, the birth of the Prison.* Knopf Doubleday Publishing Group, 1977.

Pfaller, R.: *Ästhetik der Interpassivität.* Verlag Fundus, 2008.

List of Contributors

Thomas Ballhausen is a film scholar working for the FAA - Film Archive Austria (Vienna) – and teaching at the University of Vienna (Dept. for Comparative Literature, among others). Furthermore, he is a writer, literary studies person, editor and translator based in Vienna.

Daphne Dragona is a media arts curator and researcher based in Athens, Greece. Her main fields of interest are game-based art, networked art and creativity related to the digital commons. She has collaborated for exhibitions, workshops and media art events with well known centers, museums and festivals in Greece and abroad. Among them are, LABoral Art and Industrial Creation Centre (Gijon), Mediaterra festival (Athens), the National Museum of Contemporary Art (Athens), Fundacion Telefonica and Alta Tecnologia Andina (Lima) and Transmediale festival (Berlin). She has participated with lectures and presentations in academic conferences as well as media art festivals and articles of hers have been published in books and magazines of various countries. She is a PhD candidate in the Faculty of Communication & Media Studies of the University of Athens, exploring the changing role of play in the era of the social web.

Tanja Döring (Hamburg, Germany) studied computer science and art history in Hamburg and Valladolid (Spain). Currently, she has a position as research associate in the Digital Media Group at the University of Bremen (Germany). Her research focus is on human-computer interaction (HCI), especially in the areas of tangible interaction, interactive surfaces, and embodied interaction. Tanja's media art installations have been displayed at ZKM in Karlsruhe (Germany) at the German HCI Conference Mensch & Computer, at MIT Media Lab in Cambridge (MA) and at Kunsthalle Bremen (Germany). She is a co-founder of the Fab Lab in Hamburg and co-organizer of Fab Lab workshops.
http://dm.tzi.de/en/people/staff/tanja-doering/

Günther Friesinger lives in Vienna and Graz as a philosopher, artist, writer, curator and producer. He is founder and head of the paraflows festival, co-founder and chairman of the QDK - quarter for digital culture, general manager of *monochrom*, co-organizer of the Arse Elektronika festival, the Roboexotica festival and the komm.st festival.
Publications: Context Hacking. How to Mess with Art, Media, Law and the Market (2013), The Wonderful World of Absence (2011), Urban Hacking: Cultural Jamming Strategies in the Risky Spaces of Modernity (2010), Public Fictions (2009), Pronnovation?: Pornography and Technological Innovation (2008).
Tag cloud: contemporary art, activism, media theory, radical innovation, science fiction, free software and copyright.

Johannes Grenzfurthner Edge, LA Times, NPR, ZDF, Gizmodo, Wired, Süddeutsche Zeitung, CNet or the Toronto Star. Recurring topics in Johannes' artistic and textual work are contemporary art, activism, performance, humor, philosophy, postmodernism, media theory, cultural studies, sex tech, popular culture studies, science fiction, and the debate about copyright.

Jana Herwig, M.A., is a researcher in the Vienna-based research project „Texture Matters. The Optical and Haptical in Media" (2011-2014, University of Vienna, Project leader: Prof. Dr. Klemens Gruber/Prof. Antonia Lant, PhD). M.A. in Theater, Film and Television Studies, Dutch Language and Literature and Education (University of Cologne), visiting student in Ghent (Belgium) and Grahamstown (South Africa). Various positions in the online industry from web 1.0 developer to project manager for new media to corporate blogger. Academic experience: teaching assistant for German as a Foreign Language (South Africa), lecturer for content-based English (students of media design, FH Vorarlberg), academic assistant at the Chair for Intermediality, Dept. of Theater, Film and Media Studies, University of Vienna. She can be contacted at her blog: http://digiom.wordpress.com/about/

Sylvia Johnigk studied Computer Science at Berlin Technical University, with a focus on data security and software technology. For 17 years, she has been working in IT security and privacy, starting her own business in IT consulting in 2009. She is an active member of FIfF e.V. (Forum Computer Scientists for Peace and Social Responsibility), joining its board in 2009.

Alexander Kelle is Senior Policy Officer in the Office of Strategy and Policy of the Organisation for the Prohibition of Chemical Weapons. Before joining the OPCW in February 2013 he has been working at various academic institutions over a period of more than 15 years. During that time his research interests have been mostly in the areas of chemical and biological weapons (CBW)

prohibition regimes, as well as the interface between scientific and technological developments and policies and governance measures. His publications include Preventing a biochemical arms race (with K. Nixdorff and M. Dando, Stanford: Stanford University Press, 2012), "Beyond patchwork precaution in the dual-use governance of synthetic biology" in Science and Engineering Ethics (open access, 2013) and Prohibiting Chemical and Biological Weapons: Multilateral Regimes and Their Evolution (Boulder, CO: Lynne Rienner Publ., 2014).

Lei Pei obtained her PhD in Clinical Bacteriology at Karolinska Institutet with over 10 years of research experience in life science. Since 2009, she has worked on an Austrian-Chinese cooperative project on governance schemes, safety issues and regulatory aspects of SB, TARPOL project on investigating the environmental applications of SB and SYNMOD on ethics of using SB to develop novel lantibiotics. She is now a senior scientist in Biofaction, focusing on the technological assessment and policy analysis of novel technologies.

Nicole Prutsch *1980 Wagna, Austria; lives and works in Vienna. Nicole Prutsch studied painting at the University of Applied Arts Vienna at the Studio of Johanna Kandl and Gerhard Müller. She also performed a Guestsemester at Art&Science Visualization at the Studio of Virgil Widrich, and at the University of the Arts London, Wimbledon College of Art, Print and Time Based Media. Further on she studied Biomedical Science at the University of applied Sciences, FH Campus Vienna.

Markus Schmidt is the founder and CEO of Biofaction, a research and science communications company, and has an educational background in electronic engineering, biology and environmental risk assessment. For the last 10 years, he carried out environmental risk assessment, safety and public perception studies in a number of science and technology fields, including GM-crops, gene therapy and synthetic biology. He served as an advisor to the European Group on Ethics (EGE) of the European Commission and the US Presidential Commission for the Study of Bioethical Issues. Schmidt also aims to contribute to a better interaction between science, society and art though public talks, documentary films, the organisation of the Synthetic biology science, Art and Film Festival, Bio:Fiction, and the bioart exhibition synth-ethic. For more information see:
www.markusschmidt.eu
www.biofaction.com
www.biofaction.com/synth-ethic

Frank Apunkt Schneider is an unfree author, unfree artist and unfree lecturer. He lives and works in Bamberg, Germany. In 2007 he published "Als die Welt noch unterging" (Ventil Verlag), a book dealing with early German punk/new wave culture. Frank Apunkt Schneider is member of *monochrom*.

Judith Schossböck (Vienna) is a research fellow at the Centre for E-Governance at Danube University Krems, Austria. She is member of the interdisciplinary internet research group at the University Vienna. Her research interest are net politics, the promises of new media and digital u(dys)topia.

Katharina Stöger is a film scholar and curator based in Vienna. Her research centers around contemporary Austrian cinema, Auteur Theory and Gender Studies.

Mara Verlič is a sociologist with a focus on urban studies and has worked in inter-disciplinary urban development projects, in neighborhood management and in urban cultural management. Since 2011 she is a predoc Assistant Professor at the Department of Spatial Development, Infrastructure and Environmental Planning at Vienna University of Technology focusing on urbanism and European spatial development.

Wei Wei received his PhD on Botany from the Institute of Botany, Chinese Academy of Sciences. His major research interests are in plant ecology and biodiversity conservation. He worked on the biosafety issues of genetically modified organisms for 15 years. He is now interested in studying the link between genetic engineering and SB on biosafety, and aims to develop proper risk assessment and management strategies of SB.

Anouk Wipprecht What does fashion lack? "Micro-controllers" according to Dutch based designer Anouk Wipprecht. Working in the emerging field of "fashionable technology" – a rare combination of fashion design, engineering, science, and interaction/user experience design, she has created an impressive body of tech-enhanced designs that defy convention, bringing together fashion and technology in unusual ways. She creates technological couture creatures; with systems around the body that tend towards artificial intelligence, her designs move, breathe, and react to the environments around them. The space of the body is often transformed into a stage where the garment becomes the leading actor. Anouk seeks to create a "higher connectivity of the senses through the medium of clothing" by projecting technology as an extension or prosthetic of the body. Investigating the extent to which we experience fashion (emotionally, intellectual, and sensually) both from a physical as well as psychological angle, these designs responds to us, while also affecting our sartorial experiences.

Producing garments which aim at more than just the traditional function of coverage and adornment, Anouk's techno-fashions are one-of-a-kind, architectural, avant-garde statements with bold silhouettes, vested with circuitry and a regalia of plastic tubes, fluids ,smart foils and the ability to respond in an unique and remarkable way to the wearer and his or her surroundings. Coined as "Playful exploration', her work studies the increasing intimate, personal, social and public interaction between humans and machines. Wipprecht was the curator of the TECHNOSENSUAL "Where Fashion meets Technology' exhibition which took place at the MuseumsQuartier, Vienna 2012, in collaboration with monochrom.

Stefanie Wuschitz is a lecturer, researcher and media artist from Vienna. She graduated with honors from the University of Applied Arts, Vienna, and completed her Masters at NYU's Interactive Telecommunications Program. During a Digital Art Fellowship in Sweden she coordinated the Eclectic Tech Carnival 2009 and founded Miss Baltazar's Laboratory. At the moment she is a doctorate candidate at the University of Technology, Vienna, and teaching part time at the University of Applied Arts Vienna at the department of DIGITAL ART. Her art work has been presented among others at the following venues: the Austrian Cultural Forum (NYC), Galeria Hippolyte (Helsinki), Okno (Bruessels), Videonale (Bonn), Goethe Institut (Damascus), Arthall (Budapest), Worm (Rotterdam), Murberget (Härnösand), the Ars Electronica Festival (Linz), Transmediale (Berlin), ViennaFair (Vienna), DogPigArt (Taiwan), Lisi Hämmerle (Bregenz).